Ars Judaica

The Bar-Ilan Journal of Jewish Art

The Michael J. Floersheim Memorial for Jewish Art

Editors

Bracha Yaniv

Sara Offenberg **Mirjam Rajner** **Ilia Rodov**

Volume 10 2014

Bar-Ilan University

Editorial Board

Prof. Matthew Baigell	Rutgers, The State University of New Jersey
Prof. Evelyn M. Cohen	The Jewish Theological Seminary (JTS), New York
Prof. Mira Friedman	Tel Aviv University
William L. Gross	Collector, Tel Aviv
Prof. Bernard Dov Hercenberg	Bar-Ilan University, Ramat-Gan
Prof. Rudolf Klein	Saint Stephen University, Miklos Ybl Faculty of Architecture, Buda
Prof. Katrin Kogman-Appel	Ben-Gurion University of the Negev, Beer Sheva
Prof. Lee I. Levine	The Hebrew University of Jerusalem
Prof. Vivian B. Mann	Graduate School of JTS and The Jewish Museum, New York
Prof. Avigdor W.G. Posèq	The Hebrew University of Jerusalem
Prof. Elisheva Revel-Neher	The Hebrew University of Jerusalem
Prof. Meir Roston	Bar-Ilan University, Ramat-Gan
Prof. Shalom Sabar	The Hebrew University of Jerusalem
Prof. Menahem Schmelzer	JTS, New York
Prof. Daniel Sperber	Bar-Ilan University, Ramat-Gan
Prof. Zeev Weiss	The Hebrew University of Jerusalem
Prof. Bracha Yaniv	Bar-Ilan University, Ramat-Gan

**This publication is made possible by the generosity of
Dr Yonat Floersheim and her son Alexander Floersheim**

Editorial coordinator	Aviva Carmi Levine
Administrative assistant	Rachel Hanig
Text editor	Dr Michal Michelson
Copy editor	Yohai Goell
Design and production	Nitsa Bruck, A.N.B. Project Management
Logo design	Ora Yafeh
Prepress, printing & binding	Art Plus, Jerusalem

Jechezkiel David Kirszenbaum, *Seated Peddler*, detail (see fig. 2, p. 72) oil on canvas, 30 × 20 cm. Family Collection. Photo: Ran Erde

Submission of manuscripts, book reviews, and publications:
Department of Jewish Art, Faculty of Jewish Studies
Bar-Ilan University, Ramat-Gan 52900, Israel
Tel. 972-3-5317217
ajudaica@biu.ac.il • www.biu.ac.il
Find *Ars Judaica* at facebook.com/ArsJudaica

Distributed worldwide, except in Israel,
by **The Littman Library of Jewish Civilization**
www.littman.co.uk/arsjudaica

Contents

Editors' Note

With the publication of the tenth issue of *Ars Judaica – The Bar-Ilan Journal of Jewish Art* we celebrate a decade of intensive research and academic activity in the field of Jewish art and visual culture. The journal has become a worldwide meeting place for leading experts and promising young researchers, scholars from different continents and various academic schools, and people of diverse ideological, religious, and political points of view. During this decade the dozens of articles appearing in the journal's pages and an array of lectures and discussions delivered at the *Ars Judaica* international conferences and local colloquia have revealed the accumulated scholarly research in the field that has fostered a new exchange of ideas. This, we hope, will inspire further creative insights into Jewish involvement with visual arts and exploration of the discourse with their non-Jewish surroundings. While offering to our readers a wide range of subjects from antiquity to the modern period, we strive to include as well new research dealing with the thriving field of contemporary Jewish art. All these achievements would not be possible without the deep dedication, interest, and generosity of Dr Yonat Floersheim and her son Alexander, to whom on this festive occasion we express our deep gratitude.

This anniversary volume is also our homage to the founder and editor-in-chief of *Ars Judaica*, Prof. Bracha Yaniv. The enterprise is her dream that came true and she continues to be a vivid spirit, fatigueless mover, and diligent implementer of the *Ars Judaica* project.

The threshold of a second decade of *Ars Judaica* is also a proper occasion to express our gratitude to all the authors who share the fruits of their research with our readers, and our thanks to the staff that worked devotedly on the first ten volumes of the journal: text and copy editors Malka Jagendorf, Yohai Goell, and Michal Michelson; designer Nitsa Bruck; editorial coordinator Aviva Carmi Levine; and administrative manager Rachel Hanig. In the current issue, we are honored and pleased to have Sara Offenberg join us as a new co-editor.

The current volume covers a wealth of subjects from medieval illuminated manuscripts to American feminist art.

Sarit Shalev-Eyni analyzes two illuminated *piyyutim* for the prayers of dew and rain in German Ashkenazi *maḥzorim* from the thirteenth and fourteenth centuries. Through the study of zodiac signs, the author traces the migration of Christian and Muslim as well as earlier Jewish textual and visual traditions to the Jewish communities in medieval Germany, and the adoption of these traditions in the new iconographic programs of Ashkenazi prayer books.

Katrin Kogman-Appel demonstrates that Cresques Abraham (1325–87), prominent mapmaker in the service of the kings of Aragon, and the scribe and illuminator of the Hebrew Farhi Bible, Elisha ben Abraham Bevenisti of Mallorca, are the same person. The article reveals the fascinating figure of a Jewish "universal man," well versed in both Jewish and Christian artistic traditions, in fourteenth-century Spain.

Evelyn M. Cohen investigates an illuminated manuscript exceptional in a number of aspects. Her subject is a Passover Haggadah written and lavishly illustrated by hand in 1842, during the era of book printing; it is the first known Hebrew book illuminated by a woman, Charlotte Rothschild; and it is a modern Jewish ritual book whose illustrations are modeled after a Renaissance Christian *Book of Hours* produced for Frederick III of Aragon in 1501–04. Cohen scrutinizes the way in which Charlotte Rothschild adapted her artistic model to the Haggadah's contents and the taste of the nineteenth-century Jewish elite.

Ronit Steinberg's "Sampler Embroidery Past and Present as an Expression of Merging Jewish Identity" focuses on embroidery as art specifically explored by feminist artists. In this case the subject of interest is the embroidery genre known as the Sampler. Following the exhibition of contemporary Jewish artist Elaine Reichek in the Jewish Museum in New York (1994), the article examines embroidery pieces created by young Jewish women from the eighteenth century on, most of them in the United States. It introduces a comparative model between contemporary and traditional works and argues that there is a unique common factor: a female Jewish secular identity. This article's objective is to demonstrate the presence of an acculturated American Jewish identity in both contemporary and traditional art.

"The Restoration of Loss: Jechezkiel David Kirszenbaum's Exploration of Personal Displacement," by Caroline Goldberg Igra, introduces a "forgotten" Jewish artist, Jechezkiel David Kirszenbaum (1900–54). The artist and his oeuvre were made known through the untiring efforts and dedication of Nathan Diament, a member of the family and a Holocaust survivor. Both Kirszenbaum and Diament experienced personal displacement and loss of their families during World War II. It was Kirszenbaum who expressed this in a figurative manner, primarily through topics dealing with memory, displacement, and hope. Kirszenbaum's art exhibits a programmatic attempt to restore not only his personal loss but that of his people. Whether through images of the arrival of the Messiah to the *shtetl*, exhausted displaced individuals, or the forefathers of Jewish history, the artist consistently maintains the conviction of imminent salvation, his imagery bearing testimony to the survival of the lost generation.

Eleonora Bergman's work focuses on the Great Synagogue on Tłomackie Street in Warsaw, inaugurated in 1878 and destroyed by the Nazis in 1943. Bergman records the architectural history of the synagogue from the emergence of the idea and the competition of proposed projects through to the construction of the synagogue complex. She analyzes the symbolic meanings of the synagogue built by a Polish architect of Italian origin, Leandro Marconi, and discusses the perceptions of this landmark by the Jews and Poles of Warsaw.

The "Special Item" by Sergey R. Kravtsov and Vladimir Levin examines a pair of wall paintings seen, though cropped, in a photograph taken in the Great Synagogue in the town of Radyvyliv, Volhynia, in 1912–13. The captions under the paintings substantiate the theory that certain zoomorphic images in the decoration of eastern-European synagogues were inspired by the compilation of liturgical hymns known as *Perek Shirah*.

We believe that this volume, while summarizing a decade of continuous learning and offering an opportunity to review and re-examine our endeavors, opens a new period of intellectual enrichment.

Sara Offenberg, Mirjam Rajner, Ilia Rodov

The Maḥzor as a Cosmological Calendar:
The Zodiac Signs in Medieval Ashkenazi Context

Sarit Shalev-Eyni

Jewish interest in the zodiac can be traced back to the Late Roman and Early Byzantine times.[1] Although belief in the ability of the zodiac to influence the destiny of Israel was a matter of controversy,[2] lively descriptions of it flourished in both the Palestinian Byzantine *piyyutim* (liturgical hymns) and in some collections of midrashim (homiletical treatises on the Bible),[3] which revealed the prominent place of the zodiac within the cosmos and at the same time determined its legendary and symbolic character. Many of these sources, together with their cosmological contexts, reached medieval Ashkenaz and

informed the local concept of the zodiac.[4] Other related popular traditions of Palestinian Aramaic origin were transmitted in Ashkenazi liturgical manuscripts with a short appendix of astrological excerpts.[5]

One route of transmission was France, where the Book of the Elkoshi[6] was completed in 1124/25 by Jacob bar Samson, a student of Rashi. This comprehensive treatise, dealing with astrology, astronomy, the Jewish calendar, and the Creation of the World, shows some affinity to *Sefer ha-ibbur*, written by the Sephardi scholar Abraham bar Hiyya just a short time previously.[7] Various additional sources,

1 Jacques Halbronn, *Le Monde juif et l'astrologie: histoire d'un vieux couple* (Milan, 1985); Ronald Kiener, "The Status of Astrology in the Early Kabbalah: from the 'Sefer Yesirah' to the 'Zohar'," in *The Beginnings of Jewish Mysticism in Medieval Europe*, ed. Joseph Dan (Jerusalem, 1987), 1–42; Moshe Idel, "The Zodiac in Jewish Thought," in *Written in the Stars: Art and Symbolism of the Zodiac* [catalogue, Israel Museum], ed. Iris Fishof (Jerusalem, 2001), 19–22; Reimund Leicht, "The Planets, the Jews and the Beginnings of Jewish Astrology," in *Continuity and Innovation in the Magical Tradition*, eds. Gideon Bohak, Yuval Harari, and Shaul Shaked, Jerusalem Studies in Religion and Culture, 15 (Leiden, 2011), 271–88; id., "Toward a History of Hebrew Astrological Literature: A Bibliographical Survey," in *Science in Medieval Jewish Cultures*, ed. Gad Freudenthal (New York, 2011), 255–91.

2 BT Shabbat 156a–b.

3 See, e.g., *Midrash Tanhuma (S. Buber Recension)*, vol. 1: *Genesis*, trans. John T. Townsend (Hoboken, NJ, 1989), Vayeshev; *Pirke de Rabbi Eliezer, The Chapters of Rabbi Eliezer the Great*, trans. Gerald Friedlander (New York, 1970), chs. 5 and 6.

4 Throughout the article Ashkenazi refers to Jews living in the German lands.

5 Leicht, "Toward a History," 258–62. Among the earliest German examples, are a copy of Maḥzor Vitry (Oxford, Bodleian Library, Opp. 59; ibid., n. 34), and another *maḥzor* of 1288/89 (Oxford, Bodleian Library, Mich 569, ibid., n. 3). For additional Ashkenazi contexts, see

Reimund Leicht, "The Reception of Astrology in Medieval Ashkenazi Culture," *Aleph* 13, 2 (2013): 201–34.

6 For the pronunciation of the name "Elkoshi," see Nahum 1:1.

7 See Avraham Grossman, *Ḥakhmei Zarfat ha-rishonim: koroteihem, darkam be-hanhagat ha-ẓibbur, yeẓiratam ha-ruḥanit* (The Early Sages of France: Their Lives, Leadership and Works) (Jerusalem, 1995), 419–20 (Hebrew). For Abraham bar Hiyya, see Shlomo Sela, "Abraham bar Hiyya's Astrological Work and Thought," *JSQ* 13 (2006), 128–58. The Ashkenazi perception of the zodiac was different in its popular features from that prevalent in the Iberian Peninsula and Provence. Here, under the influence of Greco-Arabic writings, the zodiac was discussed within a broad frame of astrology, which was considered, together with astronomy, a branch of science. Among the prominent figures in the field are Yehudah Halevi and Abraham Ibn Ezra, who made use of astral magic in their theological thought and commentary; see Dov Schwartz, *Astrologiah u-magiah ba-hagut ha-yehudit bi-mei ha-beinayim* (Astral Magic in Medieval Jewish Thought) (Ramat-Gan, 1999), 32–91 (Hebrew). For Abraham Ibn Ezra, see also Shlomo Sela, *Astrologiah u-farshanut ha-mikra be-haguto shel Avraham Iben Ezra* (Astrology and Biblical Exegesis in Abraham Ibn Ezra's Thought) (Ramat-Gan, 1999) (Hebrew). Despite Maimonides's strong objection (Schwartz, *Astrologiah u-magiah*, 92–121), astral magic became popular in some rationalist circles from the late thirteenth through the fourteenth centuries (ibid., 145–65).

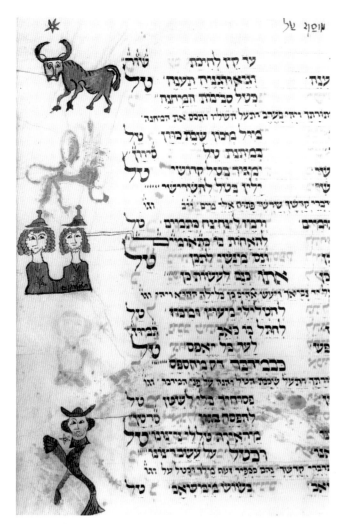

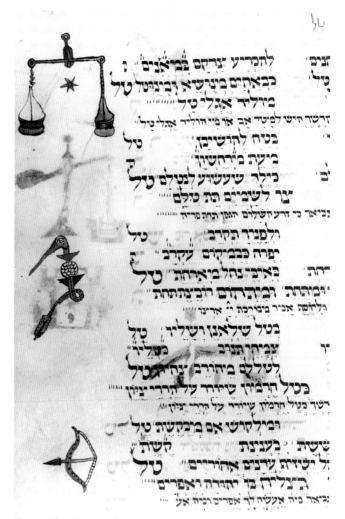

Fig. 1. Zodiac signs of Ox (Taurus), Twins (Gemini), Cancer: a piyyut for dew. Oppenheim Maḥzor, Franconia (?), 1342. Oxford, Bodleian Library, Opp. 161, fol. 63r

Fig. 2. Libra, Scorpion, Bow (Sagittarius): a piyyut for dew. Oppenheim Maḥzor, fol. 64r

some of them also going back to the early Palestinian legacy, were involved in its composition.[8] The Book of the Elkoshi reached us only in a poor and fragmentary state, with diverse passages scattered in several manuscripts,[9] as well as quotations included in other works, alluding to the penetration of the Elkoshi into German-speaking

areas.[10] The clear association of the zodiac with the calendar, which was also typical of works on astronomy and the *computus* from which Church liturgical time was formulated, was not fully developed in Ashkenaz until much later, with the crystallization and flourishing of independent calendar-handbooks.[11] The local roots of

8 For the different sources of the Book of the Elkoshi, see Grossman, *Ḥakhmei Ẓarfat ha-rishonim*, 418–23.

9 Large parts of the Book of the Elkoshi were preserved in Oxford, Bodleian Library, Opp. 317; see Adolf Neubauer, *Catalogue of the Hebrew Manuscripts in the Bodleian Library …*, 3 vols. (Oxford 1886–1906), no. 692. For additional parts preserved in other manuscripts, see Grossman, *Ḥakhmei Ẓarfat ha-rishonim*, 418–21.

10 See an Ashkenazi miscellany of 1329 with a long passage of the Book of

the Elkoshi (Oxford, Bodleian Library, Opp. 614; Neubauer, *Catalogue of the Hebrew Manuscripts*, no. 2275); Grossman, *Ḥakhmei Ẓarfat ha-rishonim*, 421–22.

11 See Elisheva Carlebach, *Palaces of Time: Jewish Calendar and Culture in Early Modern Europe* (Cambridge, 2011). Ashkenazi discussions of the calendar in earlier times were usually found in larger collections of customs and liturgy; see ibid., 24–27.

this association, however, were earlier.[12] Moreover, some visual evidence exists for the presence of the zodiac in the liturgical and the Jewish calendarial concept already in the thirteenth and fourteenth centuries. At times, as we shall see, it even played a central role in a comprehensive cosmological perception of the liturgical year.

A unique testimony is the Ashkenazi Oppenheim *Maḥzor* (Oxford, Bodleian Library, Opp. 161), probably produced in Franconia.[13] The manuscript, apparently once the first of two volumes, includes the prayers for the special Sabbaths preceding Pesah (Passover) and the feasts of Pesah and Shavuot (Feast of Weeks). As indicated in a colophon (fol. 134r), a scribe named Jacob completed the work in January 1342.[14] The illustrations were made by an unqualified hand, possibly that of the main scribe. A series consisting of the twelve zodiac signs, executed in ink and colored in blue and red, illustrates the stanzas of the piyyut for dew "Divine beings at mid-day" (אלים ביום מחוסן); some of the zodiac signs include a small star (fols. 62v–64v, figs. 1–2). A minute image of a crescent moon with a five-pointed star illustrates the month of Nisan mentioned in the same piyyut (fol. 62v) alluding to its importance as the first month of the liturgical year. The majority of all the other illustrations alongside the liturgical text refer to astral bodies. The similar combination of a crescent moon and a star illustrates the words "New Moon" (ראש חדש) in the last stanza of the piyyut, "I will praise thee, though thou wast angry with me, thine anger is turned away" (אודך כי אנפת ותשוב) for the Sabbath of Hanukah (fol. 19r). A blue crescent moon with a red star (or the sun) appears next to

the initial word of the piyyut for the Sabbath before the New Moon of Nisan (fol. 40v, fig. 3), another indication of the interest in the lunar cycle and its relation to the Hebrew calendar. The illuminator went even further, and at the end of the haftarot for the Sabbath of Pesah (fol. 84r, fig. 4) added a half-page pen drawing of concentric circles, with the zodiac signs attached along with their titles written in Hebrew; the Kid (Capricorn) is missing, while another crescent moon with a six-pointed star is added between the Fish (Pisces) and the Lamb (Aries) and has the label "*kokhav*" (star in Hebrew). The focus on the astral bodies as the sole subject of the decoration program, as well as the inclusion of the zodiac wheel, is certainly unique. Nevertheless, this unusual approach of adorning the whole liturgical book with astrological and cosmological meanings is based on an earlier tradition, which emerged a hundred years earlier in the same region, in local illuminated maḥzorim.

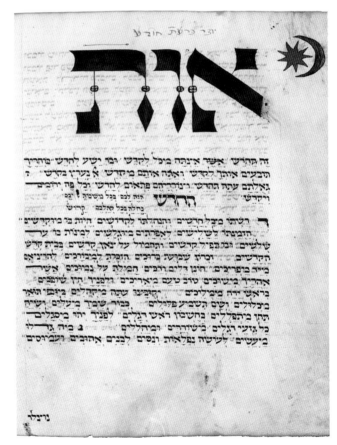

Fig. 3. "Sign of this Month": a piyyut for the Sabbath of the New Moon of Nisan, Oppenheim Maḥzor, fol. 40v

12 One testimony is an Ashkenazi manuscript of around 1300, including a treatise on the calendar (*Sod ha-ibbur*) with a collection of minor astrological texts at the end (Berlin, Staatsbibliothek, Or. Oct. 352; Leicht, "Toward a History," 260, n. 37).

13 Neubauer, *Catalogue of the Hebrew Manuscripts*, no. 1051; Malachi Beit-Arié, *Catalogue of the Hebrew Manuscripts in the Bodleian Library: Supplement of Addenda and Corrigenda to Volume I* (Oxford, 1994), no. 1051.

14 According to the colophon, the manuscript was copied on Wednesday in the year 102 of the sixth millennium after the creation of the world. It is also indicated that the *parashah* (weekly portion) read in the synagogue that week was Va'era (Exod. 6:2–9:35). וכהלכה בעזרת / ותשלם המלאכה כדת / חודש ארוכה / אשרי כל נפש לי חוכה / וסיימתיו / שנת פר' א'מ'י'ו'נ'ה' לאלף ששי יום ד / פר' וארא'' חזק ונתחזק / יעקב / הסופר לא יזק / לא היום ולא / לעולם עד שיעלה חמור / בסולם

אָרְמִת יִשְׂרָאֵל וִירַעְתֶּם מִקִּבְרוֹתֵיכֶם עַמִּי וְנָתַתִּי אֲנִי יְהֹוָה דִּבַּרְתִּי וְעָשִׂיתִי אֶרְמִיזְכֶם דַּ

כִּי אֲנִי יְהֹוָה בִּפְתִחִי רוּחִי בָּכֶם וִחְיִיתֶם נְאֻם יְהֹוָה וְנָתַתִּי וִירַעְתֶּם כִּי וַ

אֶת קִבְרוֹתֵיכֶב רוּחִי בָכֶם וִחְיִיתֶ ם וְהִנַּחְתִּי אֶתְכֶם אֲנִי יְהֹוָה

וּבְהַעֲלוֹתִי וְהִנַּחְתִּי עַל אֲדְמַתְכֶב דִּבַּרְתִּי

יַ וְעַ אֶתְכֶם וִירַעְתֶּב אֶתְכֶם מִ

יָ עַל כִּי מֵ

נְאֻם יְהֹוָה

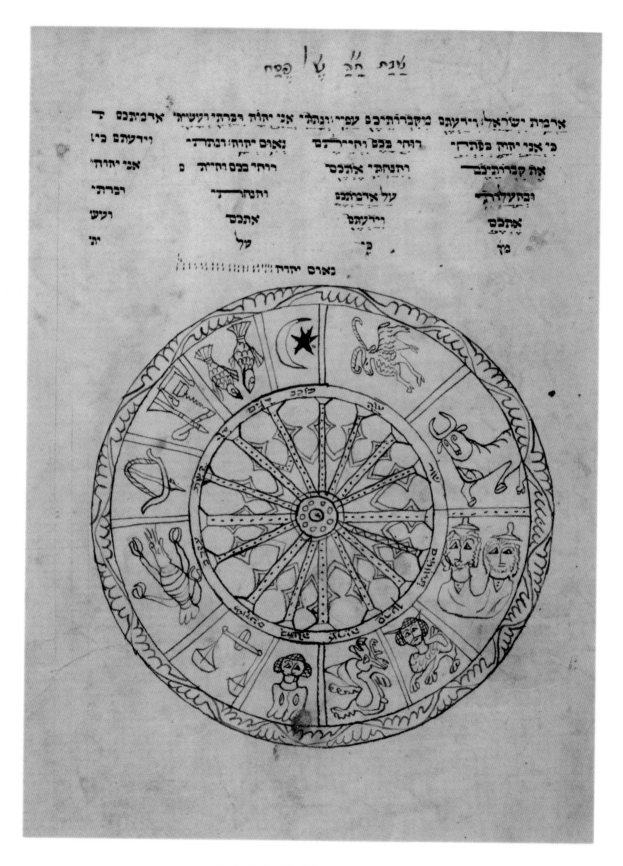

Fig. 4. Zodiac Wheel. Oppenheim Maḥzor, fol. 84r

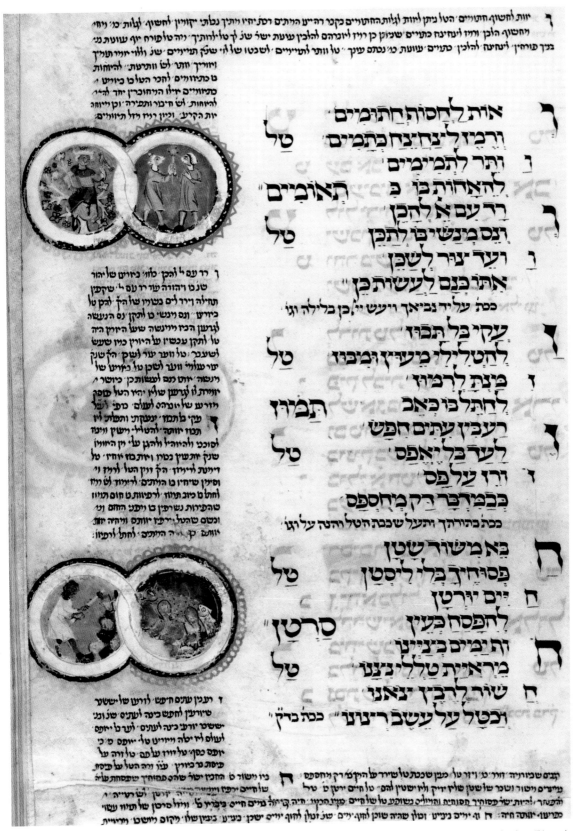

Fig. 5. Zodiac signs of Twins (Gemini) and Cancer – labors of the months of Sivan (flower bearer) and Tamuz (digging): a piyyut for dew, Tripartaite Maḥzor, Budapest volume, Lake Constance, 1322. Budapest, Library of the Hungarian Academy of Sciences, Kaufmann Coll., MS. A. 384, fol. 143r

The illuminated Ashkenazi maḥzor (lit. cycle) containing the prayers for the holidays and the special Sabbaths, arranged according to the order of the liturgical year, flourished between the mid-thirteenth and mid-fourteenth centuries. It was usually bound in two volumes: a spring-summer one for the season of Pesah and Shavuot, followed by an autumn volume for the High Holidays (Rosh ha-Shanah [the New Year] and Yom Kippur) and Sukkot (Feast of the Tabernacles).[15] The writing and decoration program usually stressed the structure of the book by using a hierarchical system of initial words written in different sizes. Initial word panels with decorative or illustrative elements supported the division of the book into sections for different liturgical events and facilitated the navigation of the cantor throughout the book.[16] An unusual component in the decoration program, which does not fit into this system, is the set of medallions of the twelve zodiac signs that spread along the stanzas of the abovementioned piyyut for dew, "Divine beings at mid-day."[17] The illuminator of the Oppenheim Maḥzor followed this Ashkenazi tradition, while dropping the traditional medallions surrounding the signs and attaching a six-pointed star to many of them. The piyyut, part of a shiv‘ata (a set of seven piyyutim), was composed by Eleazar Ha-Kalir (ca. 600) in Byzantine Palestine, where the

zodiac signs had acquired a significant degree of popularity in Jewish liturgical poetry for the prayers for dew and rain, the New Moon, and the four Sabbaths of the tkufah, the seasonal turning points of the liturgical calendar.[18] Similar dominance of the seasons and the zodiac signs was typical of contemporary decorated mosaic floors of local synagogues, but while this visual tradition was probably lost, some of the poetic material reached Europe, and the first piyyutim of the shiv‘ata of Eleazar Ha-Kalir, including the "Divine beings at mid-day," became an integral part of the Ashkenazi rite, preserving its original connection to the prayer for dew, a special prayer recited by the cantor on the first day of Pesah to mark the beginning of the spring season.[19] The piyyut "Divine beings at mid-day" consists of pairs of stanzas, each referring to a specific month and its zodiac sign.[20] Since it does not appear at the beginning of the section for dew and it is not even the first piyyut of the shiv‘ata, it is clear that the deviation from the systematic decoration program of the maḥzor points to a special interest of the Ashkenazi designers in the content of this specific liturgical poem and its focus on the zodiac cycle in the context of the months and the seasonal turning points.

The set of medallions in the decoration program of the Ashkenazi maḥzor was based on Latin calendars

15 For a preliminary study of the illuminated Ashkenazi maḥzor, see Gabrielle Sed-Rajna, Le Maḥzor enluminé: les voies de formation d'un programme iconographique (Leiden, 1983).

16 Sarit Shalev-Eyni, Jews among Christians: Hebrew Book Illumination from Lake Constance (London and Turnhout, 2010), 21–27.

17 Israel Davidson, Oẓar ha-shirah ve-ha-piyyut mi-ẓman ḥatimat kitvei ha-kodesh ad reshit tkufat ha-haskalah (Thesaurus of Medieval Hebrew Poetry), 4 vols. (New York, 1970), 1:236, no. 5126 (Hebrew). For the iconographic tradition, see Sed-Rajna, Le Maḥzor, 32–35; Bezalel Narkiss, "Description and Iconographical Study," in The Worms Maḥzor: MS Jewish National and University Library Heb. 4°781/1, introductory vol., ed. Malachi Beit-Arié (Vaduz and Jerusalem, 1985), 64–65, 79–90. See various examples in Sed-Rajna, Le Maḥzor, table on 58–59, and also the Amsterdam Maḥzor (Amsterdam, Joods Historisch Museum, B. 166, fols. 45r–47r); and the Tinted Maḥzor (London, BL, MS. Add. 26896, fols. 153r–155v). For a general introduction to the Jewish visual tradition of the zodiac signs and its variants, see Written in the Stars: Art and Symbolism of the Zodiac [catalogue, Israel Museum], ed. Iris Fishof (Jerusalem, 2001).

18 See Yoseph Yahalom, "Galgal ha-mazzalot ba-piyyut ha-ereẓ yisre'eli"

(The Zodiac in the Early Piyyut in Eretz-Israel), Jerusalem Studies in Hebrew Literature 9 (1986): 313–22 (Hebrew); Shalom Spiegel, Avot ha-piyyut: mekorot u-meḥkarim le-toldot ha-piyyut be-Ereẓ-Yisra'el (The Fathers of Piyyut: Texts and Studies: Towards a History of the Piyyut in Eretz Yisrael), ed. Menahem H. Schmeltzer (New York and Jerusalem, 1996), 124–37 (Hebrew).

19 For the piyyut "Divine beings at mid-day" and the other parts of Eleazar Ha-Kalir's shiv‘ata for dew and its acceptance as part of the Ashkenazi liturgy, see Maḥzor Pesaḥ le-fi minhag bnei Ashkenaz (Maḥzor Pesah according to the Ashkenazi Rite), edited with commentary according to the method of Daniel Goldschmidt by Yonah Frenkel (Jerusalem, 1993), 16*–19*, 40*–42* (Hebrew); for the text, see ibid., 225–34. See also Ezra Fleischer, Shirat ha-kodesh ha-ivrit bi-mei ha-beinayim (Hebrew Liturgical Poetry in the Middle Ages) (Jerusalem, 1975), 196–98 (Hebrew).

20 The system of two stanzas for each month and its zodiac sign is employed for the whole set except for the tenth, which is a pair of stanzas that combines two consecutive months – Tevet and Shevat – and their signs Kid and Bucket.

in Christian ritual books such as psalters, breviaries, and Books of Hours.[21] These books usually open with a liturgical calendar containing a list of the *Temporale* feasts and the Days of the Saints (*Sanctorale*) in a cycle of twelve units representing the months and accompanied by a double system of medallions containing the zodiac signs and the labors of the months.[22] The illustrators of the Ashkenazi maḥzorim adopted the plan of the calendar with the zodiac signs and sometime also included another set of the labors of the months (fig. 5), which further stressed their origin in the Christian books.[23] The affinity to the Christian medallions is also apparent in the iconographic design of some of the zodiac signs, such as the Lamb, the first zodiac sign in the Hebrew cycle,[24] which is designed as a ram with round horns typical of the sign of Aries,[25] or Virgo, that is depicted with a *fleur de lis* (or another flower), alluding to the Virgin Mary, as was common in Christian calendars.[26] The illuminators of the maḥzorim removed the set of medallions from its original location in a calendar at the beginning of the book, placing it as a direct illustration of the structure and verses of the piyyut for dew, while still preserving the medallions' meanings as symbolic representatives of the months. In some instances a similar set of medallions also appears in the second volume of the maḥzor illustrating the twelve stanzas of the piyyut "He shall open up the earth to salvation" (יפתח ארץ לישע),[27] written by the same poet for the special prayer for rain, which is recited on the final day of Sukkot and

inaugurates the autumn season.[28] In these cases, each volume has its own "liturgical calendar" that stresses the relevant seasonal turning point and is adorned with some popular zodiological connotations expressed in both the content of the piyyut and its illustrations.[29] Moreover, as I shall show, the design of the zodiac signs points to diverse origins going far beyond the immediate Christian environment and clearly shows that the cycle of the zodiac signs in the Ashkenazi maḥzorim is not a mere copy of Christian calendars, but part of a cosmological concept of the Jewish liturgical year.

Beyond the Christian Influence

Despite the obvious influence of local Christian iconography, some of the signs find their parallels far away from the German domain. Whereas in Western iconography *Sagittarius*, shooting an arrow from his bow, is usually depicted in full image as a centaur, in some Ashkenazi maḥzorim only the arms performing the act of archery are presented.[30] Similarly, the image of Aquarius carrying the vase of water on his shoulder is usually replaced in the Ashkenazi manuscripts with a bucket suspended by a rope over a well (e.g., fig. 6).[31] The main difference – the bucket – derives from the Hebrew name of the zodiac sign *Dli* (Bucket),[32] but the well appearing in the Ashkenazi context is not part of the Hebrew name and may have originated in some visual tradition. Both images – the arms replacing the centaur and the bucket suspended by a

21 Sed-Rajna, *Le Maḥzor*, 32–35; Narkiss, "Description," 64–65.

22 See *Time in the Medieval World: Occupations of the Months and Signs of the Zodiac in the Index of Christian Art*, ed. Colum Hourihane (Princeton, 2007). For the iconography of the labors of the months, see also James Carson Webster, *The Labors of the Months in Antique and Mediaeval Art to the End of the Twelfth Century* (Evanston, 1938). For a detailed description of the structure and components of calendars preceding Christian liturgical books, see Raymond Clemens and Timothy Graham, *Introduction to Manuscript Studies* (Ithaca and London, 2007), 192–202.

23 Narkiss, "Description," 66–67.

24 In the Jewish calendar, the months and their zodiac signs are allegedly fully synchronized; in the Christian calendar each zodiac sign begins in the final third of the month.

25 See, e.g., Sed-Rajna, *Le Maḥzor*, pl. XXXVI, figs. 73 and 80.

26 Ibid., 34.

27 Davidson, *Oẓar ha-shirah ve-ha-piyyut*, 2:418, no. 3466.

28 Fleischer, *Shirat ha-kodesh ha-ivrit*, 196–98; Daniel Goldschmidt, ed., *Maḥzor Sukkot* (Jerusalem, 1981), 37*–38* (Hebrew).

29 Shalev-Eyni, *Jews among Christians*, 27–29.

30 See, e.g., the Wrocław Maḥzor of about 1290 (Wrocław, University Library, Ms. Or. I/ 1, fol. 266; Sed-Rajna, *Le Maḥzor*, pl. XXXVIII, fig. 75; the manuscript is available online (http://www.bibliotekacyfrowa. pl/dlibra/docmetadata?id=22565&from=publication). This is true also of the earlier Amsterdam Maḥzor, possibly of Cologne (*Amsterdam Maḥzor: History, Liturgy, Illumination*, eds. Albert van der Heide and Edward van Voolen [Leiden 1989], fig. III 9).

31 See, e.g., the Michael Maḥzor (Oxford, Bodl. Libr., Ms. Mich. 617, fol. 51r) and the Darmstadt Maḥzor (Darmstadt, Hessische Landes- und Hochschulbibliothek, Ms. Or. 13, fol. 84v); Sed-Rajna, *Le Maḥzor*, pls. XXXV, fig. 72 and XLII, fig. 79, respectively.

32 See also the zodiac sign of Capricorn, which is replaced in the Ashkenazi examples by a kid in keeping with the Hebrew term.

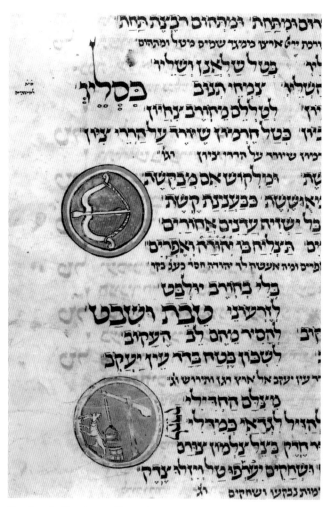

Fig. 6. Zodiac signs of Bow (Sagittarius), Bucket (Aquarius), and Kid (Capricorn): a piyyut for dew. Michael Maḥzor, 1258. Oxford Bodleian Library, Mich. 617, fol. 51r

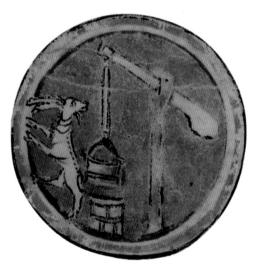

Fig. 6a. Bucket and Kid. Michael Maḥzor, fol. 51r, detail

rope over a well replacing the water-carrier – find parallels in bronze vessels originating in medieval Persia.[33] The bucket and the well were particularly common in Muslim art, where they were sometimes integrated with the image of Aquarius drawing water from the well;[34] both were also preserved in the Arabic astrological terminology.[35]

Other possible connections to the Islamic visual domain were identified by Storm Rice and Hartner in the image of the Twins (Gemini) in the Budapest volume of the Tripartite Maḥzor.[36] Here the two are designed as animal-headed people in short garments, facing each other and together gripping a stick with a glowing orb on its top (figs. 5, 7).[37] A similar format is found again on twelfth- and thirteenth-century bronze Persian vessels such as the Vaso Vescovali (fig. 8) and the Wade Cup (fig. 9), in which, like in the Budapest manuscript, the Twins hold, together, a long stem which here carries at its top a bestial mask instead of a glowing orb.[38] The

33 For the arms holding the bow and the bucket suspended over a well, see the zodiac signs on a thirteenth-century bronze vessel housed today in the British Museum of London (83 10-19 7). For the bucket suspended over a well, see also a twelfth-century Persian bucket (BL, 1958-10-13.1; Ralph H. Pinder-Wilson, "Two Persian Bronze Buckets," *British Museum Quarterly* 24, 2–2 (1961): 54–57 (pl. XVI).

34 See the thirteenth-century Vaso Vescovali; Willy Hartner, "The Vaso Vescovali in the British Museum: A Study on Islamic Astrological Iconography," *Kunst des Orients* 9, 1–2 (1973–74): 99–130. See also another vessel of copper and silver from Afghanistan (BL, 48 8-5 2).

35 E.g., *ad dalw, ad dali*. For different variations, see Paul Kunitzsch, *Untersuchungen zur Sternnomenklatur der Araber* (Wiesbaden, 1961), 22. See also Emmy Wellesz, "An Early al-Sufi Manuscript in the Bodleian Library in Oxford: A Study in Islamic Constellation Images," AO 3 (1959): 1–26, esp. 10.

36 David Storm Rice, *The Wade Cup in the Cleveland Museum of Art* (Paris, 1955), 18–19; Hartner, "Vaso Vescovali": 103–24; Willy Hartner, "The Pseudoplanetary Nodes of the Moon's Orbit in Hindu and Islamic Iconographies," in id., *Oriens, Occidens: Ausgewählte Schriften zur Wissenschafts- und Kulturgeschichte: Festschrift zum 60. Geburtstag*, vol. 2, ed. Yasukatsu Maeyama (Hildesheim, 1984), 349–404, esp. 359–401.

37 Budapest, Library of the Hungarian Academy of Sciences, Kaufmann Coll., MS. A. 384, fol. 143. The manuscript is available online, http://kaufmann.mtak.hu/en/ms384/ms384-coll1.htm. Other Ashkenazi examples, such as that seen in the Michael Maḥzor of 1258 (Oxford, Bodl. Lib. Ms Michael 617, fol. 49v), where the two are turning their backs to each other and an orb without a stick is placed between them, may have been also a variation of the same tradition.

38 Hartner, "Vaso Vescovali," figs. 9 and 14; Storm Rice, *Wade Cup*, figs. 13b and 15a.

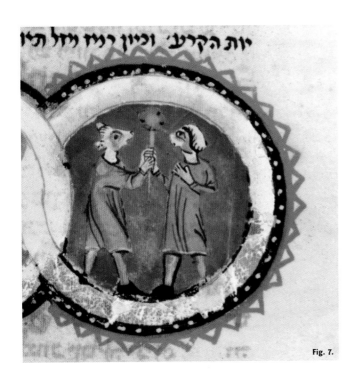

Fig. 7.

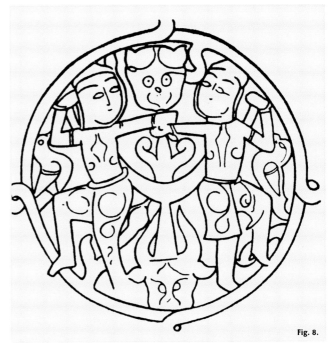

Fig. 8.

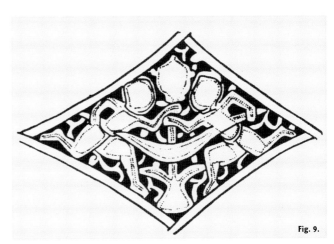

Fig. 9.

Fig. 7. Zodiac sign of Twins (Gemini): a piyyut for dew. Budapest volume, fol. 143r

Fig. 8. Zodiac sign of Gemini, drawing of the Vaso Vescovali, Khurasan, ca. 1200. The British Museum, ME OA 1950.7-25.1, detail (Photo: after David Storm Rice, *The Wade Cup in the Cleveland Museum of Art* [Paris, 1955], fig. 15a)

Fig. 9. Zodiac sign of Gemini, drawing of the Wade Cup, Persia, ca. 1200–1225, detail. Cleveland Museum of Art (Photo: after Storm Rice, *The Wade Cup*, fig. 13b)

mask in the Muslim examples is a result of the perceived relations between the zodiac signs and the planets. The Islamic astrologers divided the zodiac wheel into radial sections, each subordinated to one of the planets. They also discussed an additional invisible pseudo-planet,

the Dragon, which caused eclipses of the sun and the moon. According to this tradition, the exaltation of the dragon's head was on the third degree of Gemini, while that of its tail on the opposite point in Sagittarius. The dragon's head depicted on the top of a stick in some Muslim examples was therefore associated with the zodiac sign of Gemini.[39] In the Ashkenazi example, the mask was replaced by an orb that blurs the meaning of the image. Such is also the case in some Islamic images of the Twins, where the mask is replaced by an empty disc.[40] Various scholars have suggested that these Jewish

39 Hartner, "Vaso Vescovali": 103–24; Hartner, "Pseudoplanetary Nodes," 359–401; Sophie Makariou, *L'apparence des cieux: astronomie et astrologie en terre d'Islam*, Dossiers du Musée du Louvre, 54 (Paris, 1998).

40 See a thirteenth-century pencil case from Syria and Algeria (BL, 84 7-4 85).

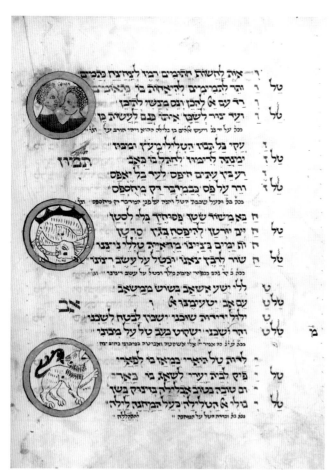

Fig. 10. Twins (Gemini), Cancer, Leo: a piyyut for dew. Darmstadt Maḥzor, Hammelburg, 1348. Darmstadt, Hessische Landes- und Hochschulbibliothek, Cod. Or. 13, fol. 83v

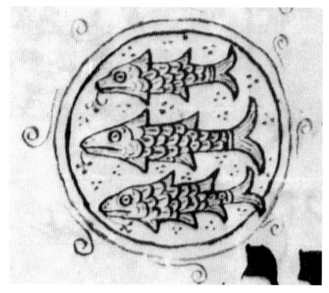

Fig. 11. Fish (Pisces): a piyyut for dew. Amsterdam Maḥzor, Germany, 13th century. Amsterdam, Joods Historisch Museum, B. 166, fol. 47r

and Muslim images are rooted in a shared visual tradition that originated in the East.[41] The same may be the case with the winged hybrids representing the Twins in the Wrocław Maḥzor of around 1290.[42] Having no parallel in other maḥzorim or Christian examples, this unique version too finds its closest parallel in Islamic examples designing the Twins as animal- or human-headed birds.[43] The lack of links between the Islamic and Ashkenazi examples makes it difficult to clarify this connection and reconstruct a possible way by which these Eastern traditions may have reached the illuminators of the Ashkenazi manuscripts.

Other Islamic visual traditions may have reached the Ashkenazi maḥzorim through the Latin West. Such is, possibly, the representation of Gemini as Siamese twins sharing a single body with two heads. This version, depicted in a maḥzor housed today at the British Library in London and originating in around 1300,[44] has a parallel in the earliest surviving illuminated manuscript of the astrological treatise of Albumasar (787–886) – a southern Italian copy from 1220–1240,[45] which had already reached France in the thirteenth century.[46]

41 Storm Rice, *Wade Cup*, 18–19; Theodor Dombart, "Eine bedeutsame mittelalterliche Darstellung des Tierkreisbildes der Zwillinge," in *Festschrift für Georg Leidinger zum 60. Geburtstag*, ed. Albert Hartmann (Munich, 1930), 47–49 and pl. XII.

42 Wrocław, University Library, Ms. Or. I/ 1, fol. 264v; Sed-Rajna, *Le Maḥzor*, pl. XXXVIII, fig. 75. The manuscript is available online, http://www.bibliotekacyfrowa.pl/dlibra/docmetadata?id=23273&from=publication.

43 See, e.g., Eva Baer, *Sphinxes and Harpies in Medieval Islamic Art: An Iconographical Study* (Jerusalem, 1965), 70–71, fig. 94; Hartner, "Vaso Vescovali": 124.

44 London, BL, Add. 26896, fol. 153. See http://www.bl.uk/catalogues/ illuminatedmanuscripts /ILLUMINBig.ASP?size=big&IllID=50091.

45 Paris, BnF lat. 7330, fol. 11.

46 See Vicky Armstrong Clark, "The Illustrated Abridged Astrological Treatises of Albumasar: Medieval Astrological Imagery in the West," PhD diss., University of Michigan, 1979, 37–84, 126–27. This parallel does not include the birds' heads, which are typical of Ashkenazi figures in illuminated manuscripts of the 13th and 14th centuries. On this Ashkenazi phenomenon, see, e.g., Zofia Ameisenowa, "Animal-headed Gods, Evangelists, Saints and Righteous Men," *JWCI* 12 (1949): 21–45; Bezalel Narkiss, "On the Zoocephalic Phenomenon in Mediaeval Ashkenazi Manuscripts," in *Norms and Variation in Art: Essays in Honour of Moshe Barasch* (Jerusalem, 1983), 49–62; Ruth Mellinkoff,

In the following centuries it may have influenced the shape of Gemini in Christian liturgical books.[47] In the Ashkenazi context, however, the two-headed Siamese twins motif was closely related to the verses of the piyyut "Stitched together like Twins" (מאוחים כתאומים). Indeed, this verse was probably a source of inspiration for the variations in the Darmstadt Maḥzor (Hammelburg, 1348) and the Oppenheim Maḥzor (1342), where the Twins are designed as two heads whose chests are stitched together (fig. 1 – middle zodiac sign, fig. 4 – left side, fig. 10 – upper medallion).[48] Some other unique representations directly related to the verses of the piyyut are seen in the design of the zodiac sign of Fish (Pisces). In the above-mentioned maḥzor at the British Library, the traditional two fish are replaced by four,[49] while in the earlier Amsterdam Maḥzor there are three (fig. 11).[50] This inflation in the number of fish, unique to the Ashkenazi context, is probably influenced by the way the verses of the piyyut play on the close relation between the Hebrew word for fish ("dag" דג) and the verb meaning "to grow into a multitude" (תדגיא);[51] such an explanation appears in the commentary written along the margins of the piyyut in the Budapest Maḥzor.[52] Here, the commentator based his interpretation on the recitation of a verse of Jacob's blessing to Ephraim and Manasseh that plays on this double meaning: "You will increase the produce of this year, like 'You will grow the fruitage into a multitude'" (Genesis 48:16).[53] The combination of the Kid and the Bucket in one medallion (fig. 6a) is also directly related to the combination of the two signs in the piyyut for dew, where the two are the only zodiac signs discussed together in the same stanzas.[54]

Sartan–Satan: The Transformation of the Crab (Cancer)

A more sophisticated demonstration of the close relation between the zodiac sign and the verses of the piyyut is the enigmatic design of the sign of Cancer (the Crab). In the Oppenheim Maḥzor it appears as a monster with a fish's tail and scales and with a woman's head, similar to that of the Virgin in the same cycle (fols. 63r and 84r, fig. 4, middle lower part), but with beard stubble and horns (figs. 12–13). The demonic features are paralleled in other maḥzorim: in the Darmstadt Maḥzor, Cancer is designed as a dragon-like hybrid with a demonic face and a huge fin in a zigzag shape, biting its tail (fig. 14).[55] In the Budapest and London volumes of the Tripartite it is designed as a demonic creature with a boar's head, sharp claws, a hairy back, and a small fish hung on its back (fig. 15).[56] Despite the diversity, all these examples share a hybridic shape with some fish features, alluding to the association of Cancer with water, though they bear no connection to its zoological shape. One may wonder why the Ashkenazi illuminators chose to replace Cancer by a demonic martial monster, which finds no parallel outside the Ashkenazi frame.

The iconography of another zodiac sign, the Scorpion, may shed certain light on this phenomenon. Already in early representations the Scorpion and the Crab were

Antisemitic Hate Signs in Hebrew Illuminated Manuscripts from Medieval Germany (Jerusalem, 1999), 35–42; Marc Michael Epstein, *The Medieval Haggadah: Art, Narrative, and Religious Imagination* (New Haven, 2010), 45–128.

47 For the Western variation of the Siamese twins, see *Time in the Medieval World*, p. lxi and figs. 487 and 488.

48 Darmstadt, Hessische Landes- und Hochschulbibliothek, Cod. Or. 13, fol. 83v; Oxford, Bodleian Library, Opp. 161, fol. 63r.

49 London, BL, Add. 26896, fol. 155v.

50 Amsterdam, Joods Historisch Museum, B. 166, fol. 47r.

51 במדושנה דגים בשער :תדגיא תנוב שנה You will grow the fruitage into a multitude / in the fish-gate of fatness. The translation loses the play of words, in Hebrew, between fish (דג) and to grow into a multitude (לדגות).

52 For this commentary, see Elisabeth Hollender, *Clavis Commentariorum* *of Hebrew Liturgical Poetry in Manuscript* (Leiden, 2005), 322, no. 5263.

53 Budapest, Library of the Hungarian Academy of Sciences, Kaufmann Coll., MS. A. 384, fol. 145v: "תרבה תנובה של שנה זו לשון וידגו לרוב".

54 See, e.g., Michael Maḥzor, 1258, Oxford, Bodleian Library, Ms Mich 617, fol. 51r. The combination of the Kid and the Bucket also appears in the list of the zodiac signs in the synagogue of Ein Gedi and the titles of zodiac signs in the synagogue of Bet Alfa; see Aharon Mirsky, "Gdi u-dli bi-khtovet Ein Gedi u-ve-fiyyutei kadmonim" (Capricorn and Aquarius in the Ein Gedi Inscription and in Early Piyyutim), *Tarbiz* 40 (1970): 376–84 (Hebrew).

55 Darmstadt, Hessische Landes- und Hochschulbibliothek, Ms. Or. 13, fol. 83v.

56 Budapest, Library of the Hungarian Academy of Sciences, Kaufmann Coll., MS. A. 384, fol.143r; BL, Add. 22413, fol. 139v.

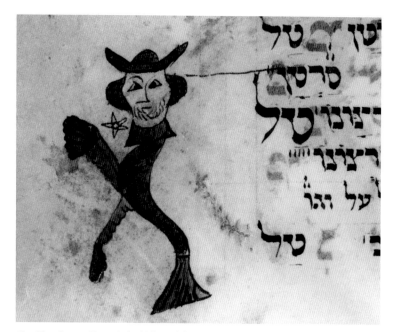

Fig. 12. Cancer. Oppenheim Maḥzor, fol. 63r, detail

Fig. 13. Cancer. Oppenheim Maḥzor, fol. 84r detail

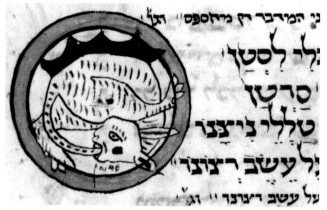

Fig. 14. Cancer. Darmstadt Maḥzor, fol. 83v, detail

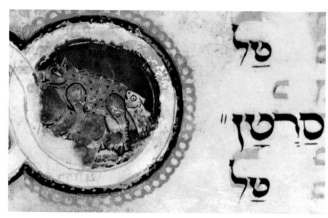

Fig. 15. Cancer. Tripartite Maḥzor, Budapest volume, fol. 143r, detail

depicted in a similar way, being displayed from above with legs stretched to both sides.[57] In medieval Europe, in a climate and habitat where scorpions were not as familiar as they were in the desert areas of the East, the shape of the predatory arthropod animal, known for its fatal poison, was significantly changed to express its aggressive character. In Latin treatises on the zodiac, which had been flourishing since the ninth century in the monasteries at St Gallen and Reichenau, the Scorpion was compared to the image of Pharaoh in the Red Sea, an event regarded as a victory over Satan, who was embodied in the figure of Pharaoh.[58] Other

versions compared the Scorpion with the Jews,[59] the enemies of Christ, who were also connected with

57 Hans Georg Gundel, *Zodiakos: Tierkreisbilder im Altertum: Kosmische Bezüge und Jenseitsvorstellungen im antiken Alltagsleben*, Kulturgeschichte der antiken Welt, 54 (Mainz am Rhein, 1992), 70–72.

58 Wolfgang Hübner, *Zodiacus Christianus: Jüdisch-christliche Adaptionen des Tierkreises von der Antike bis zur Gegenwart*, Beiträge zur klassischen Philologie, 144 (Königstein in Ts, 1983), 73, table 14. See, e.g., a twelfth-century Zodiologus: "[…] Scorpionis eo quod Pharao pro cupiditate demersus est in mari rubro" (Cod. Stuttgartensis hist. fol. 75v; ibid., 202).

59 See, e.g., in a ninth-century example: "Scorpius typus Iudeorum quemadmodum serpens mostam demulgit. Ita adversus Christum doctrina Iudaeorum…" (Cod. Fabariensis X, fol. 18-18v; ibid., 196).

Satan. A direct identification of the Scorpion as Satan himself appears in the treatise of Arnaldus of Villanova (1235–1312) on the zodiac,[60] and it is also paralleled in contemporary bestiaries discussing the scorpion outside of its zodiological frame.[61] In this context, Rabanus Maurus (ca. 780–856) previously declared, in his chapter on serpents in *De Universo*, that the scorpion signifies the devil or his ministers ("*scorpio diabolum significant vel minisros*").[62] Such demonic associations had an enormous influence on the transformation of the

Scorpion's design. Once the scorpion was appropriated from its naturalistic shape, it gained numerous bestial variations with different numbers of legs, different sorts of animal heads, a long tail, and even wings.[63] These fantastic animals often alluded to the negative symbolism attached to the Scorpion, especially in those cases where it was represented as a dragon,[64] the symbol of Satan in medieval bestiaries,[65] an iconography that also found its way into some Ashkenazi maḥzorim, such as the early Amsterdam Maḥzor (fig. 16).[66] Other maḥzorim adopted

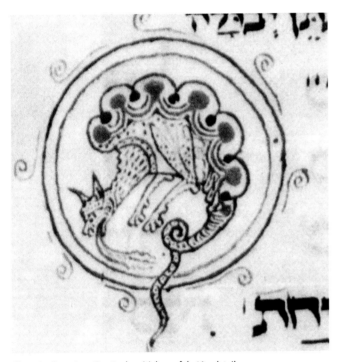

Fig. 16. Scorpion. Amsterdam Maḥzor, fol. 46v, detail

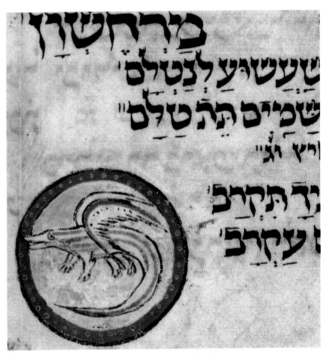

Fig. 17. Scorpion. Michael Maḥzor, fol. 50v, detail

60 Hübner, *Zodiacus Christianus*, 86 and 48, table 9. For the Scorpion in the writings of the Church Fathers, see Luigi Aurigemma, *Le signe zodiacal du Scorpion dans les traditions occidentales de l'antiquité gréco-latine à la renaissance*, École des hautes études en sciences sociales: Centre de recherches historique, 54 (Paris and The Hague, 1976), 58.

61 Richard Barber, *Bestiary Being, an English Version of the Bodleian Library Oxford Ms. Bodley 764 with all the Original Miniatures Reproduced in Facsimile* (Woodbridge, 1993), 197.

62 PL 111, 232, after Nona C. Flores, "'Effigies amicitiae…veritas inimicitiae': Antifeminism in the Iconography of the Woman-Headed Serpent in Medieval and Renaissance Art and Literature," in *Animals in the Middle Ages: A Book of Essays*, ed. Nona C. Flores (New York and London, 1996), 167–95, esp. 172. See also Revelation 9:10 as a source of inspiration; ibid.

63 See, e.g., *Illuminated Books of the Middle Ages and Renaissance: An Exhibition Held at the Baltimore Museum of Art, January 27–March 13*, ed. Dorothy Miner (Baltimore, 1949), pl. XX, fig. 35; Aurigemma, *Le signe zodiacal*, fig. 37.

64 See, e.g., a single leaf of a thirteenth-century psalter, Munich, Neue Pinakothek, Staatl. Graphische Sammlung, Inv. Nr. 39793-808; Hanns Swarzenski, *Die lateinischen illuminierten Handschriften des XIII. Jahrhunderts in den Ländern an Rhein, Main und Donau* (Berlin, 1936), pl. 154, fig. 850a.

65 Barber, *Bestiary*, 183–84; Debra Hassig, *Medieval Bestiaries: Text, Image, Ideology* (Cambridge, 1995), 129–35.

66 Gabrielle Sed-Rajna, "The Decoration of the Amsterdam Mahzor," in *The Amsterdam Mahzor: History, Liturgy, Illumination*, eds. Albert van der Heide and Edward van Voolen (Leiden, 1989), 56–70, esp. 65 and fig. 9.

the turtle-like Scorpion,[67] or other fantastic animals with legs and wings (fig. 17).[68] Although the changes in the shape of the Scorpion affected the design of the Crab in Christian cycles, the latter was never depicted in Christian art as a dragon or any other monstrous creature, as it was in the Ashkenazi examples. Moreover, in some of the maḥzorim, such as the Darmstadt Maḥzor, it was the Scorpion that preserved its original natural shape.[69] This exchange between Cancer and the Scorpion may have been inspired by the piyyut's verses describing Cancer. It was in this context (and not in regard to the Scorpion) that a reference to Satan was made. Unlike the other months, that of Tamuz, the month that is under the influence of the zodiac sign of Cancer in the Hebrew calendar, is described in the verses in a negative way as "the hurt of Tamuz," which the dew is requested to comfort: "You summoned the dew to be a sign / to cradle the hurt of Tamuz."[70] The unusual hurt of this month was related by medieval commentators to the destruction of Jerusalem, an event which occurred on the seventeenth of Tamuz, when the city's walls had been breached by the enemy.[71] In the frame of "the hurt of Tamuz," Satan plays a role: "Be hid from the destruction of Satan / those whom you passed over without stirring / Dew of life will hurry like *Sartan* (Cancer in Hebrew)."[72] In the early fourteenth-century Hamburg Ashkenazi collection of commentaries to piyyutim, these verses were interpreted in a similar way: "Israel, whom you passed from the spoil and destruction of Satan so they will not be harmed."[73]

Although in the verses of the piyyut Cancer was escaping from Satan and his harmful deeds, the phonetic similarity between Satan and *Sartan* (the Hebrew word for Crab) in this context probably contributed to the association between the two.

In an Ashkenazi context the old verses might have been related to a local tradition endowing the Crab with aggressive mythical tones similar to those of its opponent, the Scorpion. This tradition connecting the two zodiac signs is found in the Book of the Elkoshi, the aforementioned twelfth-century treatise of Rabbi Jacob bar Samson, a student of Rashi. Following Rabbi Hiyya's perception, Jacob bar Samson defined the zodiac signs as the servants of the Creator, which are fully subordinated to His will. Following an earlier source, *Braita de Rabbi Shmu'el*, he defines the stars and the zodiac signs as heavenly officers "controlling the deeds of human beings for good and bad, for life and death." Each of the four seasons is controlled by its own angel.[74] The seasonal turning points, which are called *tkufot* (sing. *tkufah*), are regarded as dangerous states, short spaces between the time when one angel completes his term of duty and the next one begins his. The zodiac signs take advantage of this gap and fight each other, causing severe damage to water sources.[75] The inclusion of this part of the Book of the Elkoshi in an Ashkenazi miscellany of 1329 that also contains, inter alia, several amulets, a book of customs according to R. Meir of Rothenburg,[76] who was the Ashkenazi rabbinic leader in the second

67 See, e.g., London, BL, Ms. Add. 22413, fol. 141. For a Christian parallel see a Cistercian Psalter from the diocese of Constance or Basel, ca. 1260; Besançon, Bibliothèque municipal, ms. 54, fol. 5v.

68 See Oxford, the Bodleian Library, Ms. Mich 617, fol. 50v.

69 Darmstadt, Hessische Landes- und Hochschulbibliothek, Ms. Or. 13, fol. 84r. Other examples replaced it by another creature with no clear demonic features similar to those of the Crab. For the confusion between Cancer and Scorpion in a regimen calendar in MS Zurich, Zentralbibliothek, Heidenheim 51, f. 157v (1398–1399), see Justine Isserles, "Some Hygiene and Dietary Calendars in Hebrew Manuscripts from Medieval Ashkenaz," *Time, Astronomy and Calendars in Jewish Tradition*, eds. Charles Burnett and Sacha Stern (Leiden, 2014), 273–326 (302 and n. 121).

70 טל זימנת לרימוז / לחתל בו כאב תמוז

71 טל תמוז נרמז לרפות חבלת חורבן עיר שנתבקעה בתמוז; Hamburg, Staats- und

Universitätsbibliothek, Cod. Hebr. 17, fol. 60v. For the Hebrew text, see the facsimile, a: ktav yad mispar 17 = Cod. Hebr. 152: nikhtav bi-shnat hei ayin ḥet: perush al ha-piyyutim; b: ktav yad mispar 61 = Cod. Hebr. 153: takkanat seder ha-tfilah u-ferush Maḥzor meyuḥas la-Ra'EBen... (A. MS 17 = Cod. Hebr. 152, ...; B. Ms 61 = Cod. Hebr. 153, reproduced in facsimile with an introduction by Avraham Naftali Tsvi [Ernst] Roth) (Jerusalem, 1980) (Hebrew). See also Hollender, *Clavis Commentariorum*, 322, no. 5266.

72 חבא משוד שטן / פסוחיך בלי לסטן / טל חיים ירטן / להפסח כמו סרטן

73 ישראל שפסחת עליהם משוד ושבר של שטן שלא יוזקו; Hamburg, Staats- und Universitätsbibliothek, Cod. Hebr. 17, f. 60v; Roth, *Cod. Hebr. 152 und 153*; Hollender, *Clavis Commentariorum*, 322, No. 5266.

74 Grossman, *Ḥakhmei Ẓarfat ha-rishonim*, 422–23.

75 Ibid., 421. See also Carlebach, *Palaces of Time*, 162–67.

76 *Minhagim de-bei Maharam*.

half of the thirteenth century, some passages of *Sefer Ḥasidim* of R. Judah the Pious, and citations of R. Eleazar of Worms, clearly shows that these ideas also reached Germany.[77] The dangerous effect of the *tkufah* is an ancient idea, known in the late Gaonic period and appearing in some Sephardi sources. It is also mentioned as a Jewish tradition in the monumental treatise of al-Bairuni (Persia–India, first half of the eleventh century). And yet, the *tkufah* became especially meaningful in Ashkenaz, where it took on halakhic implications for the making of *maẓot* due to the use of water drawn at the time of the *tkufah* of Nisan.[78]

According to the Book of the Elkoshi, the Crab and the Scorpion are the main actors in the violent incidents occurring at the turn of the seasons.[79] The selection of these two zodiac signs to represent the celestial battle poisoning the water sources is probably due to their astrological classification within the group of water elements.

The meaning of the danger of the *tkufah* that was copied from the Book of the Elkoshi, who was an expert in the wisdom of the zodiac signs (חכמת המזלות):

[...] CANCER and SCORPION, mighty men of valor, a spirit of jealousy cometh upon them, one on each other, and their fury shall arise up in their nostrils and poison and anger are fully set in them to set a battle in array one upon another [...] and while they are fighting, they will cast poison and

wrath, and this poison will fall in fountains and depths, springing forth in valleys and hills, and on every gathering of water that is upon the face of the whole earth [...] and everyone who drinks it [the poisoned water] at that time, it shall kill him [...] nobody shall escape [...] and this is what amulet writers would write in their amulets [...].[80]

Although the cosmological battle does not include any direct details regarding the shape of the Crab and the Scorpion, like in the visual images, the Crab receives the main feature of the Scorpion, which here is the dangerous and harmful poison that originally, in nature, is not associated with it. The demonic character alluded to in the visual design of the Crab and the Scorpion in the Ashkenazi maḥzorim is paralleled in the Book of the Elkoshi by their turning into unstable mythical creatures attacking each other while endangering, through their poison and aggressiveness, the whole universe.

As we have seen, the demonic features of the Crab, which in the general culture were originally linked with the Scorpion, were shared by various Ashkenazi illuminators, but apparently none of them followed a model or a uniform visual tradition; each of them designed the Crab in a different shape according to his own imagination, though always referring to its association with water. This continuous innovation testifies to a renewed interest in the mythical nature of

77 The manuscript also includes *Sefer miẓvot katan*, *midrash va-yosha*, and material on the calendar; see Ephraim Kanarfogel, "*Peering through the Lattices*": *Mystical, Magical, and Pietistic Dimensions in the Tosafit Period* (Detroit, 2000), 158, n. 65.

78 For assorted variations of the tradition, see Israel M. Ta-Shma, "Issur shtiyyat mayim ba-tkufah u-mekoro" (The Danger of Drinking Water during the Tkufah – The History of an Idea), *Jerusalem Studies in Jewish Folklore* 17 (1995): 21–32 (Hebrew). As Ta-Shma suggested, the seventeenth of Tamuz, the date of the destruction of the Jerusalem city wall (which is alluded to in the "hurt of Tamuz" mentioned in the piyyut) may also have been related to the *tkufah* of Tamuz. This possibility can be discerned in a fourteenth-century passage ascribed either to R. Eleazar or to the early mystic book of *Heikhalot*, which was known to the Pietists. Here it is recommended to repent at four times of the year: before the tenth of Tevet, before the seventeenth of Tamuz, before Rosh Ha-Shanah, and in the ten days between Rosh Ha-Shanah and Yom Kippur. Ta-Shma suggested that this custom reflects

an early tradition of four fasts fixed in accordance to the four *tkufot*; ibid.: 32.

79 Oxford, Bodleian Library, Opp. 614; Neubauer, *Catalogue of the Hebrew Manuscripts*, no. 2275. Although written in the middle of a passage, the names Scorpion and Crab are designed in larger letters and further stressed by small strokes written above the letters.

80 טעם סכנת תקופה אשר הועתק מספר האלקושי והוא היה בקי בחכמת המזלות: ארבע תקופת הן בשנה ומספר ממשלת ימי התקופה ימים י"ז שעות ומחצה, וארבע תקופות האלה להן יאמר שנה...ולעולם מלאך ממונה על כל תקופה ותקופה אזי תוך משמר נכנס ומשמר יוצא. סרטן ועקרב גיבורי החיל תעבור עליהם רוח קנאה זה על זה ותעלה חמתם באפם ויתמלאו ארס וקצף יערכו מלחמה זה על זה ויפגעו זה לזה באישי לפידות וכידודי אש יתמלטו. ומדי הלחמם ישליכו ארס וקצף ונפל הארס ההוא בעיינות ותהומות יוצאים בבקעה ובהר ועל כל מקוה מים אשר על פני כל הארץ ובעצים ובאבנים. וכל השותה מהם בשעה ההיא יהרגנו. ההוא דמו בראשו, איש לא ימלט [...] והוא [...] אשר יכתבון בעלי הקמיעות בקמיעותיהם. Oxford, Bodleian Library, Opp. 614, fols. 49v–50r; Hebrew text, Grossman, *Ḥakhmei Ẓarfat ha-rishonim*, 421.

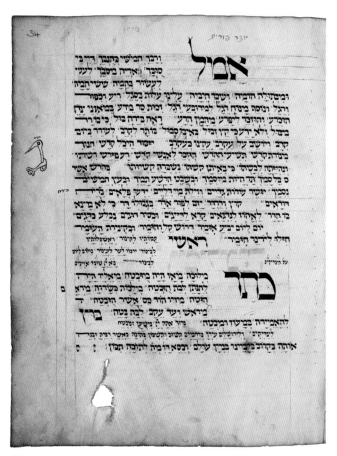

Fig. 18. Scorpion: a piyyut (*krovah*) for Purim. Oppenheim Maḥzor, fol. 34r

biblical snake is represented as a reptile, a dragon, or a beast, with a similar female head. This combination, demarcating a parallel between the tempting snake and Eve, and thus women in general, originated in the commentary of Peter Comestor to Genesis 3:1, where he explains why Lucifer chose the serpent as his tool:

> Because [Lucifer] was afraid of being found out by the man, he approached the woman, who was [...] wax to be twisted into vice and this by means of the serpent; for the serpent at that time was erect like a man [...]. He also chose a certain kind of serpent, as Bede says, which had the countenance of a virgin, because like favors like [...].[81]

The woman-headed snake became popular in Western art from the thirteenth century on and in some cases it also found its way into Hebrew illuminated manuscripts of French origin, which may also have been inspired by midrashic sources with similar meanings.[82] The illuminator of the Oppenheim Maḥzor probably knew this iconography and adjusted it to the new context of the Crab by the inclusion of the martial features. Here, too, its association with the zodiac context may have been related to the Scorpion, which in some western sources, such as the twelfth-century manual for nuns *Ancrene Riwle*, was described as a snake with a woman's face and a stinging tail symbolizing lechery.[83]

Whereas in the zodiac wheel of the Oppenheim Maḥzor the Scorpion is more naturalistic (fig. 4), in the margins of the piyyut for dew it is designed as a hybrid with a long beak and tail, stressing its harmful aspects (fol. 64r, fig. 2, middle zodiac sign). Furthermore, it is the Scorpion in the hybridic form with a long sting that appears once again in the Oppenheim Maḥzor (fol. 34r, fig. 18) as an

the Crab time and again. Especially unique is the design of the Crab in the Oppenheim Maḥzor where it has the form of a marine monster with claws and a horned female head wearing a hair net (fols. 63r and 84r, figs. 15 and 16); the beard stubble may blur the clear gender identity of the Crab but the feminine features are nonetheless more dominant, alluding to the femininity of this zodiac sign. Such a combination between a beast and a female head reminds one of misogynist representations of the Original Sin in Western Christian iconography, in which the

81 *PL*, 198, 1072; English translation after Henry Ansgar Kelly, "The Metamorphoses of the Eden Serpent during the Middle Ages and Renaissance," *Viator* 2 (1971): 308. See also Flores, "Effigies amicitiae," 167–95, esp. 168. For the interpretation of the iconography see ibid., and Frances Gussenhoven, "The Serpent with a Matron's Face: Medieval Iconography of Satan in the Garden of Eden," *European Medieval Drama* 4 (2000): 207–30.

82 See Shulamit Laderman, "Two Faces of Eve: Polemics and Controversies

Viewed through Pictorial Motifs," *Images* 2 (2008): 1–20.

83 *The Ancrene Riwle*, ed. Mabel Day, Early English Text Society, 225 (London and Oxford, 1952), 91; Flores, "Effigies amicitiae," 173. Both Cancer and Scorpion are among the feminine signs of the zodiac. Cf. Justine Isserles and Philipp Nothaft, "Calendars beyond Borders: Exchange of Calendrical Knowledge between Jews and Christians in Medieval Western Europe (12th–15th c.)," *Medieval Encounters*, 2014, in press.

illustration to a piyyut (*Krovah*) for Purim (אמל ורבך).[84] This piyyut, based on a midrash known in several versions, tells how Haman examined the signs of the zodiac in order to find the most appropriate date for committing the murder of the Jews. Starting with the Lamb (Aries) and concluding with the Fish (Pisces), he considered them carefully one by one, but ruled out all except for the last, each for a different reason.[85] In the piyyut, the Scorpion appears in its aggressive form, utilized in support of Israel: "the one who dwells on a scorpion [=Israel][86] will sting him [=Haman] like a scorpion (ויושב על עקרב / עקצו כעקרב)."

The sting of the scorpion described in the piyyut attracted the attention of the illuminator, who did not base himself on any visual tradition and, probably because of his special interest in this specific zodiac sign and its poison, chose spontaneously to illustrate only the Scorpion in a crude manner, although the other signs are mentioned in the verses of the piyyut as well.

The Oppenheim Maḥzor and the Ashkenazi Context of the Astral Bodies

The illuminated piyyutim for the prayers for dew and rain in the medieval Ashkenazi maḥzorim of the thirteenth and fourteenth centuries are the result of the migration of different textual and visual traditions to medieval Ashkenaz. These were transmitted in various periods and were then enriched by local traditions in their new geo-cultural home. The two piyyutim with the set of zodiac signs depicted along the margins of their stanzas are designed as cosmological calendars indicating the change of seasons within a liturgical context. The calendarial dimension, already expressed in the early poetic text, is reinterpreted by the addition of the set of medallions common in Latin calendars in Christian liturgical books. But the special design of some of the zodiac signs, showing affinity to distant visual traditions, alludes to additional waves of Eastern influence whose ways of penetrating Ashkenaz are not fully known. The close and unique relation between some of the zodiac signs and the verses of the piyyut alludes to the deep interest of the Ashkenazi illuminators and readers in the zodiological contents of these piyyutim, that in the case

of the Crab were merged with local Ashkenazi traditions concerning the mythical power of this zodiac sign. While in the Ashkenazi maḥzorim this interest is usually related to the seasonal turning points of autumn and spring and the prayers for rain and dew that accompanied them, in the Oppenheim Maḥzor of 1342 it encompasses the whole manuscript and becomes the main context of the liturgical book. Here the astral repertoire was enriched to include the zodiac wheel, a star above many of the signs, and the motif of the crescent moon with a star, a combination repeated in relation to different cosmological contexts of the liturgical calendar (fols. 19r, 40v, 62v). The frequent use of the motif of the moon with a star alongside the manuscript, and its unusual insertion within the zodiac wheel (fig. 4), stresses the concept of the lunar cycle, the primary basis of the Hebrew calendar. The zodiac, on the other hand, relies on the solar cycle, which also played a part in the fixing of the Jewish calendar in order to fulfil the commandment to celebrate Pesaḥ in the spring. The combination of the zodiac and the lunar months is already present in the early piyyutim, and is reinforced by the set of zodiac signs illustrating the piyyut in Ashkenazi maḥzorim, but in the Oppenheim Maḥzor it goes a step further and dominates the whole ritual cycle, through the repeated depiction of the zodiac and the recurrent addition of the moon and the star as a symbol of the lunar calendar.

The motif of the moon and the star in the Oppenheim Maḥzor has also parallels in other Ashkenazi maḥzorim, where it is usually restricted to the illustration to the piyyut "Sign of This Month" for the Sabbath before the New Moon of Nisan,[87] an illustration which is also found in the Oppenheim Maḥzor (fig. 3). This piyyut's verses are based on the biblical commandment referring to Nisan as the first month of the Jewish year: "This month shall be unto

84 Hebrew text, *Seder Avodat Yisrael*, ed. Seligman Baer (Rödelheim, 1868), 682–83.

85 Esther Rabbah 7.2; *Midrash Rabbah Translated into English with Notes, Glossary and Indices*, eds. Harry Freedman and Maurice Simon, 10 vols. (London and New York, 1983), vol. 9: *Esther and Song of Songs*, trans. Maurice Simon, 89–90.

86 See Ezekiel 2:6.

87 Hebrew text, *Seder Avodat Yisrael*, 697–99.

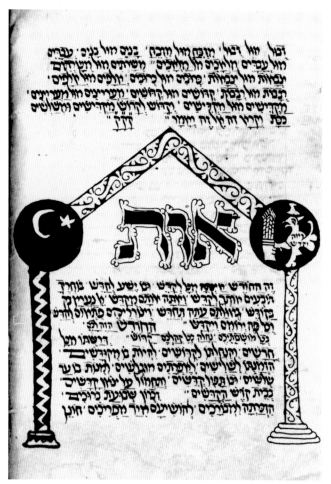

Fig. 19. Consecration of the New Moon, Sabbath before the New Moon of Nisan. Bamberg Maḥzor, Bamberg, 1279. New York, JTS, Ms. 4843, fol. 20v

the New Moon and the fixing of the Jewish calendar.[88] A messianic meaning connects the biblical redemption from Egypt, which occurred in the month of Nisan, with the future salvation, which will happen in the same month: "[…] and when He chose Jacob and his sons, He appointed for them a New Moon for redemption in which Israel were redeemed from Egypt and in which they are destined to be redeemed again."[89] In the illustration to the piyyut "Sign of This Month" in Ashkenazi maḥzorim, either the two luminaries or the crescent moon with a star were included as a cosmological "sign" of Nisan (fig. 19).[90] The star in this context may carry a messianic meaning based on the biblical verse "there shall step forth a star out of Jacob, and a sceptre shall rise out of Israel" (Numbers 24:17). According to a common midrashic tradition, the star in the verse symbolizes the Messiah,[91] an interpretation directly alluded to in some illuminated maḥzorim.[92] In the Oppenheim Maḥzor, the traditional iconography was again expanded and the combination of the crescent moon and the star was repeated as a cosmological leitmotif used at several calendarial points: the New Moon, the first month of the liturgical year (Nisan), and within the zodiac wheel, where it appears next to the Lamb, the zodiac sign of Nisan; in all cases, this motif stresses the lunar aspect of the Hebrew calendar.

The zodiac wheel in the Oppenheim Maḥzor is even more peculiar, and finds no parallel in other maḥzorim. While the zodiac signs along the piyyut are originally based on similar symbolic signs in calendars of Christian

you the beginning of months; it shall be the first month of the year to you" (Exodus 12:2). The commandment was traditionally interpreted as relating to the consecration of

88 For a visual aspect of this meaning see the illustration to this piyyut in the Leipzig Maḥzor of around 1320, where the luminaries are accompanied by two witnesses, who are pointing to the moon (Leipzig, Universitäts-bibliothek, Cod. V. 1102, vol. 1, fol. 59); see *Machzor Lipsiae: Facsimile and Introduction*, 2 vols., ed. Elias Katz (Vaduz, 1964). For the Leipzig Maḥzor, see Katrin Kogman-Appel, *A Maḥzor from Worms: Art and Religion in a Medieval Jewish Community* (Cambridge, MA, 2012).

89 Exodus Rabbah 15:12; Maurice Lehrman Simon, *Midrash Rabbah: Exodus, translated into English with Notes, Glossary and Indices* (London, 1961), 1734.

90 The Bamberg Maḥzor, Bamberg, 1279; New York, JTSL, Ms. 4843, fol. 2v. Here the crescent moon and a star are depicted to the left of the initial word "Sign." On the other side, the cantor stands next to his lectern and consecrates the New Moon, as alluded to in the inscription written on the figure: "See [the moon] like this and then sanctify,"

which is based on the discussion in the BT Rosh Ha-Shanah 20a. For the combination of the sun and moon in this context, see Sarit Shalev-Eyni, "Cosmological Signs in Calculating the Time of Redemption: The Christian Crucifixion and the Jewish New Moon of Nissan," in *Viator: Medieval and Renaissance Studies* 35 (2004): 265–87.

91 See, e.g., the interpretation of this verse in *Midrash Ha-Gadol*; Menahem M. Kasher, *Torah shlemah: Ve-hu ha-Torah she-bi-khtav im be'ur Torah she-be-al peh* (The Complete Torah: A Talmudic-Midrashic Encyclopedia of the Tanakh...) (Jerusalem, 1992), vol. 42, 142–43, no. 128; for other variations, see ibid., 141, nos. 120 and 121 (Hebrew).

92 See especially the Worms Maḥzor (Jerusalem, NLI, MS. Heb. 4°781, vol. 1, fol. 26v, probably Würzberg, 1272). Here the messianic symbolism is stressed by the inclusion of the lion, the symbol of the tribe of Judah, and the Messiah, his heir. The manuscript is available online: http://www.jnul.huji.ac.il/dl/mss/worms/.

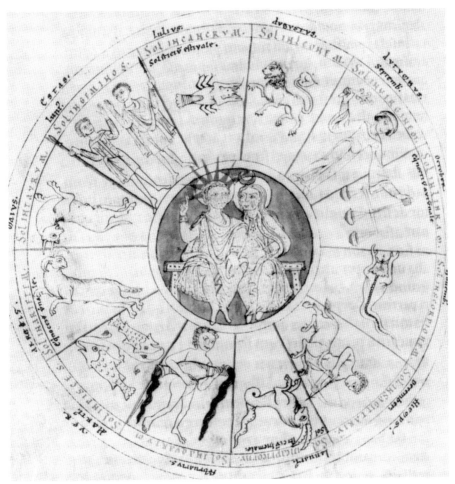

Fig. 20. Zodiac Wheel: a miscellany of astronomy and the computes.
Zwettl, ca. 1200. Zwettl Stiftsbibliothek, Cod. 296, fol. 99v

liturgical books, the zodiac wheel of the Oppenheim Maḥzor leads to a completely different direction, exposing another dimension of the illuminator's interest in cosmology. Such schemes are typical of miscellanies of texts on astronomy, and the *computus*, the measurement of time calculating the movable date of Easter and the Church calendar. These collections have been known in the West since Carolingian times and flourished in the following centuries in monastic centers of learning. Illustrations of the constellations and the zodiac, harking back to Greco-Roman visual traditions, were usually an integral part of them.[93] One example is such a miscellany from Zwettl of around 1200 (fig. 20).[94] Here on the center of the wheel of the zodiac, Sol and Luna are seated together on a bench. Our artist was inspired by a similar design of the wheel, but made some meaningful changes. Stressing the lunar basis of the Jewish calendar, he eliminated Sol, and replaced Luna by the crescent moon and the star, relocating them among the other zodiac signs with the title "Kokhav" (star) (fig. 4, middle upper part). The position of the messianic symbol of the crescent moon and the star among the zodiac signs next to the Lamb – the sign of the month of redemption – stresses the messianic aspect of the cosmological time. It may

93 For a description and study of the different examples till 1200, see Dieter Blume, Mechthild Haffner, and Wolfgang Metzger, *Sternbilder des Mittelalters: Der gemalte Himmel zwischen Wissenschaft und Phantasie, 2* vols. (Berlin, 2012), vol. 1: *800–1200.*
94 Zwettl, Stiftsbibliothek, Cod. 296, fol. 99v, in ibid., vol. 1, 562–66, no. 68; vol. 2, fig. 960. For earlier similar examples, see ibid., nos. 13, 47, 58, 59, 62, 68.

Ars Judaica 2014

have also replaced the missing zodiac sign of Kid which is not shown in the wheel.[95] Such a possibility is supported by an astrological interpretation by R. Eleazar of Worms to a verse describing the plague of the firstborn (Exodus 12:29). Here the Kid and the Lamb are defined together as the zodiac signs of the future redemption:

"And it came to pass at midnight, that the Lord smote all the firstborn" [...] the plague of the firstborn occurred at the beginning of the zodiac sign of Kid and they went out [of Egypt] early in the morning. Therefore the redemption [will be] in the zodiac signs of the Kid and the Lamb.[96]

*

As the only iconographical components in the manuscript, the zodiac signs and the crescent moon with the star, which reappear throughout the Oppenheim Maḥzor, not only empower the cosmological context of the liturgical practice, but turn the whole liturgical maḥzor into an astral cycle. The Hebrew liturgical year that begins in the month of Nisan, the public services conducted by the cantor with the aid of the prayer book, and the messianic promise of future redemption,[97] are all joined together and subordinated to a celestial scheme that connects the holy community praying in the ritual space with the entire universe.

95 The sign of the Kid is also missing in the verses of the piyyut for dew in the Oppenheim Maḥzor and the Darmstadt Maḥzor. As noted above, it appears together with the Bucket in the same stanza. While some illuminators chose to depict the two together (see above), those of the Oppenheim and Darmstadt maḥzorim showed the Bucket only and eliminated the Kid.

96 נמצא בתחילת מזל גדי היה מכת בכורות ויצאו בהשכמה, הרי הגאולה במזל גדי ובמזל טלה. R. Eleazar of Worms, *Sefer ha-rokeaḥ, hilkhot Pesaḥ*, no. 291 (*Sefer ha-rokeaḥ, Birkat Shimon* edition, ed. Barukh Shimon Shneorson

[Jerusalem, 2009], 160 [Hebrew]). See also a similar tradition which appears in the Tosafist collection *Sefer Tosafot ha-Shalem*, and attributed to Rabbenu Ḥananel. According to this tradition "The zodiac sign of the Kid shall not pass and King Messiah will come...." See Israel Jacob Yuval, *Two Nations in Your Womb: Perceptions of Jews and Christians in Late Antiquity and the Middle Ages*, trans. Barbara Harshav and Jonathan Chipman (Berkeley, 2006), 261 and n. 14.

97 For the cosmological aspect of the redemption, see Shalev-Eyni, "Cosmological Signs."

"Elisha ben Abraham, Known as Cresques": Scribe, Illuminator, and Mapmaker in Fourteenth-Century Mallorca

Katrin Kogman-Appel

One of the most informative colophons ever attached to a Hebrew manuscript was written in 1383 in Mallorca and appears in an illuminated codex, commonly known as the "Farhi Bible."[1] The words inscribed, "Elisha ben

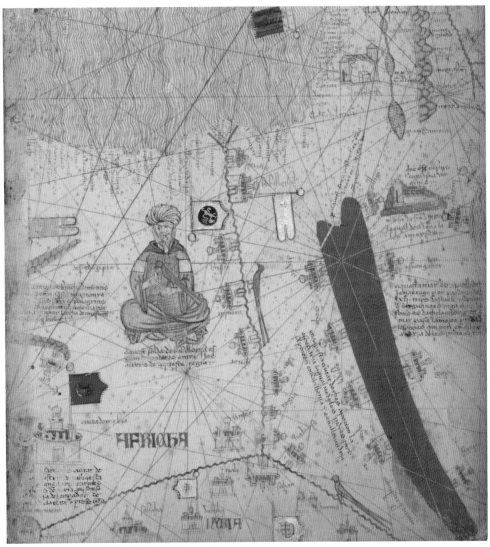

Fig. 1. Catalan *mappamundi*, Mallorca, 1375, Paris, BnF, Ms. esp. 30, sheet 8

1 Former Sassoon collection, Ms. 368, fols. 2–4. More biographical information is scattered throughout the manuscript on several other folios; for a detailed description, see David S. Sassoon, *Ohel Dawid:*

Descriptive Catalogue of the Hebrew and Samaritan Manuscripts in the Sassoon Library, London (Oxford and London, 1932), vol. 1, 6–14; see also Bezalel Narkiss, *Kitvei yad 'ivriyyim me'uyyarim* (Hebrew Illuminated

Rabbi Abraham ben Rabbi Bevenisti ben Rabbi Elisha, who is known by the name Cresques," not only identify the scribe-artist who produced the manuscript, but also, most unusually, indicate that he was born on Wednesday, the 28th of Tamuz 5085, 11 July 1325.[2] We know of a prominent mapmaker in the service of the kings of Aragon named Cresques Abraham from several pieces of documentary evidence. These sources not only shed light on Cresques' relationship to his patron, but also suggest that he should be identified with the "Elisha, known as Cresques" of the Farhi colophon. According to the Catalan usage of patronyms, Cresques Abraham means "Cresques the son of Abraham," so there is every possibility that Elisha ben Abraham, known by the – Catalan – name Cresques, and Cresques Abraham the mapmaker, are one and the same person. The Catalan historian Jaume Riera i Sans first made this suggestion in the 1970s,[3] but it was largely ignored in cartographic research as well as in the study of medieval Jewish art.

Cresques is most prominently associated with the so-called "Catalan Atlas" in Paris, a large *mappamundi* (64 × 300 cm) produced in Mallorca in 1375 (fig. 1). The documentary evidence referred to above indicates that Cresques was commissioned to prepare a map of this kind by the count of Barcelona and crown prince of Aragon,

later King Joan I, and that the map he produced was given to the French court. Even though it is not entirely certain that the map now extant in the Bibliothèque nationale is the same work mentioned in these documents, most modern scholars associate it with Cresques.[4]

Observations by art historians on the painting techniques and the decorative motifs used in both the Catalan *mappamundi* and the Farhi Codex support Riera i Sans' suggestion about Elisha and Cresques. The Farhi colophon also informs us that Elisha produced the book for his own use, and that he himself was responsible for both copying the text and for the artistic aspects of the production.[5] The Bible's aniconic decoration with its wealth of figural illustration is entirely different from that of the *mappamundi*. There are, however, several decorative elements that leave no doubt that the two were produced by the same hand. On the second page of the *mappamundi* we find the depiction of a zodiac man against a diapered background (fig. 2). This background has a parallel – in terms of color, design, and technique – in the Temple pages of the Farhi Codex (fig. 3). Moreover, both the *mappamundi* and the codex have an identical interlace design, mostly in the frames (figs. 4 and 3). Both are replete with typical late-fourteenth-century filigree designs that leave no doubt that they were created

Manuscripts) (Jerusalem, 1984, revised Hebrew edition of the earlier English version, Jerusalem, 1969), 98–99. Unlike other manuscripts from the former Sassoon collection, the Farhi Codex was not sold, but unfortunately as it is currently not accessible to scholars, no in-depth study has ever been undertaken. This article is part of a larger project on the intellectual profile of the mapmaker, scribe, and illuminator Elisha Cresques ben Abraham, supported by ISF grant no. 122/12.

2 Jaume Riera i Sans, "Cresques Abraham, jueu de Mallorca, mestre de mapamundis i de brúixioles," in *L'Atles Català de Cresques Abraham* (Barcelona, 1975).

3 Ibid.; Riera i Sans' assumption was recently confirmed by some iconographic observations made by Sandra Sáenz López Pérez, "El portulano, arte y oficio," in *Cartografía medieval hispánica: Imagen de un mundo en construcción*, ed. Mariano Cuesta Domingo and Alfredo Surroca Carrascosa (Madrid, 2009), 129–30.

4 There is copious bibliography on the Catalan *mappamundi*, and it is described in most modern works on the history of cartography; among these, see the most recent works by Evelyn Edson, *The World Map 1300–1492* (Baltimore, 2007) and Ramon Pujades i Bataller, *Les cartes portolanes: La reprenentació medieval d'una mar solcada* (Barcelona, 2007). There are several facsimile editions of the *mappamundi: L'Atles*

Català: The Catalan Atlas of 1378, ed. George Grosjean (Zurich, 1978); Hans-Christian Freiesleben, *Der katalanische Weltatlas vom Jahre 1375: nach dem in der Bibliothèque Nationale, Paris verwahrten Original farbig wiedergegeben* (Stuttgart, 1977); *El món i els dies: l'Atles català, 1375*, ed. Gabriel Llompart i Moragues, Ramon J. Pujades i Bataller, and Julio Samsó Moya (Barcelona, 2008).

5 The Farhi Codex includes thirty fully painted, elaborately executed carpet pages displaying a primarily Islamic repertoire of forms. We can discern Gothic scrollwork at the corners of these carpets, and on the grounds of the apparent formal discrepancy between the Gothic and the Islamizing repertoire, Sybil Mintz suggested that the corner motifs were added by a different artist and locates the work in the vicinity of Ferrer Bassa's workshop in Barcelona, "The Carpet Pages of the Spanish-Hebrew Farhi Bible," in *Medieval Mediterranean Cross-Cultural Contacts*, eds. Marilyn Chiat and Kathryn L. Reyerson (St. Cloud, 1988), 51–56. In terms of the painting technique, however, and the use of colors, there can, in my opinion, be no doubt that they are an integral part of the full-page illuminations and were executed during one working process, most likely by the same hand; see in greater detail Katrin Kogman-Appel, *Jewish Book Art between Islam and Christianity: The Decoration of Hebrew Bibles in Medieval Spain* (Leiden and Boston, 2004), 150–54.

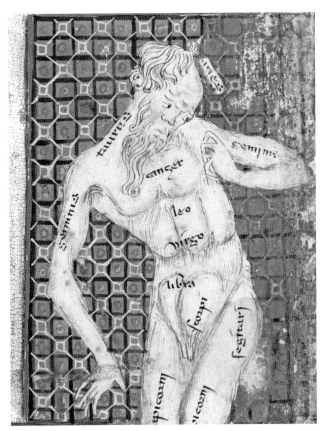

Fig. 2. Catalan *mappamundi*, Mallorca, 1375, Paris, BnF, Ms. esp. 30, sheet 1

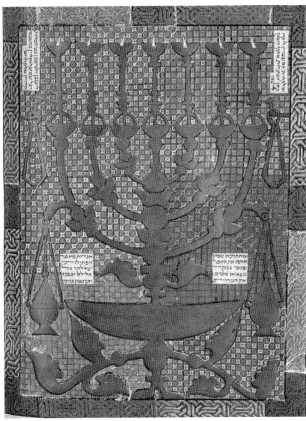

Fig. 3. Farhi Codex, Mallorca, 1366–83, former Sassoon collection, Ms. 368, p. 182

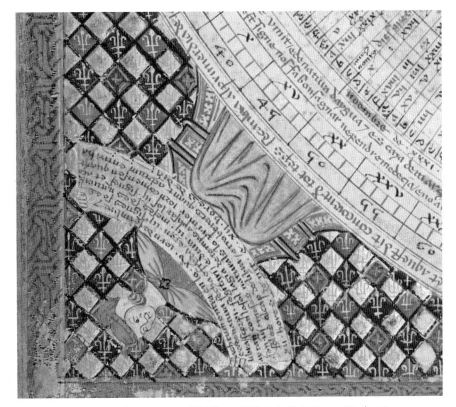

Fig. 4. Catalan *mappamundi*, Mallorca, 1375, Paris, BnF, Ms. esp. 30, sheet 3

Fig. 5. Catalan *mappamundi*, Mallorca, 1375, Paris, BnF, Ms. esp. 30, sheet I

Fig. 6. Farhi Codex, Mallorca, 1366–83, former Sassoon collection, Ms. 368, p. 59

by the same hand (figs. 5 and 6). The same applies to several other ornamental elements, such as the shapes in the inner section of the compass on the first sheet of the *mappamundi*, white highlights on pink or blue ground, with identical counterparts that are integrated in the carpet pages of the Bible (figs. 7 and 8).

The Farhi Codex is, in fact, a very sophisticated piece of work. Before the actual biblical text begins we find 194 pages filled with a variety of different texts that offer a deep insight into Elisha Cresques' intellectual profile, his education, and his cultural leanings. These texts reflect a great interest in history, philology, biblical exegesis, and

Fig. 7. Catalan *mappamundi*, Mallorca, 1375, Paris, BnF, Ms. esp. 30, sheet 5

Fig. 8. Farhi Codex, Mallorca, 1366–83, former Sassoon collection, Ms. 368, p. 52

calendrical issues.[6] The decoration of the codex reflects a late stage of the Jewish-Islamic cultural symbiosis; it

6 For an in-depth analysis of these texts, see Katrin Kogman-Appel, *Elisha Cresques ben Abraham: The Professional Profile of a Medieval Scribe, Illuminator and Mapmaker* (in preparation), chap. 2.

involves Maimonides' thought on the Temple and embeds it in the iconography of the Temple image, and more. These observations shed light on Elisha Cresques' cultural background. Whereas Riera i Sans and other more recent historians, such as Ramon Pujades i Bataller, describe him as a mere colorist, a craftsman who simply put paint on

world maps and compasses,[7] analysis of his artwork, his scribal work, and the texts he collected suggests that he was a knowledgeable, erudite member of the Sephardi elite, a man who was perhaps not an active scholar or scientist himself, but one who was well versed regarding his intellectual environment.

Thanks to Elisha Cresques' high status at court as a mapmaker for the royal family, there is a wealth of archival material, which has been published and discussed by Riera i Sans, Gabriel Llompart i Moragues, and Jocelyn Hillgarth.[8] However, the information that focuses on Elisha Cresques' professional status as a mapmaker has never been looked at in conjunction with the knowledge that can be gained from the Farhi Codex, and the life and career of the scribe-illuminator of the codex has never been examined in tandem with what is known about the man as a mapmaker. The present paper deals with Elisha Cresques' history from both aspects and attempts to put his career into focus. In fact, his story reflects a puzzling instance of scholars in three fields working without any communication among them. In the historiography of mapmaking, Cresques exists simply as a name and his personality and intellectual profile are ignored. He remains a shadow, a tool, so to speak, through which the king of Aragon communicated his political *Weltbild* to the world. For historians of Jewish art, Elisha is the scribe and illuminator of the Farhi Codex, and even though Riera i Sans' observations have been known for more than thirty years, neither the Catalan *mappamundi* nor Cresques the mapmaker have ever been considered by scholars in this field. For the Catalan historians, finally, he is a professional who was granted royal privileges, which tells us something about the intellectual interests of the court and gives us a glimpse of the economic aspects of life in late-fourteenth-century Mallorca.

As I noted above, Elisha Cresques was born on 11 July 1325 in Mallorca. The list of ancestors in the Farhi colophon seems to indicate that he came from a family of rabbis, even though not much is known of his father, Rabbi Abraham, and nothing of his grandfather Rabbi Bevenisti. A document in the Archivo de la Corona de Aragón indicates that members of his family had joined the council of the *aljama* (the Jewish community) in the City of Mallorca (modern Palma).[9] Elisha Cresques must have been educated in the 1330s and early 1340s, but whether he had a full rabbinic education cannot be determined. There is nothing to indicate that he was ever ordained. In any event and beyond doubt, Elisha Cresques did acquire traditional Jewish knowledge, as indicated by the texts that precede the Farhi Bible, a collection, as noted, of short treatises of all sorts, works of traditional rabbinic, midrashic interest, texts of massoretic background, philology, and more.

From his work we know that Elisha Cresques received superb training as a Hebrew scribe; his penmanship was of a very high standard. He knew Occitan, the language spoken in southern France, Catalunya, and Mallorca, a tongue that somewhat later would develop into three different dialects: Provençal, Catalan, and Mallorquin. Apart from speaking Occitan, he also wrote the language in both Hebrew and Latin script.[10] The Farhi Codex contains a Hebrew-Occitan dictionary, the Occitan words appearing in Hebrew letters (pp. 42–165 in the margins). The Catalan *mappamundi* includes many captions in Occitan explaining its imagery. These captions, it appears, were written in the same language as the dictionary in the Farhi Codex.

7 Riera i Sans, "Cresques Abraham," 22; Gabriel Llompart i Moragues, "Aponts iconografics des del port de Mallorca," *Cartografia Mallorquina* (Barcelona, 1995), 465; and more recently Pujades i Bataller, *Les cartes portolanes*, 487.

8 Riera i Sans, "Cresques Abraham;" Gabriel Llompart i Moragues and Jaume Riera i Sans, "Jafudà Cresques i Samuel Corcós: Més documents sobre els jueus pintors de cartes de navegar (Mallorca, segle XIV)," *Bolleti de la Societat Archeologica Luliana* 40 (1984): 341–50; Jocelyn N. Hillgarth, *Readers and Books in Majorca 1229–1550*, 2 vols. (Paris, 1991), vol. 1, nos. 67, 96, 97, 108, 112, 123.

9 Archivo de la Corona de Aragón, Canc. Reg. 1442, fol. 78v–79r, published by Amada López de Meneses, "Documentos culturales de Pedro el Ceremonioso," in *Estudios de Edad Media de la Corona de Aragón*, vol. 5 (Zaragoza, 1952), 729–30, no. 75.

10 Pujades i Bataller, *Les cartes portolanes*, 491–92, discusses the question of whether it is likely that Elisha Cresques would have been trained in the penmanship of a Christian chancellor and does not exclude that possibility.

Elisha Cresques may also have had some knowledge of Latin, as there are two Latin captions on the *mappamundi*, which also includes a Catalan paraphrase of Honorius Augustodunensis' *imago mundi*.[11] There is no way of knowing whether this implies that he was familiar with the Latin original or worked with a translation. There is a good chance that he also had command of Arabic, as Yom-Tov Assis recently argued that at the end of the fourteenth century Arabic was generally the language of choice among the Sephardi educated elite.[12]

From the collection of texts in the Farhi Codex and some observations about his approach to the *mappamundi*, we know that Elisha Cresques must have acquired some general scientific knowledge. For example, he was familiar with and wrote about the *sod ha-'ibbur*, the way of calculating leap years, which was usually known only to very few scholars.[13] He also seems to have had some idea of Ptolemaic geography, as the Catalan *mappamundi* represents the known world not by means of a circular image in the medieval tradition of *mappaemundi*, but pictures it from the Iberian Peninsula to China on a rectangular surface. He only would have had access to this sort of knowledge via Arabic and Jewish science, since Ptolemy's *Geographia* was not translated into Latin until 1406.[14]

At some time during the later 1350s, around the age of thirty, Elisha Cresques married. His wife Settadar, whose name seems to indicate a Maghrebi origin, was perhaps considerably younger than her husband, as she would outlive him by nearly twenty-five years. The couple had at least two children, a son Jafudà, born in 1360, and a daughter Astruga. Jafudà was trained as a mapmaker and collaborated with his father until the latter's death, whereupon he inherited the business.[15]

There are no precise records as to when Elisha Cresques entered the service of the king of Aragon. Neither do we now know anything about his artistic training as an illuminator and mapmaker. It has been suggested that he was the brother of Vidal Abraham, an illuminator in the king's service who painted a *Llibre del privilegis i franqueses de Mallorca*, now in the Archive of the Crown (1341),[16] which would indicate that he came from a family of illuminators and learned the trade at a young age within the family.[17] There is, however, no firm evidence for this assumption and whatever the case, the broader picture of Elisha Cresques' professional career indicates that his primary profession was that of a scribe. It was for this work that his father honored him with the gift of his own seat in the synagogue, as we learn from one of the archival documents (see below).[18] The practice of taking young teenagers into one's household to teach them a profession was, indeed, customary, as we know from yet another document in the Archivo Capitular de Mallorca from September 1368. This text records that the youth Bonjuha, the grandson of Astruch de Montblanc, moved into Elisha Cresques' household to learn Hebrew reading and writing and the craft of a scribe.[19] It should be noted,

11 Honorius' text was edited and published by Valerie Flint, *Archives d'histoire doctrinale et littéraire du Moyen Age* 56 (1982): 48–152; for a short discussion of the version as it appears in the Catalan *mappamundi*, see Edson, *The World Map*, 75–78.

12 Yom-Tov Assis in an oral presentation in Jerusalem, Institute for Advanced Studies, May 2012.

13 For some background on the *sod ha-'ibbur*, see Elisheva Carlebach, *Places of Times: Jewish Calendar and Culture in Early Modern Europe* (Cambridge, MA, 2011), chap. 1.

14 For more details on the knowledge of Ptolemaic geography, see Patrick Dalché Gautier, *La Géographie de Ptolémée en Occident (IVe–XVI siècle)* (Turnhout, 2009), who stresses the role Arab sources played in the preservation of geographic knowledge based on Ptolemy.

15 Archivo de la Corona de Aragón, Canc. Reg. 1944, fol. 36v; Antoni Rubió y Lluch, *Documents per l'història de la cultura Catalana mig-eval*, 2 vols. (Barcelona, 1908–21), 1:345, n. 1; Archivo de la Corona de

Aragón, Canc. Reg. 1972, fol. 146; Rubió y Lluch, *Documents*, 1:345; Hillgarth, *Readers*, 2:no. 123.

16 Codèx de la Casa Reial 8; Gabriel Llompart i Moragues, *La pintura medieval mallorquina: Su entorno cultural y su iconografía*, 4 vols. (Palma de Mallorca, 1977–80), 1:169.

17 On a possible connection between Vidal and Cresques, see most recently *Llibre dels Reis: Llibre de franqueses i privilegis del regne de Mallorca*, ed. Ricard Urgell Hernández (Palma de Mallorca, 2010), 118; Riera i Sans, "Cresques Abraham"; Llompart i Moragues and Riera i Sans, "Jafudà Cresques": 344; Pujades i Bataller, *Les cartes portolanes*, 491–92.

18 Archivo Capitular de Mallorca, Not. Num. 14621, s. f., Gabriel Llompart i Moragues, "El testamento del cartógrafo Cresques Abraham y otros documentos familiares," *Estudis Baleàrics* 64/65 (2000): appendix, no. 1.

19 Archivo Capitular de Mallorca, Not. Num. 14632, s.f., Llompart i Moragues, "Testamento": appendix, no. 5.

Ars Judaica 2014

however, that according to this document, Bonjuha was taught to be a scribe rather than an illuminator.

The first time we hear of Elisha Cresques as a professional is in 1361, when his father proudly bought him a seat in the synagogue of Mallorca in honor of Elisha's scribal work (*negociis scripturarum*).[20] Other documents mention some Bibles in the family's possession and there is reason to assume that they were produced in Elisha Cresques' workshop. The most prominent of these is the Farhi Codex, where we find a colophon in which he notes explicitly that he copied and illuminated the work himself, having begun the project in 1366 at the age of forty-one. Apparently there were numerous other projects that were more pressing, which provided him with income, and he completed the book only sixteen years later, in November-December 1382 (*Kislev* 5143, according to the Jewish calendar). It is possible that he was also involved in the illumination of another Bible, now in St. Petersburg.[21] A document from 1372 reports on the arrangement of a marriage between Jafudà, twelve years old at the time, and Stella, the daughter of Jahuda Beniadde, and indicates that Elisha Cresques presented a Bible to his son's father-in-law to be.[22] The marriage never took place, but we know that a Bible would have been a suitable gift for that kind of occasion. Yet another Bible, perhaps from Elisha Cresques' workshop, is mentioned in a document from 1409. Settadar, then already a widow, received a loan of 100 Mallorcan pounds; she offered a precious Bible and a Book of Hours as collateral, both books adorned with silver clasps.[23] In 1418 Lluis da-Granada, perhaps Settadar's brother, who ran her estate after Jafudà's death, sold a Bible decorated with the Temple of Solomon and a *mappamundi* to the convert Bernat de Mon Ros.[24] In short, the Farhi Codex is apparently the sole survivor of a whole group of books that can be associated with Elisha Cresques.

From 1368 at the latest until his death, Elisha Cresques worked for the king and the crown prince of Aragon, and there are several documents that refer to him as "master of *mappaemundi*," or "maker of compasses (*bruixoler*)." As Riera i Sans points out, he was the only mapmaker or compass maker in the king's service during his time.[25] In 1368, some two years after he began to work on the Farhi Codex, he was granted a privilege that made him a "royal *familiar*," an individual who received a royal salary for his services.[26] This designation as a *familiar*, which Elisha Cresques obtained at the age of forty-three, indicates a particularly high status at court. Moreover, as a Jewish *familiar*, he was not obliged, as most Jews were, to wear the *rodella* on his garments.[27]

Other documents from the 1370s indicate that at this stage in his life Elisha Cresques was quite successful. He appears to have been a wealthy, honorable individual who resided in a large house and was the recipient of various privileges from the king.[28] However, it seems that his success cast some shadow on his standing within the Jewish community. In 1380, Elisha Cresques and Jafudà complained to the Royal Council that the officials of the *aljama* had taxed them unfairly, claiming that they were overtaxed because the officials envied their status as royal *familiars*.[29] Two years later Elisha Cresques was denied membership in the council of the *aljama* and was apparently re-admitted only after the king's intervention.[30]

In March 1387 royal documents record Elisha Cresques' death. A world map that had been commissioned, but left unfinished, was completed by Jafudà.[31] It seems that the

20 See n. 18.

21 National Library of Russia, Firkovich collection, hebr. II B. 101; this Bible was originally written and illuminated in northern Africa and later additions were made in the second half of the 14th century. The style of these additions resembles that of the Farhi carpet pages; see Bezalel Narkiss, *Illuminations from Hebrew Bibles of Leningrad* (Jerusalem, 1990), 68–69.

22 Archivo Capitular de Mallorca, Not. Num. 14636, s. f., Llompart i Moragues, "Testamento": appendix, no. 6.

23 Archivo Capitular de Mallorca, Not. Num. 14707, s. f., Llompart i Moragues, "Testamento": appendix, no. 16.

24 Llompart i Moragues, *Pintura medieval mallorquina*, 4:no. 493.

25 Riera i Sans, "Cresques Abraham," 25.

26 Archivo de la Corona de Aragón, Canc. Reg. 1426, fols. 74r–v; Riera i Sans, "Cresques Abraham," n. 53.

27 Riera i Sans, "Cresques Abraham," 35.

28 Riera i Sans, "Cresques Abraham"; Llompart i Moragues, "Testamento."

29 Archivo de la Corona de Aragón, Canc. Reg. 1442, fol. 78v–79r; López de Meneses, *Documentos*, 729–30, no. 75.

30 Archivo de la Corona de Aragón, Canc, Reg. 1438, fol. 135r; López de Meneses, *Documentos*, 744, no. 93.

31 See n. 15 above.

family business did not thrive after Elisha's death, since in August of the same year Jafudà and Settadar took a loan of 200 Mallorcan pounds from one Isach, son of the physician Aron Abdelhac, to whom they also rented out the upper floor of their residence.[32] Further, as noted earlier, Settadar was in need of yet further loans during the years after the riots of 1391.

Elisha Cresques appears to have been a learned individual, a Hebrew scribe, and a trained illuminator. This information can now be correlated with the imagery of the Catalan *mappamundi*. A late medieval map was, in many ways, a scientific endeavor. Late medieval knowledge about the world was nourished from a variety of sources. Navigational knowledge had been accumulated in written records, usually referred to as *portolani* ("referring to ports"). This information was translated into a visual, cartographic, medium in what are commonly referred to as "portolan charts," relatively accurate maps of the coastlines of the Mediterranean and the Black Sea. Such navigational charts were produced in Italy and Catalunya from the thirteenth century on.

Angelino Dulcert, who emigrated from his native Genoa to Mallorca, was an outstanding mapmaker of the first half of the fourteenth century. Historians of cartography assume that Dulcert's maps were very important influences on Elisha Cresques' work, and indeed the Catalan *mappamundi* presents Europe and the area of the Black Sea as a somewhat stylized portolan chart. However, aside from being a navigational tool as is a portolan chart, a late medieval world map had political, theological, or ideological overtones. This applied in particular to those areas that were not part of the portolan system, such as North Africa, Central Asia, and the Far East, which were presented in the form of a traditional *mappamundi*. Representations of these areas are significantly less accurate in terms of geographic knowledge and various categories of information are transmitted iconographically.[33] For instance, political realms are defined by flags and the portraits of rulers (fig. 1), and Christianity is pictured time and again, as is biblical history. Some anthropological interest also shines through the iconography of the Catalan *mappamundi*: nomads in northern Africa, a Chinese junk, and a cremation ceremony in northern Asia, which Europeans knew about through the reports of Marco Polo.[34] A great wealth of sources was used to create this work: we find echoes of Isidore of Seville, Honorius of Autun, Marco Polo, Ibn Battutta, other European travelers, the Hebrew Bible, and the famous Letters of Prester John. All of these details first of all express the Christian worldview and the politics of the king of Aragon.

What lies at the core of my own interest in the *mappamundi*, however, is the role played by Elisha Cresques and his Jewish-Sephardi identity in this endeavor, as well as how his profile can be placed in tandem with what we can learn from an in-depth analysis of both the texts and the illuminations of the Farhi Codex. The framework of this brief article does not allow me to go into detail on this matter, and I limit my remarks here to one short comment.

The iconography and the captions of the Catalan *mappamundi* offer a great wealth of historical information. They include references to biblical narratives, such as the Flood, the Tower of Babel, the Crossing of the Red Sea, the Giving of the Law to the Israelites, and the Destruction of Nineveh. Alexander the Great is represented prominently. Elsewhere the map figures numerous Christian motifs, such as the Magi on their journey to Bethlehem, Christian rulers in the East, and various sites of Christian interest. Elements of Islamic

32 Archivo Capitular de Mallorca, Not. Num. 14753, s. f., Llompart i Moragues, "Testamento": appendix, no. 12.

33 This approach of combining the portolan approach with iconographic elements typical of a medieval *mappamundi* was introduced as early as in 1339 in one of Angelino Dulcert's maps (Paris, BnF, CPL, GE B-696). It had been suggested that this map, which, similar to all portolan charts, covers Europe and the Black Sea, is only a fragment and was originally part of a world map. For a discussion of this possibility, see Pujades i

Bataller, *Les cartes portolanes*, 487. Following up on this hypothesis, it was also suggested that the Catalan *mappamundi* is nothing but a copy of Dulcert's world map, ibid. Elsewhere I shall demonstrate on the basis of visual analysis and composition that it is unlikely that Dulcert's map of 1339 included much more than it does in its surviving form, Kogman-Appel, *Elisha Cresques*, chap. 2.

34 *The Travels of Marco Polo*, ed. and trans. Ronald Latham (London, 1958), 86.

relevance are also included, such as the image of a pious Muslim praying in Mecca.

The Farhi Codex reflects a similar concern with historical events and figures. For example, the colophon mentioned above elaborates on the date of the completion of the manuscript. It offers not only the date according to the Jewish calendar typical of all colophons in Hebrew manuscripts, but embeds this date – the year 5143 – in a historical framework of events that calculates the timespan between those events and the completion of the book. At the same time Elisha Cresques determined the date of completion according to the Seleucid, the Roman, the Christian, and the Muslim calendars. Moreover, throughout the texts that are included at the beginning of the codex we find several treatises of historical interest, such as paraphrases of *Seder Olam* and *Seder Olam Zutta*.[35] These are chronographical Hebrew treatises, the first of which, in fact, instituted the traditional Jewish method of determining the calendar in relation to the Creation of the World. Hence in many senses the Catalan *mappamundi* and the Farhi Codex share a concern with historical matters that, on the one hand, goes beyond the historical interests of a maker of portolan charts and, on the other, beyond the interests of a Sephardi scribe, whose job it was to copy Hebrew Bibles.

By putting the two works into one intellectual context we will reach a fuller understanding of Elisha Cresques' career as a painter and a scribe and as a man who contributed to both Jewish and Christian culture. Such a study will reveal not only how a craftsman such as Elisha worked, but, in a larger context, might well illuminate the role Sephardi erudition played in cultural interactions and the transmission of knowledge in late medieval Europe.

35 For an edition of both these texts together, see *Seder olam rabba, Seder olam zutta, Sefer haqabalah* (Jerusalem, 1997). For an English version of the former, see *Seder olam: The Rabbinic View of Biblical Chronology*, ed. and trans. Heinrich W. Guggenheimer (Northvale, 1998).

A Surprising Model for
Charlotte Rothschild's Haggadah of 1842

Evelyn M. Cohen

Charlotte Rothschild (1807–1859), the oldest child of Nathan Mayer Rothschild (1777–1836), founder of the Rothschild Bank in London, and Hannah Barent Cohen (1783–1850), was born in Manchester, England and raised in London.[1] After she married her cousin Anselm von Rothschild (1803–74) in 1826, they moved to Frankfurt am Main. Her correspondence indicates that when she was there she spent her days painting, reading, tending to her children, and performing household duties.[2] Her uncle Amschel Mayer von Rothschild, the oldest of her father's four brothers, was the only banker of his generation to remain in Frankfurt. Charlotte and her family frequently celebrated Jewish festivals with him;[3] she created a Haggadah for him, completing it in 1842.[4]

The manuscript's dedication, in German, appears on page 4 (fig. 1). It begins, "To you uncle, who as the fathers, faithfully preserves the pious teachings, to you I give this book today." On the tenth line from the bottom of that page Charlotte continued, "Nimm auch die Bilder, die ich fand und zeichnete" (Take also the pictures, which I found and drew). All ninety-nine pages of this lavish manuscript are illuminated.[5]

The earliest known reference to the Haggadah appears in the memoirs of Moritz Daniel Oppenheim, who served as a painter and art dealer for members of the Rothschild family. In his brief description of his employment under Anselm and his *"kunstliebenden Frau"* (art-loving wife) Charlotte, Oppenheim wrote that she had asked him if he

I would like to express my gratitude to the Hadassah-Brandeis Institute for funding my research on Charlotte Rothschild, and to the staff of the Rothschild Archive in London for facilitating and aiding the advancement of my research. I would also like to thank Angelo Piattelli for his helpful recommendations in the early stages of my work and Menahem Schmelzer for his insightful comments in the last stage.

1 As two of Charlotte's cousins, who were also her sisters-in-law, bore the first name Charlotte, there has been some confusion over the identity of the illuminator of the Haggadah. Charlotte von Rothschild, the daughter of Nathan's brother Carl Mayer von Rothschild, who founded the Rothschild Bank in Naples, married Charlotte's brother Lionel Rothschild in 1836, while Charlotte de Rothschild, the daughter of Nathan's brother James Mayer de Rothschild, who established the family bank in Paris, married Charlotte's brother Nathaniel Rothschild in 1842. Although the French Charlotte was also a painter, she was not involved in the production of the Haggadah.

2 See, for example, her correspondence from Frankfurt to her mother on 17 October [1834], Rothschild Archive, London, XI/109/27/3/11, and to her brother Nathaniel, Christmas week [1840], Rothschild Archive,

London, I/104/0/404. Charlotte depicted herself seated at an easel painting a portrait of her husband Anselm while in the company of two of her children and their nanny in a painting of 1838, NM Rothschild & Sons Limited, London.

3 See, for example, her letter to her mother of 17 October [1834] Rothschild Archive, London, XI/109/27/3/11, where she mentions that as usual her family would be eating in her uncle's "tent" the next day, for the festival of Sukkot.

4 The Haggadah is currently part of the Braginsky Collection in Zurich, B314. The manuscript can be viewed in its entirety at www. braginskycollection.com. The Haggadah is described in *A Journey through Jewish Worlds: Highlights from the Braginsky Collection of Hebrew Manuscripts and Printed Books*, eds. Evelyn M. Cohen, Sharon Liberman Mintz, and Emile G.L. Schrijver (Amsterdam, 2009), no. 55, 148–53, and *Schöne Seiten: Jüdische Schriftkultur aus der Braginsky Collection*, eds. Emile Schrijver, Falk Wiesemann, et al. (Zurich, 2011), no. 16, 80–85, with a brief essay by Evelyn M. Cohen, "Charlotte Rothschild: eine jüdische Künstlerin als Illustratorin der Haggada," 78–79.

5 The manuscript comprises fifty-five parchment leaves measuring 208 × 190 mm.

Fig. I. *Charlotte Rothschild Haggadah*, Zurich, Braginsky Collection, B314, p. 4.
All the photos of the *Charlotte Rothschild Haggadah* reproduced in this article were done by Ardon Bar-Hama

would teach her.[6] He told her that he did not customarily provide instruction, to which she responded that she had studied with Baron Gérard, and had paid him a Louis d'or for every hour. The painter to whom she was referring was Baron François Gérard (1770–1837), who was considered one of the greatest portrait painters of his day, and who, among other honors, had been the first painter of King Louis XVIII of France.[7] Oppenheim took Charlotte on as a student. Although he claimed in the same paragraph that the highpoint of his teaching career was when she illustrated a Haggadah for her uncle,[8] it should be understood that he had been instructing her for some time. As early as 1831 Oppenheim wrote a letter introducing her to Wilhelm Hensel, his colleague in Berlin, because Charlotte was interested in having an artist at her side if she had time to paint during her stay in that city.[9]

Oppenheim recorded that for the text of the Haggadah, the best Jewish scribe of the time, [Eliezer Sussman of] Meseritsch, was hired.[10] The manuscript is bilingual, with Hebrew on the right and German on the left. It is likely that Meseritsch penned the text of both languages. Regarding the illumination, Oppenheim claimed somewhat vaguely, "*ich entwarf die Sujets dazu*" (I designed the subjects for it),[11] which, he continued, Charlotte executed in accordance with the style of old missals she obtained from the Paris Library, at considerable expense.[12] Oppenheim's description of the production of the illuminations seems somewhat at odds with Charlotte's statement in her dedication on page 4 of the Haggadah that *she* "found and drew" the pictures.

Regardless of whose statement is more accurate concerning the process by which the manuscript was illuminated, based on what both artists wrote, the mixture

Fig. 2. *Charlotte Rothschild Haggadah*, Zurich, Braginsky Collection, B314, p. 42

of artistic styles found in the Haggadah is not unexpected. Charlotte clearly relied on various sources. The delicate design in the border around page 42 contrasts with the style of the illustration of the seder that occupies most of the page (fig. 2). Within the scene itself, various influences are discernible. Although set in a contemporary interior,

6 See Moritz Oppenheim, *Erinnerungen* (Frankfurt am Main, 1924), 74.

7 Although no correspondence has been found between Charlotte and Gérard, her letters indicate that she spent a considerable amount of time in Paris in the 1830s. It seems likely that a relationship already existed between the French artist and Charlotte's cousin Betty, who lived in Paris and with whom she was extremely close. In the list of Gérard's unpublished portraits that appears in *Lettres adressées au baron François Gérard, peintre d'histoire, par les artistes et les personnages célèbres de son temps* (Paris, 1886) vol. 2, 413, there are entries for a painting of "La baronne JAMES DE ROTHSCHILD" for both 1828 and 1829.

8 Oppenheim, *Erinnerungen*, 75.

9 Jerusalem, NLI, Moritz Oppenheim Archive, MS Var. 388, 154a. I am indebted to Nicole Bojanowski for transcribing this document for me.

10 Oppenheim, *Erinnerungen*, 75. There is no indication of the identity of the scribe within the manuscript itself.

11 Both the German verb *entwerfen* and the English "to design" are ambiguous terms that can refer either to drawing or to conceptualizing the images.

12 Oppenheim, *Erinnerungen*, 75.

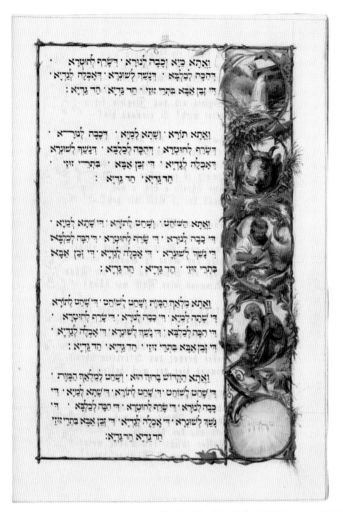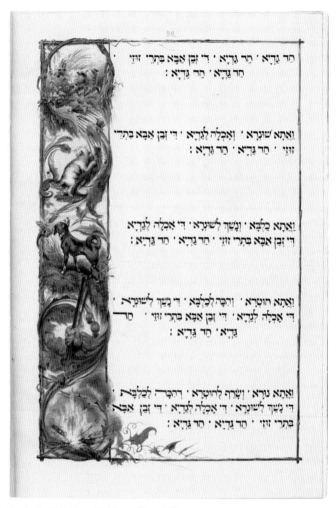

Fig. 3. *Charlotte Rothschild Haggadah*, Zurich, Braginsky Collection, B314, pp. 96 and 98

the clothing worn by most of the seder participants appears to be from another time and place. In keeping with nineteenth-century tastes, the image is, to a certain degree, a Romantic evocation of a seder.

The Hebrew inscriptions in this illustration, as well as those throughout the manuscript, appear to have been written by Charlotte, rather than by a professional scribe. As was common among family members of her generation, Charlotte studied Hebrew, and could read Hebrew prayers and write Hebrew characters. In 1832 she sent her sister Louisa a letter asking her to give Charlotte's "best love to Papa," and to "be so good as to tell him I would write him a Hebrew letter, but that as he considers himself an Englishman, I think an English letter would give him more pleasure."[13] Her statement that Nathan considered

himself an Englishman is interesting, as he was from Frankfurt, and thus German, not English. By "a Hebrew letter," she probably meant a letter in Judendeutsch, which was written in Hebrew characters, and which appears in much of the Rothschild correspondence of this period. Although Charlotte could write Hebrew, her letters were not always formed well and occasionally she made mistakes. In the verse ברוך אתה בבואך וברוך אתה בצאתך (blessed shall you be in your comings and blessed shall you be in your goings; Deut. 28:6) inscribed above the doorway at the left, the last word of each line is missing the letter *aleph*.

13 Rothschild Archive, London, XI/109/27/3/13. The letter is dated Paris, 11 November [1832].

This seder scene is significant because it is the only place in the manuscript where Charlotte asserted her authorship. Her initials, CR, appear on the back of the chair of the bearded man seated in the foreground at the right.[14] Although Oppenheim later produced a well-known rendition of a German family at the seder that is reminiscent of this image, Charlotte's painting predates Oppenheim's work. There is no reason to doubt that she created this image; it is even possible that her painting served as a model for Oppenheim, who produced a more contemporary depiction.

The question remains as to what Oppenheim intended when he said he designed the subjects for the Haggadah. A few drawings by him are currently known to have been used for this project. Most are illustrations for Ḥad Gadya.[15] Of the images found in Oppenheim's sketchbook, only seven of ten motifs were used by Charlotte, sometimes in reverse.[16] Their placement as a rectangular border forming a frame was not repeated in the illuminated pages of the manuscript (fig. 3).

Charlotte's statement that she "found and drew" pictures makes it seem unlikely that Oppenheim provided her with drawings for all the images in the Haggadah. Traditional Jewish sources for some of the illustrations are obvious, whether designed by Charlotte or by Oppenheim. The illustrations for the order of the seder on page 3 (fig. 4), may have been inspired, albeit loosely, by earlier Haggadot. The inclusion of seder scenes for this text ultimately derives from the Venice Haggadah of 1609, which includes contemporary seventeenth-century depictions of the sequence of events at the seder. This

tradition continued in eighteenth-century manuscripts, with elements that reflect daily experience, such as clothing and the interiors of the room in which the seder was celebrated being redesigned in response to changing fashions. The Romantic depictions of Orientalized figures wearing turbans in the Rothschild Haggadah reflect a nineteenth-century taste.

The border of the page contrasts strongly with the Jewish elements and the contemporary imagery within it. With its trompe l'oeil jewels and decorative strapwork, the frame seems inspired by a Renaissance model. Especially striking are the four square-cut gems surrounded by pearls: at the top left, a sapphire, beneath which is an emerald, and at the top right a ruby, with a diamond below. The appearance of the richly illuminated border calls to mind Oppenheim's statement that Charlotte executed the subjects in the taste of old missals, which she obtained from the Paris Library.[17]

The model for this border is, undoubtedly, a page that Charlotte "found" in the Book of Hours of Frederick III of Aragon, produced between 1501 and 1504 and acquired by the Bibliothèque Nationale in Paris in 1828.[18] The border design framing the figure of Saint Barnabas on page 356 of the Book of Hours is almost identical to that of the Haggadah (fig. 5). To accommodate a larger central image, Charlotte increased the width of her frame by including two rosette-like designs toward the center at the top instead of only one, and by adding vertical panels on either side of the central panel at the bottom and a further decorative element at each of the bottom corners. The colors are similar on both pages, with a green ground

14 These initials, with a coronet above them, are embossed in the upper left-hand corner of several of Charlotte's letters.

15 See Annette Weber, "Moritz Daniel Oppenheim and the Rothschilds," in *Moritz Daniel Oppenheim: Die Entdeckung des jüdischen Selbstbewusstseins in der Kunst = Jewish Identity in 19th Century Art* [catalogue, Jüdisches Museum der Stadt Frankfurt am Main], eds. Georg Heuberger and Anton Merk (Cologne, 1999), 185, n. 25 and cat. no. XII.10. A sketch for the title page will be discussed below.

16 The sketchbook is in the Archive of the Heinrich-Heine-Institut, Düsseldorf, Inv. Nr. 71.154. The drawings were examined by Falk Wiesemann and reproduced in an unpublished report in 2006.

17 Oppenheim, *Erinnerungen*, 75.

18 Paris, BnF, MS Lat. 10532. The manuscript is available on the library's

website: http://gallica.bnf.fr/ark:/12148/btv1b8427228j. For a discussion of the decoration of the manuscript, see François Avril and Nicole Reyaund, *Les manuscrits à peintures en France, 1440–1520* (Paris, 1993), no. 163, 296–97 and Raymond Limousin, *Jean Bourdichon, peintre & enlumineur, son atelier et son école* (Lyon, 1954), 72–74; figs. 52–55, 124–27. Page 198 is also reproduced in Jonathan J. G. Alexander, *Medieval Illuminators and Their Methods of Work* (New Haven and London, 1992), 147. The Book of Hours is paginated, rather than foliated, with a number appearing at the top outer corner of each page. This may have inspired Charlotte to carefully number each of her pages with golden numerals that at times were placed between a break in the framing element at the top of the page.

Fig. 4. *Charlotte Rothschild Haggadah*, Zurich, Braginsky Collection, B314, p. 3

used for most of the frame, and red painted around the circle at the bottom. Gold ornamentation is filled in with blue, red, and green in each manuscript. Although more numerous in the Haggadah because of alterations made to accommodate the difference in proportions, even minor details, such as the loops that encircle the gold lines along each edge, are depicted in both, while the placement of a sapphire, emerald, ruby, and diamond, each set within four pairs of pearls, is identical.

The appearance of the Haggadah became known only recently, after it was sold in 2008. It had been assumed previously that the title page was a traditional one, based on another Oppenheim drawing, which depicts Moses and Aaron standing at either side of the lower part of the composition.[19] Occupying more than half the height of the page, Moses, at the left, holds the Tablets of the Law against his right shoulder while he looks toward his left, in the direction of his brother. Aaron, in three-quarter view, wears priestly attire and holds a censer in his right hand. There is a large void between them, probably left empty for the inclusion of a title and other dedicatory information. In the upper part of the sheet are five biblical scenes, two at either side and one in the center. A frame surrounds each. The Israelites gather manna at the top left, while on the right they worship the golden calf. Below, at the left, Moses strikes the rock, causing water to flow from it. Opposite this illustration, on the right, is a scene of the brazen serpent. In the open space in the center, Moses kneels facing left, about to receive the Tablets of the Law that hover above.

Although Oppenheim probably provided Charlotte with the sketch, she did not use it for either of the pages at the opening of the Haggadah.[20] On page 2, Moses is posed frontally as he stands holding the Tablets of the Law (fig. 6). Unlike Oppenheim's rendition, in which Moses turns to face his brother Aaron and rests the tablets

Fig. 5. *Book of Hours of Frederick III of Aragon*, Paris, BnF, MS Lat. 10532, p. 356

against his right shoulder, in Charlotte's portrayal, Moses is an iconic figure, who holds the tablets, numbered with Roman numerals and placed one behind the other, on his left side.

19 See Weber, "Moritz Daniel Oppenheim," 185, n. 25. The drawing in pencil on paper, measuring 22 ×15.15 cm, is in the Hanau Museum at the Schloss Philippsruhe and is reproduced in *Moritz Daniel Oppenheim*, 379, illustration VII.63.

20 The central composition of Moses receiving the Tablets of the Law was used, in reverse, for the figure of Moses on Mount Sinai at the top of a full-page miniature of the Giving of the Law, in which the dominant element is the group of Israelites who watch in awe at the bottom of page 40. Although the gathering of manna appears within the letter 'ayin on page 39, and Moses striking the rock appears within the letter "U" on page 41, the compositional arrangement of these scenes does not relate closely to the known Oppenheim sketches.

Fig. 6. *Charlotte Rothschild Haggadah*, Zurich, Braginsky Collection, B314, p. 2

Moses is presented within a landscape, as a dominant figure within a framed painting. The panel is revealed by two angels who hold open the drapes that hang before it. In their other hands they hold long tapers. The angels stand on what seems to be a table covered with a white cloth on which has been placed a seder plate containing the ceremonial Passover foods. The carved pink relief on the front of the table depicts *Pesaḥ miẓrayim*, described in Exod. 12:3–11. Israelite men and women are shown hurrying to the table on which the Paschal sacrifice is placed.

This image is based, once again, on a composition found in the *Book of Hours of Frederick III of Aragon*. On page 198, the scene depicted in the panel within the miniature is that of the Deposition, in which Jesus is lowered from the cross (fig. 7). In the foreground is an altar; the side facing the viewer is covered by a blue cloth decorated with a pattern of gold crosses. Two large candlesticks with lit candles, an incense burner, and a cross are placed before the altar.

The resemblance between these two pages is unmistakable. In each, the large panel in the center is made visible by taper-bearing angels who hold the curtains open. The architectural and spatial elements are similar. Although Charlotte copied many details, she removed the Christian elements in the front of the altar and replaced them with a scene related to the Passover in Egypt; atop the table she substituted a seder plate in place of the chalice used for the Christian ritual of communion.

While the architectural details are similar, the type of material used for the curtains, and the folds of the drapery, are almost identical. In the *Book of Hours* the artist created an illusionistic trick making it seem that a real piece of parchment, with holes and tears, was placed around the miniature. Charlotte fashioned her own trompe l'oeil. She created the illusion that the Hebrew inscription חקת

21 Comparable images bearing Latin inscriptions that give the impression they are incised into wood and stone appear in the *Book of Hours* on pages 94 and 106. Perhaps the closest in approach is found on page 100, in the writing on the side of the platform on which a priest stands holding the Host. The gold fringes of the fabrics in this scene also may have inspired the rendering of the edge of the cloth on the table on page 2 of the Haggadah.

Fig. 7. *Book of Hours of Frederick III of Aragon*, Paris, BnF, MS Lat. 10532, p. 198

עולם תחגהו (you shall celebrate it as an institution for all time; Exod. 12:14) was actually carved into the frame at the bottom.[21] In both cases the artists were making their two-dimensional paintings appear to be three-dimensional.

The architectural format of the title page (fig. 8) is similar to the page depicting Moses that faces it. The panel within the frame, however, has a burgundy background that provides a colored surface for the text written in gold. The initial letter *pei*, at the beginning of

Fig. 8. *Charlotte Rothschild Haggadah*, Zurich, Braginsky Collection, B314, p. 1

Fig. 9. *Book of Hours of Frederick III of Aragon*, Paris, BnF, MS Lat. 10532, p. 199

Fig. 10. *Book of Hours of Frederick III of Aragon*, Paris, BnF, MS Lat. 10532, p. 120

the word *Pesaḥ*, is decorated in a highly ornate manner. Once again, the table below displays a white cloth. The front is decorated with a blue brocade cloth, on which are placed the Rothschild coat of arms and strands of precious gems. At the bottom of the frame, Charlotte created the

illusion that the date of the creation of the Haggadah was carved into the wooden frame. The text reads: שנת ליל שמרים הוא לה׳ לפק (That was for the Lord a night of vigil; Exod. 12: 42). The words שמרים הוא, written larger than the others, numerically yield the date 1842.

This image was modeled on page 199 of the *Book of Hours*, which contains the text that faces the Deposition scene (fig. 9).[22] Once again Charlotte removed all Christian elements. In both compositions the angels, posed as mirror images of one another and here dressed in

22 The notion of having images with virtually identical frames on facing pages of the Haggadah, with the text on the right and the religious figure on the left, probably was inspired by the *Book of Hours of Frederick III of Aragon*, as thirty paired images of this type appear in the manuscript.

pink, hold the curtains open. As before, the lining of the drapes is green. Now, however, the blue and gold drapery is embellished with circular patterns. Trompe l'oeil is employed again. In the Haggadah, Charlotte created a fictive carved inscription, while in the *Book of Hours* the illuminator placed greater emphasis than before on the visibility of the stitches used to repair the imaginary tears of the parchment. The use of the decorated initial letter *pei*, rather than an ornamented initial word – common in Hebrew manuscripts – echoes the adornment of the letter "D" at the beginning of *Deus* in the Latin text.

The architectural details are strikingly alike. In the spandrels at the upper corners identical circular motifs flanked by dolphins appear in both. As was true of the previous pair, the capitals are similar, as are the carvings on the pilasters, which depict flowers rising up from vases that rest on the tops of the bases. On all four pages, between the two smooth areas of the gold frame at the top and on each side, a separate space is decorated with a running floral motif.

Depicted in front of the table is the Rothschild coat of arms, granted to the five Rothschild brothers by the Austrian emperor in 1822. The escutcheon as designed by Charlotte is based, once again, on an earlier model. The acanthus leaves along the sides and bottom of the cartouche, as well as the jewels, were copied from the

central motif in the bottom border of the scene of the Visitation on page 120 in the *Book of Hours* (fig. 10).[23] In each, an oval-shaped pearl dangles beneath the beard of the gold head at the center. Both have jewels placed within golden diamond-shaped settings embellished with a stylized *fleur de lys* at each corner. The disposition of the jewels is the same, with a ruby at the left and an emerald at the right. The placement of the five pearls in each design is duplicated, though Charlotte sometimes included a larger number of beads between them. In both designs, however, the color of the beads is identical, alternating from left to right: red, green, red, green, and further to the right, only red beads. It is clear that in culling models for the Haggadah, Charlotte utilized designs of all types and sizes.

Both Charlotte's statement that she "found" the pictures, and Oppenheim's comment that she used Christian models, are now confirmed.[24] At a time in which the creation of a handwritten and painted book was a rarity in itself, Charlotte took on the challenge of illuminating one herself. In planning it, for many scenes she relied on traditional Jewish sources, while for others she created original designs. For some she sought out the most beautiful decorations she could find in Christian art. The result is a richly illuminated Haggadah for her uncle, unlike any other.

23 A similar decoration is also found on page 121 in the Christian prayer book. At times Charlotte loosely adapted ornamental motifs from the *Book of Hours*, while positioning them in a different manner. Placed above the frame on pages 206 and 207 of the Christian prayer book are a pair of dolphins flanking a sapphire in a diamond-shaped frame, and the six pearls. While these elements were employed by

Charlotte, their final arrangement on page 31 of the Haggadah is decidedly different.

24 Oppenheim referred to Charlotte having borrowed *Missalen*, in the plural form, from the Paris Library. It seems likely – also based on the appearance of other borders within the Haggadah – that Charlotte used other Christian manuscripts as decorative sources as well.

Sampler Embroidery Past and Present
as an Expression of Merging Jewish Identity

Ronit Steinberg

"If you think you can be a little bit Jewish, you think you can be a little bit pregnant." This sentence appears in one of the embroidered works by artist Elaine Reichek, *A Postcolonial Kinderhood*, displayed in the Jewish Museum, New York, in 1994.[1] The embroidered works in this exhibition were of the sampler type, a traditional genre of embroidery characterized by a combination of text and visual images.[2] Reichek presented her Jewish parents' social yearning to be absorbed in American society, and at the same time related to assimilated Jewish identity. The artist adopted traditional American sampler patterns, as embroidered by schoolgirls during the eighteenth and nineteenth centuries, and within them, embroidered quotes from members of her family and her friends with regard to their Jewish identity. Although she did not use Jewish sources, her work is the starting point for this article, in which I will be presenting a number of the embroidery pieces created by Jewish girls up until the eighteenth century, most of them in the United States. In a comparison between contemporary and traditional works, it is my contention that there is a unique common ground: folkloristic Jewish identity regardless of any religious characteristics. Despite the tendency to see traditional embroidery, and certainly embroidery containing Hebrew letters, as an expression

of religious art, I will point to the unique character of these works, which do not relate to religious ritual and in which the Hebrew letters are just a means of learning to read and write. Even if a critical concern with concepts of identity was not part of the cultural language of the eighteenth and nineteenth centuries, in this article I will demonstrate the presence of assimilated Jewish identity in both contemporary and traditional art.

What is a Sampler?

The term sampler relates to a type of embroidery work done by children, young girls, and women. The morphological characteristics of the sampler are a light fabric background, linear embroidery with a small number of filled-in areas, a collection of abstract decorations, the use of symbols, and a few figurative images. A main group in this genre is pieces containing a text, appearing in one of the following three forms:

a. Meaningless letters and numbers intended for developing and practicing embroidery skills;
b. The signature, age, and origin of the embroiderer;
c. Text excerpts of different lengths, from one paragraph to several verses of a poem copied from the written canon of the period, mainly relating to religious or moral topics.

I wish to thank my dear friend, Dorit Dym, for her wise advice.

1 Artist Elaine Reichek (b. 1943) lives and works in New York. In 1963 she completed her studies at Brooklyn College, New York, and then studied another year for a Bachelor of Fine Arts at Yale University, New Haven. Starting in 1973, the artist held numerous solo exhibitions that expressed elements of conceptual arts and introduced various creativity

processes. This article is partly based on my doctoral dissertation, "'Rikmat ha-zehuyyot': ommanut ha-tekst ve-ha-tekstil shel Elaine Reichek" (Cross-Stitching Cross-Cultural Identities: Elaine Reichek's Art of Text and Textile), Ph.D. diss., The Hebrew University of Jerusalem, 2011 (Hebrew), written under the supervision of Prof. Gannit Ankori.
2 In all references to the embroidery genre known as the sampler, the term appears in lower case.

In the course of time since the fifteenth century, the role of the sampler in the culture of the western world has changed. By analyzing the works, written testimony, and literary discussions, research attributes three main functions to the sampler.[3] The first use of the sampler was to preserve and pass on embroidery designs. According to the research, these were collections of patterns for embroidery. The name "sampler" maintains the historic meaning of this genre, and comes from the ancient French *essamplaire*. More specifically, the name relates to pieces of embroidery used by the embroiderer as a sample, or as defined in a French-English dictionary of 1530, "Exampler for a woman to work by; exemple."[4] This term refers to all types of work intended to be copied or to serve as a pattern for imitation. They appear to have been patterns created by women for their own personal use; for example, when an embroiderer thought of a new design she would embroider it on the sampler, and could then go back and use it whenever she wanted.[5] There is also evidence that these pieces were kept throughout their maker's life, and even passed on as an inheritance.

It also appears that, at a very early stage, they were purchased for private collections.[6] This leads to three conclusions with regard to the early use of the sampler. The first is that the name of the genre is inaccurate and misses the truth. They are not merely a source of patterns, but actual works of art based on creativity and originality. The second conclusion relates to collections of patterns accumulated by embroiderers, which are no less important than other acts of assemblage or research. The fact that this assiduous and lengthy process was valued by the people of the time highlights its importance. And the third conclusion indicates the common point of origin underlying the genre. Passing on patterns between embroiderers is an indication of a social organization that is worthy of attention, both with regard to modernist perceptions of art and with regard to gender-based points of origin in the study of the history of art.

The second use of the sampler lies in the field of education, and examples will be given in this article. Here, it is necessary to distinguish between two stages, based on a class division. The first stage, occurring in a number of European countries during the seventeenth century, involved the education of girls from families of high social standing. The second stage, typical of the eighteenth and nineteenth centuries, involved the schools for lower class girls that were common in England and also, in particular, in North America. Here, too, use was made of the copying technique. The creative process was based on the pedagogic approach of practice and imitation as a means of memorizing and taking in the material studied. In copying the decorative and textual motifs, social views and forms of behavior were acquired.

Upper-class young ladies were taught sampler embroidery as part of a program of lessons aimed at teaching them what were called "genteel accomplishments."[7] The aim of this program was for the girls to acquire technical skills in the crafts that they would need for their future role as managers of the household, which also involved a complete system of social and status-appropriate content. Since embroidery pattern books already existed at this time, the examples were taken from them. Research indicates that books from the sixteenth century were still in use even many years later, as a means of passing on the social and aesthetic tradition.[8]

3 The history of the sampler is based on a number of research papers: *Samplers from the Victoria and Albert Museum* [catalogue, V&A Museum], eds. Clare Browne and Jennifer Wearden (London, 1999); *Embroiderers* [catalogue, British Museum], ed. Kay Staniland, *Medieval Craftsmen* (London, 1991); Santina M. Levey, "Sampler," *The Dictionary of Art*, 34 vols. (New York, 1996), 27:693–94; Clarence P. Hornung, *Treasury of American Design and Antiques: A Pictorial Survey of Popular Folk Arts Based upon Watercolor Renderings in the Index of American Design, at the National Gallery of Art* (New York, 1986); Albert F. Kendrick, *English Needlework*, 2d rev. ed. (London, 1967).

4 *Samplers from the Victoria and Albert Museum*, 7.

5 *Embroiderers (Medieval Craftsman)*, 62.

6 For example, the 1509 inventory of the king of Spain mentions fifty pieces, and in the household accounts of Queen Elizabeth of York for around 1502 there is mention of a bill "To Thomas Fissch, for an elne of lynnyn cloth for a sampler for the queen, viijd." During the latter part of the life of Queen Elizabeth I, Shakespeare also related to these works; see Kendrick, *English Needlework*, 113–14.

7 *Young America; a Folk-Art History* [catalogue, The Museum of American Folk Art], eds. Jean Lipman, Elizabeth V. Warren, and Robert Bishop (New York, 1986), 46.

8 Pattern books began to appear in the 1520s (Germany, 1524). One of

Researcher Rozsika Parker, in her formative book *The Subversive Stitch: Embroidery and the Making of the Feminine*, emphasizes the complexity that resulted from the use of this genre as an educational device. According to her, the different symbols and patterns express couple relationships and puritanical gender attitudes. The handiwork itself is a manifestation of training, progress and diligence, utilization and investment of time. Parker claims that it is not surprising that this technique was popular in the seventeenth century, a period in which a cultural trend of organizing and utilizing time to the maximum developed. There is actually a paradox in the artistic context of the pieces. While handicrafts were a good means of preventing idleness, engaging in art was seen in a negative light, as an expression of boastfulness and decadence. One of the quotes that Parker gives in her book is: "Fear God and learn women's housewifery, Not idle samplery or silken folly" (Thomas Milles, 1613).[9] Nonetheless, sampler work was also common among extremely puritanical families.

As noted, by the eighteenth and nineteenth centuries the sampler was no longer used only for educational purposes, the province of the upper classes alone, but had become common in schools for girls of low standing. Here, too, teaching the technique was seen as a way of promoting the girls. Samuel Johnson's *Dictionary of the English Language* of 1799 defined the genre as "a pattern of work; a piece worked by young girls for improvement."[10] In various paintings we see girls learning in the bosom of their family, as well as in classrooms, where embroidery students are helped, among other things, by pattern diagrams.[11]

This genre of work began to appear in the United States in the days of early settlement, in places where settlers arrived with the appropriate equipment. According to one explanation, the settlers brought with them items for decorating the home that were easy to transport, among them samplers. Over the years stylistic signs identifying the samplers that were made in America began to develop, such as depictions of landscapes, maps, and emphasis of the embroidered texts.[12] The high point of this process was between 1800 and 1835, in the regions of New England and Pennsylvania, where there were schools for girls teaching the technique. We also find descriptions of girls already beginning to learn basic techniques of sewing, embroidery, and knitting as young children at home, from their mothers. Later, at school, they were taught more complex techniques. At the age of around eight the girls were ready to specialize in the writing techniques used in the sampler.[13] Since this was a basic device for teaching handicraft skills while at the same time practicing basic writing skills, even girls who received very little schooling had experience of this technique. The more years of schooling that parents could afford for their daughters, the greater the knowledge the girls acquired in sampler work. In most schools, it was usual to hold an exhibition at the end of the year, displaying all the pieces as a demonstration of the girls' good education.[14] Researchers studying the field point to the typical content of these pieces, which, as defined by Parker, deal mainly with the expression of emotions. Among the nineteenth-century middle classes, where this technique was in common use, there were clear definitions regarding what emotion was and who should feel it: "To be useful a woman must have feeling [...] forgetting oneself and sympathizing with others" (Elizabeth Sandford, 1831).[15]

Expressions of affection and respect towards parents, grief and sorrow over the death of a family member, and

the most popular pattern books mentioned in the research was printed in Italy in 1561 and in England in 1591 under the title *New and Singular Pattern and Works of Linnen*. Another popular book came out in 1597 in Germany and in translation into English in 1634 under the title *The Needle's Excellency*. For details, see Kendrick, *English Needlework*, 117; *Samplers from the Victoria and Albert Museum*, 9.

9 Rozsika Parker, *The Subversive Stitch: Embroidery and the Making of the Feminine* (London, 1984), 90.

10 Quoted in Betty Ring, *Girlhood Embroidery: American Sampler &*

Pictorial Needlework 1650–1850 (New York, 1993), 11.

11 For example, the anonymous *The Benevolent School*, ca. 1795, watercolor on paper, 38 × 58 cm. City of Bristol Museum and Art Gallery, Bristol, England.

12 *The Story of Sampler* [catalogue, Philadelphia Museum of Art] (Philadelphia, 1971), 14.

13 Hornung, *Treasury of American Design and Antiques*, 569–70.

14 Ring, *Girlhood Embroidery*, 14–16.

15 Quoted in Parker, *The Subversive Stitch*, 160.

traditional religious attitudes with regard to the avoidance of ungodliness were among the frequent messages of the sampler. The content system presented in the texts and visual images was a demonstration of the girls' spiritual education. In addition to scenes taken from religious texts, hunting scenes, buildings, and churches, other texts relate to a modest and religious lifestyle, adopted from a wide range of sources including women's magazines.[16]

The third use of the sampler is as decoration. This is more typical in the United States, although it also provided a source of income for poor girls in a number of European countries. In the United States, use of the sampler as decoration first appeared at the end of the nineteenth century, and continues to this day.[17] As noted, samplers were already part of American culture in the early settler period, but they are also related to modern American culture, thanks to what is called the Colonial Revival period (1876–1917).[18] The subject of handicrafts, in fact, demonstrates the paradox of the modern feminine image. The yearning for a return to feminine crafts and the flourishing of embroidery took place during the same period that the identity of the modern woman was formed. At the same time that women were emerging from the narrow confines of the home into the public space, mainly as working women, the handicraft that was so identified with seclusion in the domestic, motherly arena was flourishing. On the one hand, this was in line with the development of the Arts and Crafts movement and its influence in the United States, and in stylistic terms we can see the use of similar images. But additionally, the other concept related to these pieces, the "good wife"

happily engaged in the housework, quiet and polite, may have been an ideal of the progressive movement but categorically did not suit the changed lifestyle of the Colonial Revival period.[19] Beverly Gordon discusses this paradox in her article.[20] The changes taking place in the way in which embroidery was done indicate that, in the end, this craft was successfully integrated into the modern lifestyle. Instead of the eighteenth- and nineteenth-century schools, teaching feminine professions and not infrequently relating technical and aesthetic ability to education and class, by the 1920s embroidery patterns were available to everyone through magazines containing very precise instructions, mainly purchased by middle-class girls. Even today, specialist stores sell kits ready to be embroidered. The embroidered pieces became more abstract and were largely worked in a simple and easy cross-stitch. Ready-made framed samplers can also be purchased at popular prices.

This history of the sampler genre does not relate directly to the Jewish arena, but it is reasonable to assume that it had parallels there, especially because of its educational, social, and moral role.

Jewish Identity in Samplers

Various collections of Jewish art also include sampler pieces embroidered in the Jewish space beginning at the eighteenth century. Identification of the Jewish ethnic origin of the embroidery is based on the works themselves, the names of the embroiderers, or other historic evidence. The clearest examples are those containing Hebrew letters. In most cases, the Hebrew letters appear in alphabetical order, evidence of the didactic role of the

16 For example, *Ladies' Album*, *Godey's*, *Harper's Magazine*, and Isaac Watts' *Divine Song for Children*; see Hornung, *Treasury of American Design and Antiques*, 571.

17 I will relate here to use of the sampler as a decoration in American culture, but it is worth mentioning that in Belgium and Germany it was already a professional expertise for impoverished young women around 1830; see, for example, Levey, "Sampler," 694.

18 With regard to exact dating of the period, there are different opinions and there is room to see the influence of the rules even beyond the time limits mentioned here. See, for example, *The Colonial Revival in America*, ed. Alan Axelrod (New York, 1985), 12; Karal Ann Marling, *George Washington Slept Here: Colonial Revival and American Culture*

1876–1976 (Cambridge, MA, 1988).

19 These images appear in the literature of the revival period, for instance: Alice Earle Morse, *Colonial Dames and Good Wives* (Boston and New York, 1895). Reichek's library contains a book relating to these images, connecting them with women from the Bible, and comparing them all in the foreword with the sampler craft of the seventeenth century as work made up of a combination of images: Laurel Thatcher Ulrich, *Good Wives: Image and Reality in the Lives of Women in Northern New England 1650–1750* (New York, 1982).

20 Beverly Gordon, "Spinning Wheels, Samplers, and the Modern Priscilla: The Images and Paradoxes of Colonial Revival Needlework," *Winterthur Portfolio* 2/3 (1998): 193, n. 61.

Fig. 1. *Sampler* (B. Lazarus), 1843, silk embroidery on cotton, 24.1 × 28.2 cm. National Museum of American History, Washington, DC

Fig. 2. *Sampler* (B. Holländer), 1845, silk embroidery on cotton, 25.4 × 24.1 cm. National Museum of American History, Washington, DC

embroidery. As noted, unlike traditional embroidered items, we should not attribute any ritual role or religious custom to the Hebrew letters here, or even to the texts or visual images taken from the Bible.[21] Although in most cases children learned to read the Hebrew letters in order to pray or read the Scriptures, the embroidery presented here is not religious art.[22]

The traditional model, containing only letters and called an Alphabet Sampler, clearly demonstrates the second use of the sampler as explained at the beginning of this article – the didactic use. Hebrew letters appear in two very similar pieces in the collection of the National Museum of American History in Washington DC, embroidered two years apart (1843 and 1845) (figs. 1–2). Both pieces have narrow inner borders with basic,

Fig. 3. *Sampler* ("S.G.M." in Hebrew), 1813, cotton embroidery on linen, 44.5 × 38.1 cm. Courtesy of National Museum of American Jewish History, Philadelphia

21 Detailed research of the subject of embroidery in this connection appears, for example, in Bracha Yaniv, *Ma'aseh rokem: tashmishey kdushah mi-tekstil be-veit ha-kneset ha-ashkenazi, ha-sfaradi ve-ha-italki* (Ma'ase Rokem: Textile Ceremonial Objects in the Ashkenazi, Sephardi, and Italian Synagogue) (Jerusalem, 2009) (Hebrew).

22 This can be compared with learning from the alphabet tables that were in use in a number of Jewish communities, and even mentioned in the Talmudic literature. See, for example, Shalom Sabar, *Ma'agal ha-ḥa'im* (Circle of Life) (Jerusalem, 2006), 100–104 (Hebrew).

uncomplicated patterns. The letters that make up the main part of the sampler appear in a number of variations and colors, and are arranged in lines separated by simple, easily-worked embroidery stitches. The overall appearance of the pieces indicates that they are the result of the basic learning of embroidery techniques, practicing the shape of the stitches, changing to different colored threads, and forming the letters. The main issues of compositional structure and the different lengths of the rows show the embroiderer's lack of skill. The Hebrew letters in these pieces are part of the learning material.[23]

The way in which the letters are worked, and the relative proportions of these letters and the Latin letters following them, indicate the cultural point of origin of the embroiderers. Although the line of Hebrew letters in both pieces is in the opening, upper register, at the same time the Latin letters are embroidered over more lines, in varied writing styles. This repeated Hebrew-Latin structure appears in other examples from the same period.[24] From this it may be concluded that Jewish identity was part of the culture being studied, but at the same time it was necessary to establish greater skill in the local language. The differences in the line of Hebrew between the two pieces indicate that the earlier embroiderer, who signed her name as B. Lazarus, had difficulty with the Hebrew writing. This can be

concluded from the manner in which the letters are crowded and the embroidery stitches are pulled tight, indicating the tension of her hand movements.[25] It is possible that her lack of skill is due to the fact that this is the first part of her work.

The second embroiderer, signing her name as B. Hollünder, has spread the letters more widely and shows more accurate scholarly knowledge, as can be seen in the fact that the sequence of letters includes final letters.

In *The Art of Judaic Needlework*, the embroidered writing in the sampler is presented as a Jewish indicator related to the tradition in two ways, both in the use of Hebrew letters, Hebrew names, and dates from the Hebrew calendar, and also in the traditional ritual objects and the commemorative embroidery with which they are often decorated.[26] As we can see, these pieces should not be related to any kind of ritual objects; on the contrary, what is emphasized here is the didactic starting point: practicing writing as a demonstration of public and general learning.

The use of Hebrew letters also occurs in the reverse – Latin-Hebrew – form, where the Hebrew letters are embroidered after the rows of Latin letters.[27] In a piece signed with the initials S.G.M. and the date 1813 (fig. 3), the registers containing a series of numbers and a series of Latin letters are followed by two rows of Hebrew letters.

23 Already during the early settlement period, when the Jewish communities began to open their own schools, the study content was adapted to the general American model. In schools where the Hebrew language was taught, this was at a basic level, and mainly for the older students. A language textbook for adults was published in 1815, and in 1838 the first book for teaching Hebrew to children in elementary school classes was published; see *A History of Jewish Education in America*, ed. Judah Pilch (New York, 1969), 13–15. On the other hand, in Sunday schools the study of Hebrew and reading from the prayer book developed at an early stage, even before 1755, and thereafter general subjects were also added; see Alvin Irwin Schiff, *The Jewish Day School in America* (New York, 1966), 21.

From research into the education of Jewish girls in nineteenth-century Europe, the impression arises that sometimes girls studied in a ḥeder with the boys, while in other cases they had separate classes. It is also argued that in some countries the girls learned to write, while the boys only learned to read. See, for example, Avraham Greenbaum, "Ḥadar banot u-vanot ba-ḥadar banim be-mizraḥ eropah lifnei milḥemet ha-olam ha-rishonah" (The Girls' Ḥeder and Girls in the Boys' Ḥeder in

Eastern Europe before World War I) in *Ḥinnukh ve-historiah* (Education and History), eds. Rivka Paldachi and Emanuel Etkes (Jerusalem, 1999), 297–303 (Hebrew).

24 For example, a piece signed with the letters L.D. from 1836 in the collection of the Jewish Museum New York, or a piece from Germany in the Israel Museum collection, B68.0041, 165/19.

25 A photograph of the reverse side of the piece, in which the embroidery technique can be seen, is shown on the Museum website. On this website, the possibility is also put forward that the similarity between the two pieces indicates that their makers were students of the same teacher. On the basis of the embroidery style, it is suggested that they may have been made in the southern United States of America. http://blog.americanhistory.si.edu/osaycanyousee/2011/04/in-pursuit-of-jewish-sampler-makers.html

26 Ita Aber, *The Art of Judaic Needlework: Traditional and Contemporary Designs* (New York, 1979), 17–29.

27 For example, the piece signed with the initials LM from 1874, on display in the Israel Museum, B46.05.1071 165/016, and apparently originally from Poland.

In the upper row, the letters are crowded, small, and outlined with a single line, while in the second row the letters are embellished, and it can be seen that the embroiderer has also acquired calligraphic skills. This may reflect a more advanced stage of artistic education and language learning.

The piece, as is usual in the sampler genre, incorporates visual patterns together with the writing. The didactic aspect can also be seen in the visual images appearing in the embroidery, which are typical of the style. With regard to this piece of embroidery, Norman Kleeblatt points out that despite the obvious skill, the composition is unplanned.[28] Composition analysis indicates the existence of two neat axes: the bottom widthwise axis consists of three images, the well, and the two plants from both sides that create a symmetrical impression, and a middle axis is created by the well and the flower basket above it. However, this impression is nullified by the other images which indeed create the impression of a lack of design. Perhaps this is an indication of initial planning that later was abandoned. This fact emphasizes the process of learning through embroidery. What is required is to acquire skill in copying the visual images, and therefore the compositional structure is of no importance. The indication of Jewish identity through the embroidered symbols is not unambiguous, because these are typical motifs that occur in the sampler genre in different cultures, such as fruit trees and bowls of fruit. Nonetheless, there are two images which may also have a Jewish context. In the lower part of the piece is a magnificent well, with a bucket suspended on a rope. The well may express abundance, similar to the plant motifs, but it can also be seen as a reminder of the biblical well, and in a more focused way, women connected with the well in the Bible, such as Rebecca, Rachel, Zipporah, and Miriam.[29]

While the Jewish context of this image is not unequivocal, there is another image in the lower part of the embroidery, a pair of candles in candlesticks with a kind of covered wine goblet between them. This motif is a clearer indication of a possible connection with the Jewish lifestyle. In another piece embroidered in 1817, belonging to the Jewish Museum, New York, collection,

it is possible to identify the biblical motif of the spies returning from the Land of Canaan bearing a cluster of grapes. This motif is familiar in sampler embroideries since the middle of the eighteenth century.[30] Like other biblical motifs, here too, even though it does not have an unequivocal Jewish character, it is reasonable to assume that the biblical context contributed to the embroiderer's choice of subject. In the Israel Museum, an embroidered work from 1830 depicts the spies, and on the left side, a depiction of the Binding of Isaac (fig. 4). Abraham is seen standing in profile in the center of the scene, grasping Isaac's head with his left hand and the ram's horns in his right hand. Only the upper part of the ram's body is shown, emerging from a tall flowering bush with a cream-colored collar around his neck. Both Abraham and Isaac are wearing long garments, trousers in shades of light and dark blue, and black shoes. Above the scene is an overcast sky, and in the center, an image that resembles two eyes. Despite the fact that this piece of embroidery has no Hebrew letters and its Jewish identity is not unequivocal, the two biblical scenes may point in this direction. In another piece the study identifies a small motif of eight candles (fig. 5).[31] This motif, hinting at the Hanukah menorah, also appears after rows of Hebrew writing, among a collection of other visual motifs that are hard to identify clearly. Its form, tending to the abstract, could indicate the lack of skill of the young embroiderer, while at the same time it is similar to the decorative patterns found near it, raising the possibility that this too

28 *The Jewish Heritage in American Folk Art* [catalogue, The Jewish Museum and The Museum of American Folk Art], eds. Norman L. Kleeblatt, and Gerard C. Wertkin (New York, 1984), 41.

29 The well also represents the meaning of Torah, because of its image as living waters. In light of this, it can be argued that the well simultaneously represents both the Hebrew letters as holy letters, and the feminine identity of the embroiderer, attributing to female qualities relating to the well. However, it is hard to know to what degree the symbolism was familiar to the embroiderer or to her teacher. See Ellen Frankel and Betsy Platkin Teutsch, *The Encyclopedia of Jewish Symbols* (Northvale, 1992), 189–90.

30 Averil Colby, *Samplers Yesterday and Today* (London, 1964), 58, 181, 183.

31 Joy Ungerleider-Mayerson, *Jewish Folk Art: From Biblical Days to Modern Times* (New York, 1986), 92.

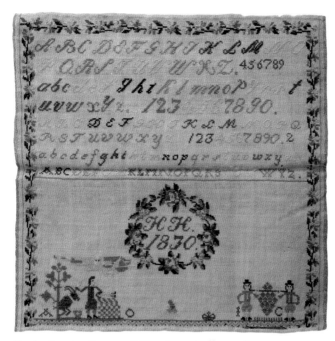

Fig. 4. *Sampler*, Germany, 1830, cotton embroidery on linen, 30.5 × 30 cm. Israel Museum, Jerusalem, Photo © The Israel Museum, Jerusalem, by Bchory Frisch

is an abstract motif that fortuitously appears to resemble eight candles.

A number of sampler pieces include the central motif of a text from biblical sources, for example the Ten Commandments or a verse from Psalms. In the embroidered piece made in 1771 by Elizabeth Judah (1763–1823), we can see the complexity of the sources of influence (fig. 6).[32] Although parts of the work have been damaged and unraveled over the years, it is clearly possible to identify the compositional structure. A border of greenery surrounds four pieces of text. Two are spread across the width of the fabric at the top and bottom, while the other two are written in short rows in two columns in the center of the composition. Rows of vegetal patterns separate the texts, showing trees, baskets of flowers, and a flowery pattern. The hierarchic embroidery technique indicates the skill of the embroiderer and the thoughtful

32 Mentioned, for example, in *The Jewish Heritage in American Folk Art*, 18, 33, and also in *A Philadelphia Sampler: Art and Artifacts from Jewish Collections* [catalogue, The Museum of American Jewish History], ed. Cissy Grossman (Philadelphia, 1980), cover. Israel Museum B80.1738 165/26 is an earlier piece from 1738, embroidered by Judith Torres, with the text of the Ten Commandments.

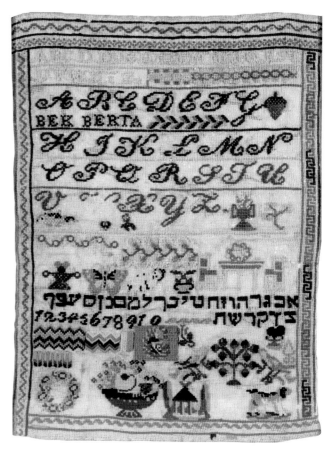

Fig. 5. *Sampler* (Berta Bek). 19th cent., undyed cotton on double-mesh canvas (known as Penelope canvas) embroidered with polychrome wool, 57 × 42 cm. The Jewish Museum, New York. Gift of Dr. Harry G. Friedman 1946. Photo © The Jewish Museum, New York / Art Resource, NY

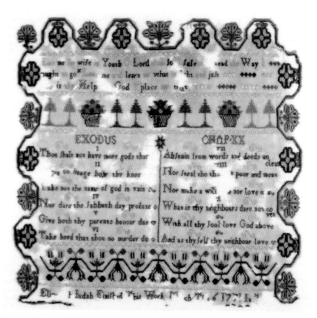

Fig. 6. *Sampler* (Elizabeth Judah), 1771, silk embroidery on linen, 46.6 × 47.6 cm. The Sherwin Miller Museum of Jewish Art, Tulsa, OK

planning of the whole piece. This can be seen, for example, in the care taken over the uniform repetition of the pattern rows, the legible and clear text, and the attention paid to details such as emphasizing the center of the composition with a change in the central flower of the upper border. The central text is the one that points to the complexity of the sources of influence. The two columns are typical of the structure of the Ten Commandments, and even bear the heading "Exodus." However, the text itself contains twelve numbered sentences which are not quotes from the Bible but from the book *Divine and Moral Songs: Attempted in Easy Language for the Use of Children*, written by Isaac Watts and published in 1715.[33] In addition to the Ten Commandments, the embroiderer has added two sentences:

With all thy soul love God above
And, as thyself thy neighbor love.

These sentences appear in the book immediately after the Ten Commandments, and are a reworking of the text of Matthew 22:37–39.[34] In light of the identification of the embroiderer as the daughter of a Jewish family,[35] a far-reaching environmental influence can be seen here, to the point of adopting Christian sources within a scriptural whole. It is reasonable to assume that the sourcebook, which was intended for children, was available to the young eight-year-old embroiderer and its availability overshadowed the lack of religious suitability.

In a sharp and brief transition to the present, it may be remarked that sampler patterns with a Jewish connection are fashionable even today, sold to the general public and appearing in embroidery booklets such as those produced by the group of embroiderers known as The Pomegranate Guild of Judaic Needlework.[36]

To conclude this section, I can argue that following educational processes of the Jewish community through history explicitly indicates the significance of the sampler works. The few samples presented above show that this was a basic folkloristic work that was probably common in certain Jewish communities. The childish design, the naïve look, and the religious-moral-educational context of the sampler genre enabled its acceptance by the Jewish community without any worries or principle hesitations. The fact that the Hebrew letters are the only significant characteristic of Jewish identity in these works indicates cultural assimilation was a fundamental worldview of the Jewish society. As summed up by Kleeblatt: "Although some samplers created by young Jewish girls in America introduce the Hebrew alphabet, most share in the design vocabulary of the samplers of the day and include similar prayers and pious verses (although the samplers by Jewish girls do not display specific Christian allusions or quotations)."[37]

Artist Elaine Reichek's Series of Samplers

In the second part of this article I will refer to a single exhibition of an individual contemporary artist. As mentioned before, this exhibition provides an opportunity for historical investigation of the sampler genre in Jewish society, emphasizing the socialization as well as cultural-integration processes that characterized this community. Reichek's involvement with techniques that were previously designated as "feminine crafts" and catalogued at the bottom of the artistic hierarchy such as sewing, knitting, and embroidery began in the 1970s and expressed her choice to create in her own domestic space. Since Reichek is an autodidact in the diverse techniques of handcraft, the comparison to the girls who created the samplers as a technique presents an essential as well as

33 During the eighteenth and nineteenth centuries, the book came out in a number of editions under different titles. Although the copy available to me was dated later than this text, the source is the same.

34 Isaac Watts, *Divine and Moral Songs for Children* (New York, 1866), 85–86.

35 Elizabeth Judah, born to a well-known Canadian Jewish family in 1763, made this embroidery when she was eight years old. In 1781 she married Chapman Abraham, who was the first Jewish resident of Detroit, and who died two years later. In 1787 she married again, to Moses Myers,

and they settled in Norfolk, Virginia, where she established a large family and lived until her death in 1823; see *The Jewish Heritage in American Folk Art*, 33.

36 Various articles on sampler motifs appear in the group's journal; for example, Joyce Gilbert, "Greek Motif Frames Contemporary Judaic Sampler," *The Paper Pomegranate* 16, 1 (Summer 1992): 17–19. I wish to thank Barbara and Samuel Dershowitz for the information.

37 *The Jewish Heritage in American Folk Art*, 47.

substantial model that exists not only as a theoretical appropriation.[38]

A major part of Reichek's work is devoted to pieces in the sampler genre. As mentioned above, she adopted early examples of embroidery without any Jewish traditional origins and incorporated other texts into them (figs. 12–13). Reichek made a few changes to the original model, which do not stand out and merge with the earlier structure. Sampler embroidery, similar to other handicrafts, is characterized by its human scale, and this is true also of Reichek's works. This scale reflects the handicraft process and domestic use.[39] Following the traditional designs, Reichek also uses square and rectangular formats. The various changes that she makes to traditional models do not affect the composition, and they retain their proportions, symmetry, and balance. Internal borders appear in a large part of the works, made of an interwoven plant or geometric pattern, also based on the early models of what are called border patterns. These factors contribute to the cohesion of the series, while at the same time indicating the artist's freedom of action in the diversity of her choices. This freedom remains within the bounds of the genre and her choices are taken from sampler patterns only, for example, the Band Sampler, Alphabet Sampler, and Spot Sampler. Instead of rebelling against the constraints of the tradition, the diversity demonstrates the richness of the genre and the abundance that its patterns offer to the contemporary artist. This richness is presented to viewers in the detailed references written by the artist, references that reinforce the anthropological aspect of the series as a whole and validate its research basis. The use of traditional patterns, wholly or in part, creates an impression of eclecticism

that fits with the original role of the sampler genre as a collection of examples for quotation.

The Exhibition Space as a Venue for Structuring American Identity

The merging worldview described in the previous section also appears in Reichek's work. One of the major exhibitions of her work was the 1994 exhibition at the Jewish Museum, New York, called A Postcolonial Kinderhood.[40] In this exhibition, the artist dealt with her personal identity, in this case, Jewish-secular-American. The exhibition space was constructed as a building interior, with pieces of furniture scattered around. Entrance was through the front door, and dim lighting connected the parts into one shared space (fig. 7). The furniture, in American colonial style, included a canopy bed, various chests of drawers, a towel rail (fig. 8), a rocking chair, and a standard lamp (fig. 9). On the walls and on various pieces of furniture family photographs and samplers were displayed. According to Reichek, the transition to dealing with her Jewish identity followed a visit by curator Susan Tumarkin Goodman to Reichek's studio two years prior to the exhibition. Due to Reichek's occupation over the years with expressions and ideas of identity, the curator suggested that she refer also to her own Jewish identity. The artist described her response to this suggestion as: "It was something I hadn't really thought about."[41] Despite Reichek's resolute words, it is clear that her earlier and ongoing interest in the subject of identity had prepared the ground, leading her, in the end, to deal in this exhibition with her Jewish identity.[42] In addition, in my opinion Reichek's childhood and adolescence in Brooklyn also had an effect on her decision to examine

38 As is well known, in the 1970s a few female artists engaged in similar techniques, many of them Jewish. It is important to mention that Reichek was focusing on conceptual processes such as translation and transfer, and worked quite independently and with no relation to these artists.

39 The scale of the pieces was usually determined by the size of the linen fabric. This use indicates a tendency to economize on material, and can explain the uniform appearance of the sampler pieces of the seventeenth century; Colby, Samplers Yesterday and Today, 29.

40 This exhibition has been reintroduced in the autumn of 2013.

41 Interview with Elaine Reichek, 12 Feb. 2007.

42 The artistic involvement with the terms and ideas of Jewish identity

began with a few artists during the nineties of the twentieth century. The exhibition Too Jewish?-Challenging Traditional Identities displayed in the Jewish Museum in New York, pointed to this development and intensified the dialogue referring to it. See Too Jewish?-Challenging Traditional Identities [catalogue, The Jewish Museum], ed. Norman L. Kleeblatt (New York, 1996). The fact that Reichek first approached the theme of gender identity and then engaged the Jewish identity issue expresses a cultural process that is appropriate for several other female artists. See Ziva Amishai-Maisels and Gannit Ankori, "Art," in Jewish Women in America: An Historical Encyclopedia, eds. Paula E. Hyman and Deborah Dash Moore (New York, 1997), 68.

Fig. 7. Elaine Reichek, *A Postcolonial Kinderhood* (Installation View), 1994. The Jewish Museum, New York. Photo © The Jewish Museum, New York / Art Resource, NY

her Jewish identity. On more than one occasion Reichek mentioned the Jewish presence in the Upper West Side neighborhood where she has lived since 1967. The history of the place shows that a Jewish community had already developed there at the end of the nineteenth century, and there were Jewish institutions, synagogues, schools, and stores selling kosher food.[43] Reichek noted that there was always a noticeable Jewish presence in the public space, especially in the playground where she spent time with her children. These descriptions create the impression of a marked, but not invasive, Jewish space that enabled her to preserve her Jewish identity

even from a secular standpoint. Eli Lederhendler uses a range of quotes to indicate that the children born in New York in those years grew up knowing that they belonged to the cultural majority in the city – Judaism. He recalls the words of Deborah Dash Moore, stressing that the Jewish neighborhoods were mainly secular. His book makes a distinction between Judaism, the religious lifestyle, and Jewishness, the distilled creativity of popular experience with a certain history. According to him, it is the awareness of this distinction that explains the nature of the connection that exists in New York between Jewish culture and Jewish secularism.[44]

43 Peter Salwen, *Upper West Side Story: A History and Guide* (New York, 1989), 277–93.

44 Eli Lederhendler, *New York Jews and the Decline of Urban Ethnicity, 1950–1970* (Syracuse, NY, 2001), 64, 91.

Fig. 8. Elaine Reichek, *A Postcolonial Kinderhood* (Installation View), 1994. The Jewish Museum, New York. Photo © The Jewish Museum, New York / Art Resource, NY

The main message arising from the exhibition involves the sense of a search for identity that characterizes the artist's generation. The discussion examines intergenerational processes related to the artist's biographical sources. The rooms of her childhood, with their colonial furniture, were the inspiration for the design of the entire space, but the way in which she relates to them also preserves the artist's adopted style. This can be seen in the creative act, for example in the choice of the furniture from the catalogue of Ethan Allen, an old, established company supplying industrially-produced furniture in a traditional style, or, as it says on the cover page of the catalogue: A Treasury of American Home Interiors. Shoppers can choose their favorite style of furniture there from different periods of American history. Reichek made her choice from the page displaying furniture from around 1776. The double replication enhances the discussion of the concept of appropriation, both in artistic terms and in social terms. Reichek's artistic involvement with post-colonial approaches is expressed in her choice of the commercial catalogue as a fascinating cultural text and as a source for processes relating both to her personal identity and to the pioneering American identity. Building the home and dressing the family in an American style was part of her childhood, and according to her: "My parents had the hope that they could access a past, a family history that wasn't their own."[45]

45 Suzanne Slesin, "Perils of a Nice Jewish Girl in a Colonial Bedroom," *The New York Times*, 17 Feb. 1994, C7.

Fig. 9. Elaine Reichek, *A Postcolonial Kinderhood* (detail), 1994. The Jewish Museum, New York. Photo © The Jewish Museum, New York / Art Resource, NY

Similar to other exhibitions created by Reichek, in this exhibition the artist relates to the display space, and it can be defined as site-specific. In her preliminary research regarding the display hall, she discovered that the museum building had been the home of a German Jewish family, the Schiffs, and that the exhibition space had been the dining room. As a result, Reichek requested that the later wall-facing be taken down, revealing the fireplace and the moldings.[46] The design of the exhibition thus created a dual impression. While the appearance of the room and its furniture resembled typical American rooms of the 1950s, at the same time the small details in the exhibition revealed the presence of a Jewish identity. Additionally, in contrast with the first impression of a room in a private home, the spaces between the works and the focus of the light on the objects created an artificial sense of emptiness actually reminiscent of a home furnishings show room or an anthropological display.[47] These dual combinations are related to Reichek's biography, growing up in an assimilated home as the daughter of a furniture store owner. The world of childhood is expressed in the name of the exhibition, *A Postcolonial Kinderhood*, in the low hanging of the pieces, and in the subdued lighting which, according to her, symbolizes evening after the children have gone to bed, and the illumination of the small nightlight. This return to the world of childhood expressed Reichek's search for signs of Judaism in her childhood home. Her research led her to the conclusion that her parents' home reflected a state of assimilation: "There was no Judaica in the house, nothing that remotely suggested Jewish culture."[48] In Reichek's conceptual style and her artistic involvement with the concepts of copying, sampling, and appropriation, she presents an assimilated domestic space.[49]

Fig. 10. Elaine Reichek, *A Postcolonial Kinderhood* (detail). 1994. The Jewish Museum, New York. Photo © The Jewish Museum, New York / Art Resource, NY

The exhibition included wall pictures and albums of Reichek's family photographs that the viewer could leaf through. The photographs depict scenes from family trips across the United States. Reichek makes a connection between them and the concepts of identity in the exhibition through the field of tourism. The one-time, staged view experienced by the tourist is emphasized

46 Interview with Elaine Reichek, 12 Feb. 2007.

47 One of the artist's earliest childhood memories relates to her attraction to the period rooms in the ethnography exhibitions that she saw at the Brooklyn Museum. This attraction represents the same process of assimilation she underwent as a child in the museum, learning to relate to American folk art.

48 Emily Whittemore, "Interview with Elaine Reichek," in *A Postcolonial Kinderhood* [brochure, The Jewish Museum] (New York, 1993).

49 Lisa Bloom related to the exhibition as an expression of the "practice of 'passing'." According to her, the irony of the exhibition put across very successfully "[…] how obsessed Jews were with passing, going so far as to be concerned about passing at home, in private." See Lisa Bloom, *Jewish Identities in American Feminist Art* (New York, 2006), 115–17. Reichek's quotes and their specific locations in the exhibition highlighted the presence of the Jewish identity and its public representation within the domestic and private space.

in the family photographs, such as in those where they stand smiling against a distant background of a historic site, together with actors dressed in the local costumes of Indians or black slaves. The tourists' need to mark their physical presence at the site in a photograph and the staged replication of local costumes are connected to previous exhibitions in which Reichek dealt with the ethnographic photography genre as well as with cinematic stereotypical representations.[50] By using these photographs, the exhibition introduced several methods of visual structuring of the concept of American ethnic identity and shows the irony of this identity perception by the artist's parents and their generation in search of a monolithic authentic identity. This self irony becomes clearer and sharpens when Reichek herself quotes in her artworks from visual representations that specifically served as tools for the construction of social-ethnical identity.

The photograph of the artist's grandfather is separated from the other photographs, and is fastened on the lampshade above the children's rocking chair (figs. 9–10). By contrast with the other photographs, in which there is an absence of any religious or ethnic signs, the grandfather's religious Jewish identity is clear, emphasizing the stages of inter-generational transition that are typical of migrants in general, and the Jewish migration to America in particular. Morris Reichek, Elaine's grandfather, was the oldest in his family. He was born in Poland and came to America as a child. In many ways he continued the family tradition and remained loyal to the lifestyle of the old country, since he remained ultra-Orthodox all his life. At a young age (18–20) he married Celia Kuchiniak Bernstein and they moved to Brooklyn. Morris combined his professional occupation with religious studies. The incorporation of his photograph above the rocking chair also relates to the fact that he earned a living from his furniture store. This underlines the family connection with the field of furniture, in both its handmade and factory-made forms.[51] A clear sign of identity has also been introduced, in an almost subversive manner, into the impressive towel rail. The decorated lacework towels, representing dignity, hygiene, and a traditional aesthetic, contain a monogram of the word Jew. The fact that this word is used creates an

iconic sign of traditional identity that also incorporates a racist meaning, in particular by comparison with the sewn yellow star. The group affiliation incorporated in the personal towel consequently creates an ironic impression and hints at well-known anti-Semitic connotations with regard to the purported lack of aesthetics and cleanliness of the Jews.

Jewish Identity in Embroidery in the Exhibition

The sampler pieces presented in the exhibition are based on examples from the settler period in America which the artist found in national libraries and museums in the United States. Most of them contain elements of landscape depiction, defined in the research literature as typical of the American sampler style as it developed in the middle of the eighteenth century.[52] Reichek asked twelve of her family members and friends to relate to their Jewish identity, to messages put across to them by their parents' generation, and to their relationship with non-Jewish society. In the context of the social discussion presented in the exhibition, the incorporation of the quotes in the traditional American framework demonstrates a yearning for social and cultural merging. Among the various aspects of the sampler, what is emphasized here is their social importance in America as a symbol of family rootedness. An examination of the quotes indicates the presence of a division by generation: the parents' generation, the intermediate generation, and the generation of the children. Reichek's generation is identified with the intermediate generation. The division into three generations is typical of different migrant societies.[53] I will relate to these quotes in more detail below.

50 For example: New York, Barbara Braathen Gallery, *Desert Song*, 1988; New York, 56 Bleecker Street Gallery, *Revenge of the Coconuts: A Curiosity Room*, 1988.

51 The typical combination between learning and doing in his generation could be seen in the furniture store, which had an inner room containing a library of religious books, where Morris Reichek used to study and pray when there were no customers in the store. Like his father, at a certain stage Morris Reichek also moved to Israel, where he is buried.

52 *The Story of Sampler*, 14–15.

53 For example, Dash Moore mentions it in connection with Reichek's generation as the third generation of a migrant family. This generation

Fig. 11. Elaine Reichek, *Untitled (Hilda Reichek)*, 1993, embroidery on linen, 41.4 × 28.1 cm. The Jewish Museum, New York. Photo © The Jewish Museum, New York / Art Resource, NY

Her instructions regarding behavior make the mother an agent of social culture. The obsessive repetition of the same sentence structure creates an intensity whose significance is engrained within us. The mother is directing her words to her child, in the first place, according to Western codes of polite behavior. At the same time, we can identify in her words a rejection of the anti-Semitic stereotype of Jews as being loud and talking accompanied by many hand gestures.

This piece, which contains lines of the Latin alphabet, also contains a depiction of the typical western home, which is a repeated motif in the history of the sampler genre.[54] The tree alongside it takes on the form of a Hanukah menorah, and the star above is in the form of a Star of David. These details, which are incorporated as part of the piece, merge with the overall typical appearance and are not particularly emphasized. As noted, this was typical of Jewish sampler work, which was not differentiated from the usual style. In addition to the structure, other pastoral patterns also appear in the pieces in the exhibition, such as the couple gathering crops in the field on either side of a flowering tree (fig. 12). The cheerful colorfulness of the work, the accentuated flowered frame, and the hearts and birds floating in the air reinforce the childish and naïve impression. For the most part, these figures stand in contrast to the meaning arising from the text and emphasize the tension between blending in and social alienation. Into the pattern of the couple taken from a sampler created in 1796 by a twelve-year-old girl, apparently in New York (fig. 13), the artist has incorporated a quote of her uncle's shrewd and cynical words with regard to the fact that one cannot change one's Jewish identity: "If you think you can be a little bit Jewish, you think you can be a little bit pregnant." The contrast between the visual relationship of the couple and the picturesque image of "a little bit pregnant" makes the uncle's words all the more extreme.[55]

The parents' generation is represented, for example, in quotes relating to states of assimilation. The piece quoting the artist's mother, Hilda Reichek (fig. 11), includes the following:

> Don't be loud.
> Don't be pushy.
> Don't talk with
> Your hands. — H.R.

developed a secular identity, as expressed, for example, in this quote from a Jewish newspaper: "Three generations rejoiced: The old – over the Torah, the middle-aged – over the business page in the newspaper, the young – over the sport page," quoted in Deborah Dash Moore, *At Home in America: Second Generation New York Jews* (New York, 1981), 10.

54 For example, Nancy Mary Lindley, *Sampler*, silk and cotton on linen, 1800–25, 40 × 40 cm. National Museum of American History, Washington.

55 Obviously, the image of the couple on either side of the tree is influenced by the common sampler pattern of Adam and Eve. I would also like to mention that Shmuel Rajczyk, Elaine's great-grandfather, briefly tried

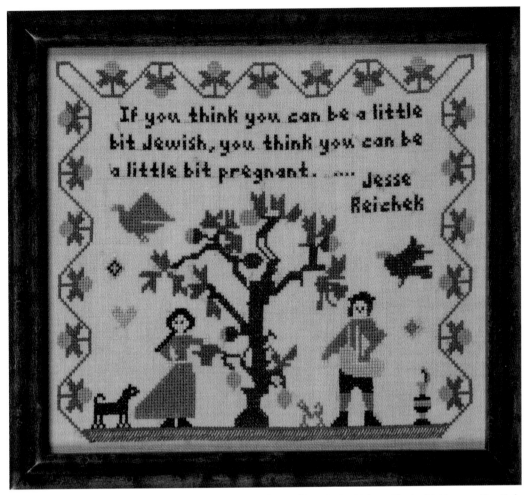

Fig. 12. Elaine Reichek, *Untitled (Jess Reichek)*, 1993, embroidery on linen, 31.6 × 34.8 cm. The Jewish Museum, New York. Photo © The Jewish Museum, New York / Art Resource, NY

Among the pieces quoting from the artist's generation, there is a noticeable tone of criticism regarding the education provided by their parents. Some of the quotes make use of irony, for example:

As a child I fell off the merry-go-round
at Coney Island. My parents were very
disappointed. They knew I'd never be
part of the horsy set.

The longing of the parents' generation to merge into the aristocratic social milieu is expressed in the texts.

working on an agricultural farm in Connecticut, but after discovering how difficult it was to maintain an ultra-Orthodox religious life there, left and moved to Israel, where he is buried. Author's electronic interview with Morton Reichek, 13 Dec. 2005.

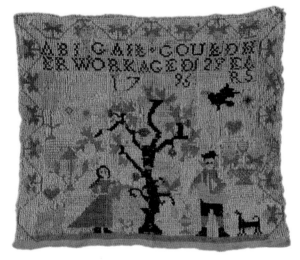

Fig. 13. *Sampler* (Abigail Gould), 1796, linen plain weave embroidered with silk and wood, 25 × 30 cm. Photograph © 2014 Museum of Fine Arts, Boston. Gift of Miss Jeannette Woodward

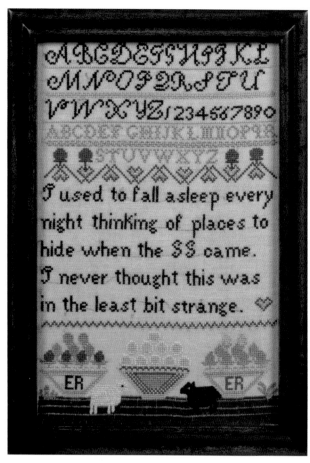

Fig. 14. Elaine Reichek, *Untitled (Elaine Reichek)*, 1993, embroidery on linen, 38.1 × 26.7 cm. The Jewish Museum, New York. Photo © The Jewish Museum, New York / Art Resource, NY

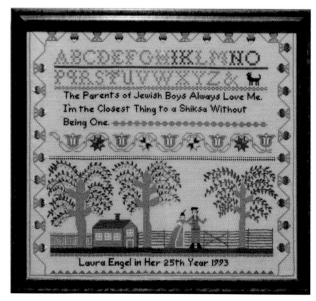

Fig. 15. Elaine Reichek, *Untitled (Laura Engel)*, 1993, embroidery on linen, 47.3 × 52.1 cm. The Jewish Museum, New York. Photo © The Jewish Museum, New York / Art Resource, NY

It is noticeable that the intermediate generation has internalized this longing, and at the same time is collapsing under the pressures that it dictates. In this context I would like to mention that Dash Moore, in relating to the success of the synthesis that the parents' generation made between Jewish life and American culture, claims that their children did not even notice the differences. In their eyes, even the overcrowded furniture in their parents' home was an expression of the synthesis of the Jewish middle class.[56] The exhibition space, reflecting the artist's memories of her home, was also connected to her own quote embroidered on one of the pieces (fig. 14):

> I used to fall asleep every
> night thinking of places to
> hide when the SS came.
> I never thought this was
> in the least bit strange.

This quote, which brings awareness of the Holocaust into the arena of Jewish identity in the United States, reflects a different content that penetrated and took root in the consciousness of her generation. Through the atmosphere of complete assimilation and social confidence that the parents' generation tried to project, the members of the artist's generation absorbed the differences of identity and sense of separateness. Sometimes, this awareness was sufficient to establish the presence of their Jewish identity. Lederhandler quotes Nathan Glazer as saying: "the historical drama shaped a community intensely conscious of its Jewishness."[57] Here too, the patterns chosen are typical of the sampler, and the letters, abundant bowls, and sheep demonstrate a youthful and naive pastoralism that contrasts with the sense of fear arising from the text.

The children's generation is represented in the exhibition by a quote from the artist's daughter Laura. The form of the image appearing alongside the quote (fig. 15) depicts another accepted pattern of a couple standing alongside their home.[58] The clothing of the couple and the size of the house in this pattern usually

56 Dash Moore, *At Home in America*, 10.
57 Lederhandler, *New York Jews*, 61.
58 Colby, *Samplers Yesterday and Today*, 82.

reflect a respectable status. The source for this work is taken from a piece made in Pennsylvania in 1779.[59] Laura's quote:

> The Parents of Jewish Boys Always Love Me.
> I'm the Closest Thing to Shiksa Without
> Being One.[60]

In the words of the children's generation we notice an awareness of the ingrained views of Judaism, such as the outward appearance of the Jewish girl. It is noticeable that the children have internalized the merging processes of their grandparents' generation, as well as the searching awareness of their parents. Their ability to use self-humor indicates acceptance and fulfillment.

The fact that Reichek did not choose samplers made by Jewish girls as sources for her work fits the subject of the exhibition. The assimilation of the Jews into American society and reconstruction of the cultural history of this society could not have been clarified had she done this. The comparison that I have made here is intended to point out the act of appropriation as an expression of assimilated Jewish identity.

Public Words – Private Rooms

Another part of Reichek's exhibition contains a bed, with additional quotes emphasizing the introduction of external American world views into the domestic space, as part of the same yearning for merging. The quotes have been taken from American leaders and are written on the furniture itself (fig. 16). The structure of the texts on the bed creates a triangular composition. The headboard and footboard carry contrasting inscriptions. The quote of George Washington is taken from a letter he wrote to the Jewish community in 1790, in which he emphasizes American tolerance towards different groups.[61] It is contrasted with a sentence in which President Richard

Fig. 16. Elaine Reichek, *A Postcolonial Kinderhood* (details), 1995. Wexner Center for the Arts, The Ohio State University, Columbus, OH

Nixon refers to the radical group, the Chicago Seven, saying: "Aren't the Chicago Seven all Jews?" This sentence summarizes the ambivalent relationship that prevailed between him and the Jews in America.[62] The contrast between the two approaches both incorporated within the colonial style bed represents the limitations

59 Catharine Spangler, *Sampler*, 1779, embroidery on linen, 40 × 45 cm., Philadelphia Museum of Art.

60 Yiddish: a non-Jewish girl or woman.

61 "May the children of the Stock of Abraham, who dwell in this land, continue to merit and enjoy the good will of the other inhabitants, while everyone shall sit in Safety under his own vine and fig tree, and there shall be none to make them afraid." George Washington, "Letter

to the Hebrew Congregation Newport," August 1790, in *The Papers of George Washington*, Presidential Series, vol. 6, ed. Dorothy Twohig (Charlottesville, 1996), 285.

62 Despite the fact that many of the president's close acquaintances were Jews, this impression accompanied him throughout his entire term. See Herbert S. Parmet, *Richard Nixon and His America* (Boston, 1990), 631–33.

of the process of merging and absorption. Consequently, the sentence embroidered in the middle of the bed, "Was willst du von meinem Leben?" (German for "What do you want of my life?"), expresses, more than anything else, a feeling of helplessness and actually produces the image of a Procrustean bed. The choice of German illustrates Reichek's connections with her husband's family. While her own parents' families were part of the migration from eastern Europe, her husband's family was among the German Jews who arrived in the USA in the middle of the nineteenth century. In many senses, they represented a more American identity, educated, cultural, and secular, and more deeply rooted in the local culture.[63] The folksy nature of the sentence reflects a spontaneous expression of helplessness as to the possibility of making a decision. The German language represents the Diaspora Jewish identity and the direct and private truths spoken within the group.

The quote that could serve as the motto of the entire exhibition is embroidered on the seat cushion of the relaxing rocking chair:

> "Jews are the intensive form of any nationality whose language and customs they adopt" (Emma Lazarus).[64]

The fact that this sentence by Emma Lazarus is cited here represents a combination of social acceptance and the preservation of national identity, and not only by virtue of the fact that her poem is quoted at the foot of the Statue of Liberty. The text included in the exhibition is taken from *An Epistle to the Hebrews* (1882), which she wrote following the waves of Jewish migration from eastern Europe and her awareness of incidences of anti-Semitism. The lines denote Jewish identity as being characterized by a complete blending with its environment, and therefore what is sometimes presented in the exhibition as exaggerated yearning turns out to be a familiar ethnic sign.

My intention in this article is to bring together contemporary art with much earlier and older art. This compelled collaboration is not trivial and is uncommon in academic writing, which has a tendency to be very focused and usually neglects historical comparisons of this kind. As mentioned previously, my intention in choosing this method was derived from the essence of contemporary artworks and influenced by the pattern in which contemporary art refers to the research perspective as well as to the critical observation upon the history of culture. I hope that despite this, the world of research will benefit from this article.

Reichek's choice to present the viewpoint of the young embroidery student represents a naive position that is considerably influenced by traditional, gender-based, ethnic, national, and other perceptions. This perspective enables a greater degree of accessibility and identification, which leads to the development of a focus on the artist's personal identity. The girl's signature on the sampler piece reflects the artist's presence and the signs of her identity, and suits the form of the quotations appearing in Reichek's work. Unlike the traditional, ethnic, and religious voice of the embroiderers, dictated by the system of education of the period, her work expresses personal voices.

The comparative association presented in this article, inspired by the process created by Reichek, indicates processes of cultural merging that have always been typical of Jewish culture. By focusing on work belonging to the pedagogic space, I have tried to sharpen this awareness. I feel that the fact that this is one of the only times in which Hebrew writing appears on items that are not ritual objects is worthy of attention. The young girls, learning to read Hebrew in order to say their prayers, encountered their Jewish identity through embroidery. Reichek also encountered this identity in her embroidered pieces, even if they did not include a single Hebrew letter.

63 Much has been written about the differences between the migration from Germany and the later migration from eastern Europe. See, for example, Arthur Hertzberg, *The Jews in America: Four Centuries of an*

Uneasy Encounter (New York, 1989), 102–12.

64 Emma Lazarus, "Letter IV," 1882, in id., *An Epistle to the Hebrews*, with an introduction and notes by Morris U. Schappes (New York, 1987), 21.

The Restoration of Loss:
Jechezkiel David Kirszenbaum's Exploration
of Personal Displacement

Caroline Goldberg Igra

Slumped forward with head in hand, eyes wide with both acceptance and resignation, the figure in J.D. Kirszenbaum's *My Tears Will Become a River* (fig. 1) carries the burden of an entire generation. The plight of this individual, obviously of Jewish faith with long beard and skull cap, is accentuated by his forward placement – pressed to the very edge of the frame. The viewer has no room to escape from his misery. The vague sea of figural clusters scattered across the background of the image emphasizes that this figure represents only one among hordes of individuals experiencing the same kind of displacement and loss. The common plight of these individuals – children and adults alike, dressed in similarly nondescript overcoats and noted shuffling along in an undefined landscape with no distinct destination – is indicated by the unifying effect of the artist's undulating brushstrokes.

This depiction of the experience of the exiled extends far beyond an explication of physical discomfort to encompass the emotional cost of displacement. The male figure singled out for our notice evokes the yearning for salvation shared by all. His direct, clearly discouraged appeal to the viewer recalls something of that emotion described in Psalm 137: "By the rivers of Babylon, there we sat down, yea, we wept, when we remembered Zion." Painted in 1945, at the end of World War II and the Holocaust, this work marks the beginning of a long period of personal recovery and healing for the Polish artist. Just returning to Paris after years of hardship in various work camps in southern France, Kirszenbaum (1900–1954) discovered that his studio had been plundered and most of his works had been destroyed – effectively erasing decades of artistic development. If that weren't enough,

he received the devastating news that his wife Helma, who had been sent to Auschwitz at the beginning of 1944, was never to return.

My Tears Will Become a River represents one aspect of the artist's programmatic exploration of the subject of loss:

Fig. 1. *My Tears Will Become a River*, 1945, oil on canvas, 100 × 75 cm, unknown location. All works reproduced in this article are by Jechezkiel David Kirszenbaum, unless otherwise indicated.

a body of work exhibiting both stylistic and emotional development as it traverses both periods of time and the limits of reality. Included are images that recall the past as if a dream world, distinctly removed from reality, in which instead of the Jews being forced out and persecuted the Messiah arrives to save the day; those that capture the gritty experience of displacement and perpetual movement through depictions of people being shuffled from one place to another, abandoned in indistinct and unfamiliar environments, completely displaced from their natural habitats; and finally those who retreat to the world of the Old Testament where the prophets, as we are told, overcame their disappointments and loss through fortitude of belief.

Staszów to Dessau – Berlin to Paris – Brazil to Morocco and back to Paris: Jechezkiel David Kirszenbaum's itinerant lifestyle, including stops within major European cities and several continents, did not differ significantly from that of many of his generation. The events which unfurled in the early twentieth century and culminated in the official rise of the Nazi regime in the early 1930s forced hordes into a vortex of movement – compelling them to seek refuge again and again and again. Kirszenbaum's peripatetic lifestyle, however, was equally driven by a desire to develop an artistic inclination thwarted by the limited opportunities available within his own homeland. This internal stimulus, occurring at a time when the oppressive local atmosphere encouraged departure, resulted in the permanent separation from the world of his forefathers.

Nevertheless, no study of Kirszenbaum's oeuvre, full of reminders of his roots, can be complete without an understanding of the environment into which he was born. By the middle of the nineteenth century life for Jews in Staszów, located 120 kilometers northeast of Cracow, was virtually untenable. Although in present-day Poland, Staszów had changed hands continually at that time; part of the Austrian Empire in the late eighteenth century until the Congress of Vienna, it then became Congress Poland, a Russian protectorate. The official regime established measures that severely curtailed the ability of Jewish residents to run effective businesses, and the economic conditions under which they lived plummeted. Although Jews were actually the majority of the population in Staszów by 1886, the growing resentment of the regime made their life unbearable, and by 1913 the Jewish population had dwindled to 7634 – slightly more than half of the total population.[1] Desperate to escape this oppression and find a venue that would satisfy his artistic curiosity, all documented within a journal kept by the artist in his native Yiddish, Kirszenbaum fled Poland in 1920.[2]

The intolerable discrimination he experienced during the following years, which forced him to move from one European city to another, ironically provided him with exposure to the most avant-garde schools of art – providing both a wealth of inspiration as well as the stimulus for the later development of a personal iconography of loss. This journey began in the early 1920s when he established himself at the Bauhaus in Weimar. There Kirszenbaum was fortunate to work side by side with cutting-edge artistic figures such as Wassily Kandinsky, Paul Klee, and Lyonel Feininger. Within a very short time his circles had broadened and he was in contact with a group of German expressionist artists in Berlin, including representatives of Die Pathetiker such as Ludwig Meidner and Jacob Steinhardt. The Polish artist was more comfortable with the expressionistic mode they embraced[3] than with the

1 Nathan M. Gelber, "Le-toldot ha-yehudim bi-Stashov" (History of the Jews of Staszów), in *Sefer Staszow* (The Staszów Book), ed. Elhanan Ehrlich (Tel Aviv, 1962), 25–35 (Hebrew). Jews were 57 percent of the population of Staszów by 1913.

2 Jechezkiel D. Kirszenbaum, "Yaldut u-n'urim bi-Stashov" (Childhood and Youth in Staszów). Original Yiddish was translated into Hebrew by M. Halamish and appeared in the Hebrew journal *Al Ha-Mishmar*, 2–9 Sept. 1955; reprinted in *Sefer Staszow* (The Staszow Book), ed. Elhanan Ehrlich (Tel Aviv, 1962), 221–29. Translated from Hebrew into

English by Dr Leonard Levin with the assistance of Dr Dobrochna Dyrcz-Freeman; reprinted in *J.D. Kirszenbaum (1900–1954): The Lost Generation*, eds. Caroline Goldberg Igra and Nathan Diament (Paris, 2013), 128–69.

3 Although there was some discussion that Kirszenbaum would stay on at the Bauhaus as a teacher, his artistic inclination toward Expressionism, which had been the vanguard earlier in the century, clashed with the new movement toward linear abstraction espoused by Kandinsky. See Caroline Goldberg Igra, "Kirszenbaum's Artistic Journey," in

Ars Judaica 2014

more abstract one becoming popular at the Bauhaus[4] and soon enough he had established himself among those artists of similar artistic inclination who were lining the walls of the new Der Sturm art gallery.[5]

This early period in Germany was one of extraordinary development for Kirszenbaum. During this time he developed a main line of work by providing illustrations for the local press[6] under the assumed pseudonym of Duvdivani, "Cherry Tree" in Hebrew. He also participated in several exhibitions both in Germany, for example the Juryfreie Kunstaustellung of 1929 in Berlin, and abroad, such as one in Utrecht in 1931. Unfortunately it wasn't long before the political instability of the region, which had earlier compelled him to leave his homeland, again disrupted his personal and artistic development. When the Nazis came to power in 1933 Kirszenbaum, whose work was considered "degenerate" because of its expressionistic style, was forced to seek refuge elsewhere.[7] He and his new wife Helma left all of their belongings behind and fled to Paris.

Again, this desperate escape, with the painful loss of the new career he was just beginning to develop in Berlin, resulted in an extraordinary artistic opportunity. The City of Light offered an excellent environment for this still-developing artist, and indeed, Kirszenbaum's first years in Paris were marked by exposure to a range of styles by avant-garde artists including Georges Rouault, Marc Chagall, and Chaim Soutine. The artist flourished in Paris, participating in many major exhibitions (including the Salon d'Automne and the Salon des Surindependants) and gaining genuine renown.[8]

His relationship with individuals in the School of Paris was not limited to mutual artistic affinities but rather included an understanding based on their shared status as foreigners seeking refuge. Whether recent arrivals or ones who had arrived closer to the beginning of the century, many of the artists within the School of Paris had left their native eastern European towns for reasons similar to those of Kirszenbaum: either looking for an environment in which they could develop their artistic interests or escaping persecution and seeking refuge.[9] Mass immigration to Paris in the early twentieth century had been spurred by increasingly difficult conditions for Jewish residents in the East. Escaping extreme anti-Semitism and pogroms, as well as the humiliation and human suffering which were part and parcel of it, many eastern European Jews sought refuge in Paris.

Although in some cases a sanctuary, Paris in 1933 was not the welcoming place it had been earlier in the decade. In fact, the number of anti-Semitic publications rose dramatically around this time and there was general acknowledgement of a "Jewish Problem."[10] This shift was markedly felt in the art world. Critics, who had formerly supported Jewish artists such as Kirszenbaum, began to reverse their position and disdain them, even going as far as to indicate some kind of degeneracy in their work. Waldemar George, for example, a major proponent of many Jewish School of Paris artists until the early 1930s, began to distinguish between "genuinely" French art, such as that by Chardin and Poussin, and that by artists from the Montparnasse circle. By the mid-1930s his embrace

J.D. Kirszenbaum (1900–1954), 49. See also Frédéric Hagen, *Catalogue de l'exposition J.-D. Kirszenbaum*, galerie Karl Flinker, Paris, 7–28 février 1961, 28.

4 Despite his obvious partiality to an expressionistic style, several works from this period indicate his interest in more abstract approaches including cubism. See, for example, *Studying the Rambam*, from 1925. His purposeful incorporation of a cubist style in a work with a Jewish theme parallels much of the efforts of the artists such as Ryback and Lissitsky, involved in the Kultur-Lige's attempt to develop some kind of Jewish modernism in Russian art just a few years earlier.

5 See Inna Goudz, "Herwarth Walden und die jüdischen Künstler der Avantgarde," in *Der Sturm-Zentrum der Avantgarde* [catalogue, Von der Heydt-Museum], II: *Aufsätze* (Wuppertal, 2012), 533.

6 Kirszenbaum published caricatures in a number of publications, including *Berliner Tageblatt*, *Der Rote Pfeffer*, *Magazin fur Alle*, and *Der Querschnitt*.

7 It is unclear whether his membership in the Communist alliance, Revolutionarer Bildender Kunstler (ASSO-BRBKD-ARBKD), had anything to do with this assignation.

8 His name appears repeatedly within the art criticism of the period; see A.B., *Echo de Paris*, 3 Nov. 1933; R. de Roudine, "Salon d'Automne," *Agence Havas*, 6 Nov. 1936; Dolce, *Beaux-Arts*, 2 Nov. 1934; "Salon des Surindependants," *Beaux-Arts*, 14 Oct. 1938.

9 See Nadine Nieszawer, Marie Boyé, and Paul Fogel, *Peintres juifs à Paris: École de Paris, 1905–1939* (Paris, 2000), 14.

10 Romy Golan, "In Defense of French Art," in *Modernity and Nostalgia: Art and Politics in France between the Wars* (New Haven, 1995), 153. See also Ralph Schor, *L'Opinion Française et les étrangers en France 1919–1939* (Paris, 1985).

Fig. 2. *Seated Peddler*, oil on canvas, 30 × 20 cm. Family Collection

of Nazi morality resulted in a publicly documented search for a solution to the "Jewish Problem."[11]

Despite the unsettled environment, this group of transplanted eastern European Jewish artists flocked together, sharing the common experience of being uprooted and attempting to reestablish oneself in a new environment.[12] In some cases this led to the creation of works focused on individuals forced to live on the edges of society. Soutine, for example specifically painted portraits of people "living on the margins": people who would never be part of mainstream Parisian life, such as immigrants like himself.[13] Unfortunately, due to the loss of most of his oeuvre through the destruction and looting of the Nazis, it is unclear to what extent Kirszenbaum focused on local Parisians or other immigrants like himself. The few

examples that do exist, including *Seated Peddler* (fig. 2), indicate that he, too, was interested in exploring this genre.

The instigation for Kirszenbaum's expressive explorations of loss no doubt emerged from that experience shared with certain of his artistic associates in Paris. Although realistic recollections of the life left behind within the oeuvre of School of Paris artists are limited in number, many expressive examples exist among their joined oeuvre. Indeed, several of these displaced artists, most significantly Chagall, painted specifically Jewish subjects in an attempt to express their emotional attachment to the past from which they had fled. There is significant indication that it was the effect of displacement, and the earlier need to escape, which accounted for the tendency toward Expressionism among artists of the School of Paris. The common existential difficulty experienced within this group of uprooted and hounded artists may account for the intense spirituality of their works.[14] There is no question that it was at this point in his career, after establishing himself within this particular environment, that Kirszenbaum actually felt able to explore his own loss. According to the works left behind, one can date the exploration of his own personal journey to the period immediately after his arrival to Paris.

Kirszenbaum's interest in exploring his Jewish roots at this time was probably stimulated by specific projects begun in Paris, including illustrating stories by classic Yiddish writers such as Mendele Mokher Sefarim (Shalom Y. Abramovich), Yitzhak Leib Peretz, and Shalom Aleichem. His attraction to these projects, beyond the occasion they presented to create visual parallels to words,

11 Waldemar George, "L'Art et le National-Socialisme," *La Revue Mondiale* 8 (15 November 1933): 38–40. Waldemar George's critique of Kirszenbaum is especially interesting in light of his Jewish heritage. See Yves Chevrefils Desbiolles, "Le critique d'art Waldemar-George: Les paradoxes d'un non-conformiste," *Archives Juives* 41, 2 (2008): 101–17. It should be noted that following the war Waldemar George did an about-face and changed his tune, adopting a less anti-Semitic tone indicative of his rehabilitation.

12 Golan, "In Defense of French Art," 153.

13 Ibid., 146.

14 Yves Kobry, "C'est leur conjonction, leur confluence qui dessine les contours d'une peinture spècifiquement juive" (Paris, 1992), in Nieszawer, Boyé, and Fogel, *Peintres juifs*, 24.

Fig. 3. *The Jewish Villagers Greeting the Messiah*, 1937, oil on cardboard, 59 × 69 cm. Bequest of the artist through B. Alix de Rothschild, Paris, collection of The Israel Museum, Jerusalem, Photo © The Israel Museum by Elie Posner

no doubt stemmed from the opportunity they offered to nostalgically recall his former life in the *shtetl*. And indeed, although his earlier work had been replete with descriptions of events and ceremonies of life in Staszów, populated by peddlers, craftsmen, tradesmen, musicians, porters, Hasidim, and those who studied the Torah, the works from the mid- to late 1930s soon began to assume

a more nostalgic, fantastic, and dreamy appearance.[15]

By the mid- to late 1930s Kirszenbaum's attempt to "remember" the life he had left behind on the painted canvas resulted in a series of semi-realistic, semi-fantastic images of the arrival of a Messianic figure to his native Staszów. One excellent example is *The Jewish Villagers Greeting the Messiah* (fig. 3) from 1937.[16] In this work the

15 Goldberg Igra, "Kirszenbaum's Artistic Journey," 60.
16 Cecil Roth, *Jewish Art: An Illustrated History*, rev. ed. (Jerusalem 1971),

251–52; *The Jews: A Treasury of Art and Literature*, ed. Sharon R. Keller (New York, 1992), 318.

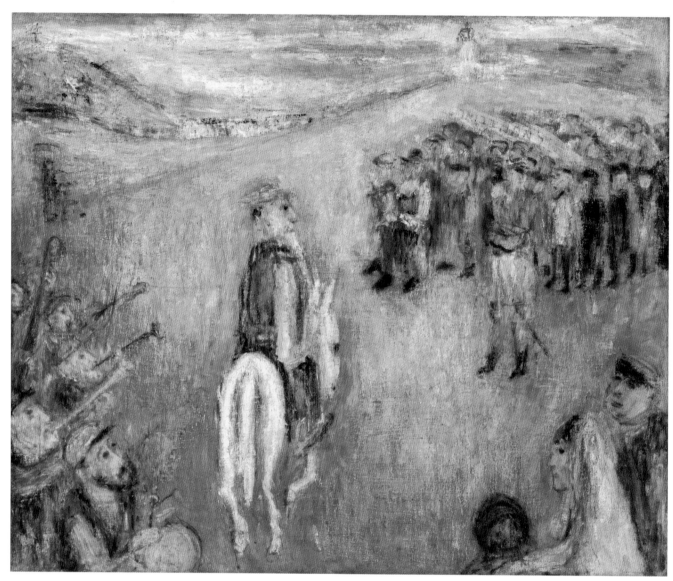

Fig. 4. *Messiah's Arrival in the Village*, 1939, oil on canvas, 60 × 75 cm. Family collection

artist describes the Messiah's arrival to Staszów in the form of a Hassid riding on a white donkey. In one hand he holds a bag with *tefillin* (phylacteries), in the other, the reins. Peeking from the saddle bag is an embroidered bag with the 613 Commandments, the statement and principle of law and ethics found within the five books of Moses. In his memoirs Kirszenbaum describes how he was especially drawn to these at a young age: "The only interest that was awakened in me in my studies in ḥeder

17 Kirszenbaum, "Yaldut u-n'urim bi-Stashov," 1, reprinted in J.D. Kirszenbaum (1900–1954), 129.

was for the marvelous tales of the Ḥumash."[17] The Messiah is met at the local train station by an official representative of the regime in full dress uniform. Across the canvas are a group of Hassidic rabbis. Several individuals among the townspeople hold welcoming signs up in the air, hoping to get the attention of the arriving savior. A general feeling of energy and excitement is created by patches of glowing color and open, hopeful, facial expressions.

In 1939 Kirszenbaum depicted an image very similar to that noted above titled *Messiah's Arrival in the Village* (fig. 4). Here the arrival is literally trumpeted by a group of musicians depicted on the left edge of the canvas.

Fig. 5. James Ensor, *Christ's Entry into Brussels in 1889*, 1888, oil on canvas, 99 1/2" × 169 1/2". The J. Paul Getty Museum, Los Angeles, Photo: © 2013 Artists Rights Society (ARS), New York / SABAM, Brussels

Counterbalancing this group, in the right hand corner, is a group of welcoming individuals including a small family composed of mother, father, and child. Although this work is a bit less "immediate" than its predecessor, the action being depicted at a slightly larger remove from the viewer, it manages to more accurately represent who was waiting back in the *shtetl*: rabbis, musicians, embracing townspeople, and families. Accordingly, the emphasis here is more on who stayed behind than who was coming (the Messiah himself).

Interestingly enough, Kirszenbaum actually described a prototype for this "messiah" in his written memoirs. There he describes Rabbi Motele, the grandson of Rabbi Mordecai of Chernobyl, a man who had made a great impression on him.

He was a frail Jewish man, short of stature and limping on one leg. But his colored silk underwear, which served him as trousers, was clean; the cut of his robe had a distinctive pattern; and it was also made of pure colored silk. He had a small face, framed by a little white beard. On his short nose were set spectacles with thick glasses, behind which radiated two rays that resembled the sun's rays – his two eyes. People said that this was the only Tzaddik on whom one could see God's presence resting visibly.[18]

The Messiah depicted by Kirszenbaum in these images shares many characteristics with this figure from his past.

A possible visual source of inspiration for Kirszenbaum's Messiah images is Belgian artist James Ensor's *Christ's Entry into Brussels in 1889* (fig. 5), a large-scale religious pageantry painting dating from 1888 that was very well-known at the time. Ensor's work also focuses on the reception of the Christian Messiah by the local crowds. Kirszenbaum's eastern European, *shtetl* version of Ensor's painting indicates his comprehension of the desperate search for the Messiah amongst displaced Jews in the face of the growing threat of the Nazi regime. There is no question that the repeated appearance of the theme within Kirszenbaum's oeuvre indicates its significance as a means for coping with his sense of loss.[19]

A source for the particular mixture of reality (the local figures) and the fantastic (the entry of the Messiah)

18 Ibid. 2, reprinted in *J.D. Kirszenbaum (1900–1954)*, 131.
19 Another work on the theme is: *Messiah's Arrival to the Village*, 1946, oil on canvas, 60 × 75 cm, Family collection; see Goldberg Igra, "Kirszenbaum's Artistic Journey," 65.

might be found in the nearly contemporary work of Marc Chagall. This artist, as noted in his *I and the Village*, 1911 (fig. 6), also depicted *shtetl* life, as left behind in his native Russia with a dreamy, spatially unrealistic, and expressive style incorporating a minimum of realistic detail.[20] There is no question that there are similarities between the oeuvre of these two artists, both instilling their folkloric and Hassidic subject matter with an extremely dreamlike character that departs from the confines of realism.[21]

Like Chagall, Kirszenbaum's reflections on the life he had left behind quite often departed from reality, filtered through his experience of loss and feelings of nostalgia. This

20 Chil Aronson, *Bilder un geshtaltn fun Monparnas* (Scènes et visages de Montparnasse) (Paris, 1961), 425 (Yiddish).

21 The influence of Chagall on Kirszenbaum was well acknowledged at the time but by 1933 critic Ernst Collin, reviewing Kirszenbaum's exhibition at the Galerie F. Weber, suggested that the Polish artist's work had moved on to incorporate its own individualistic expression; see Ernst Collin, "J.D. Kirschenbaum in der Galerie F. Weber," in *Ausstellungskatalog der Galerie F. Weber* (Berlin, 1931), Bauhaus-Archiv, Inv.-Nr. 2239, cited in Goudz, "Herwarth Walden," 535.

Fig. 6. (Above) Marc Chagall, *I and the Village*, 1911, oil on canvas, 192.1 x 151.4 cm. Mrs. Simon Guggenheim Fund, © 2013 Artists Rights Society (ARS), New York / ADAGP, Paris, Photo © The Museum of Modern Art/ Licensed by SCALA/ Art Resource, NY

Fig. 7. (Left) *There Is No Place for Jews in Our World*, oil on canvas, 33 x 40 cm. Private collection

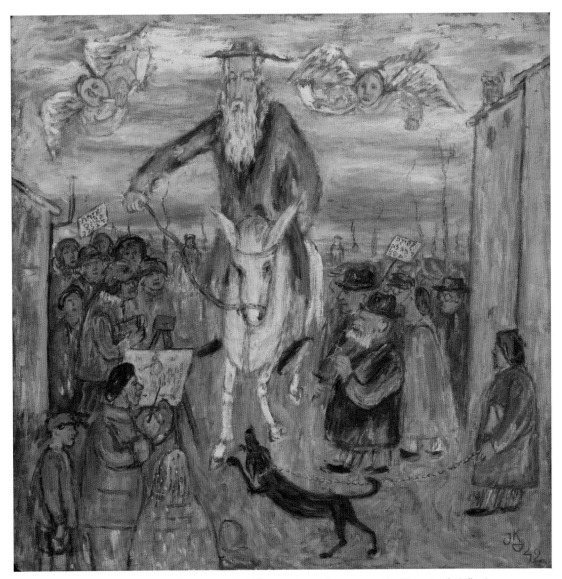

Fig. 8. *Messiah and Angels Arriving in the Village*, 1942–44, oil on canvas, 40 × 45 cm. Family Collection
Fig. 9. (Next page) *Wandering Jews*, 1938, oil on canvas, 65 × 85 cm. Bequest of the artist through B. Alix de Rothschild, Paris, collection of The Israel Museum, Jerusalem, Photo © The Israel Museum by Elie Posner

is noted in *There Is No Place for Jews in Our World* (fig. 7), wherein a winged angel lifts two displaced figures to the sky holding one over her right shoulder, tightly gripping his bag of belongings, and another by his suspenders.[22] This figure is obviously doing her utmost to save whom she can, her goodness as guardian angel emphasized by the manner in which her luminous white dress glows in contrast with the creamy, deep blue of the background sky. Despite the image's obvious departure from reality the artist is careful to base the two local figures delineated on his recollection of reality in the *shtetl*. And, indeed, the

refugees depicted resemble other displaced figures that appear throughout his oeuvre.

Within Kirszenbaum's development of the theme of the Messiah is an image that departs even further from the three-dimensional reality presented in the former two examples. *Messiah and Angels Arriving in the Village*, 1942–44 (fig. 8) most definitely indicates not only the

22 The defiance of laws of strict perspective again indicates the artist's acquaintance with the formally flexible artwork of Chagall; see Collin, "J.D. Kirschenbaum."

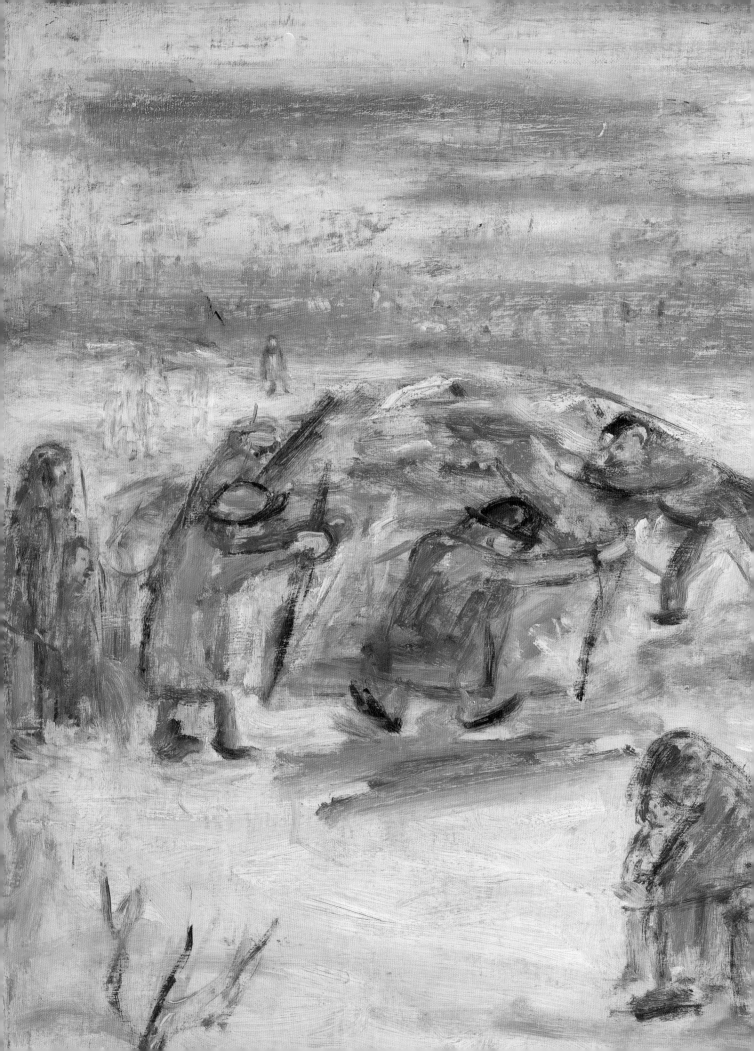

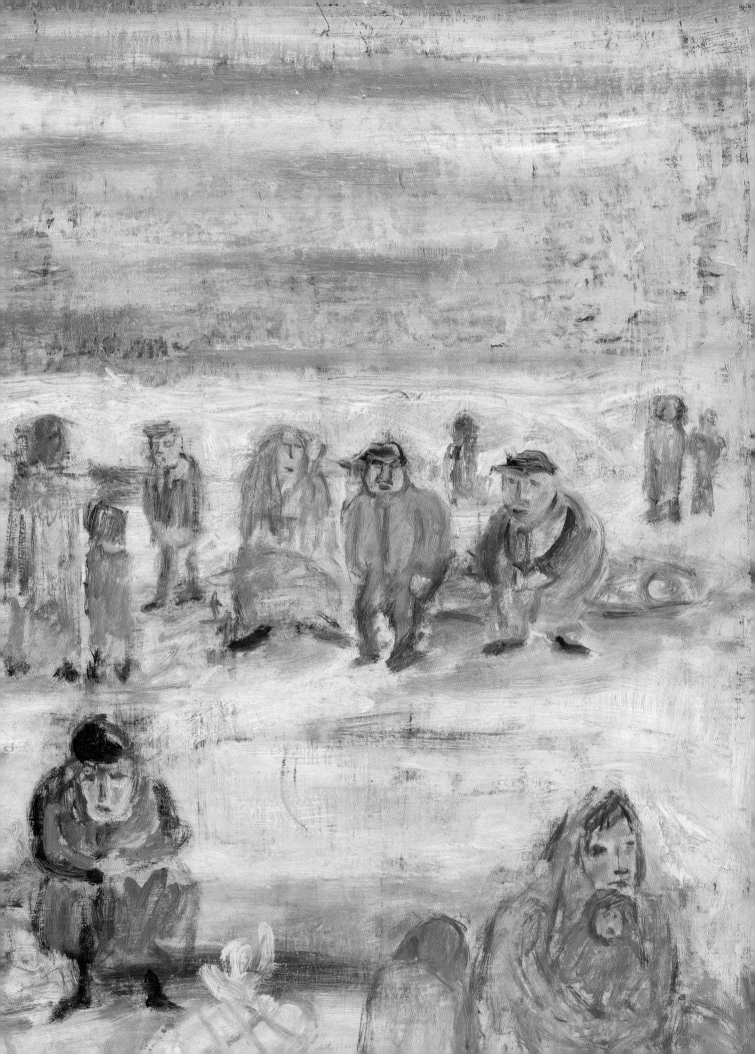

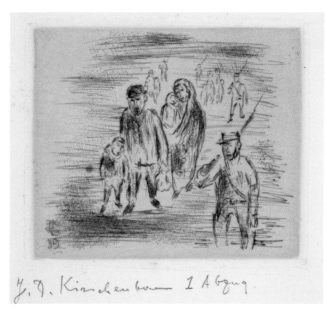

Fig. 10. Exodus series: *Fleeing*, 1939, engraving, 9 × 12 cm. Family collection

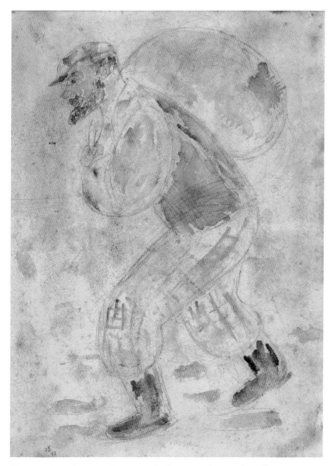

Fig. 11. *Man Carrying Bag on His Back*, watercolor. Family Collection

artist's own attempt to describe an *otherworldly* presence with an *otherworldly* style but furthermore, his awareness of contemporary artistic innovation in Paris. Here the Messiah, seated on a donkey, is depicted at the center of the image, literally parting the crowds of welcoming figures from left to right, reminiscent of the biblical parting of the Red Sea. There is a sense that he is actually floating upward towards a group of accompanying angels, his physical presence no longer adhering to any terrestrial or logical conception of space.

As noted earlier, the artist makes a point of incorporating striking notes of expressive realism within these spatially untenable and almost fantastic settings. The villagers and the Messiah himself wear customary head coverings, and a singularly earthly figure, a small dog, takes center stage; nevertheless, lest we forget that the whole concept of the Messiah returning to the *shtetl* is a fantastic one, this mundane creature's description also departs from standard spatial expectation. Depicted in silhouette, without any shading or indication of depth, the dog's sinuous body seems to reach upward towards the Messiah instead of assuming a more spatially-correct stance beside him. True to contemporary artistic innovation in Paris, any sense of standard spatial accuracy has obviously become less essential to the artist; instead, his goal is to express the ethereal, unearthly aspect of the Messiah and the effect of his miraculous arrival on the locals.[23]

In this series of images the artist has stylistically joined his nostalgic memory to his deep sense of loss and desperate hope. In many ways the series resembles what is known as "forgetful memory": that interruption of the fabric of memory caused by an event that it can't contain or handle. Michael Bernard-Donals explains that

> Forgetful memory doesn't retrieve the lost event; instead it produces what might be called a memory-effect, a sense of displacement that disrupts the viewer's ability to construct any narrative of, or to

23 Although the similarity between the artists' work was commented upon in the contemporary press, their differences were also carefully delineated. See *Chronica Israelite*, 31 May 1948 and Jean Rousselot, "Kirszenbaum, peintre de l'âme juive," *L'Esprit*, 19 June 1947.

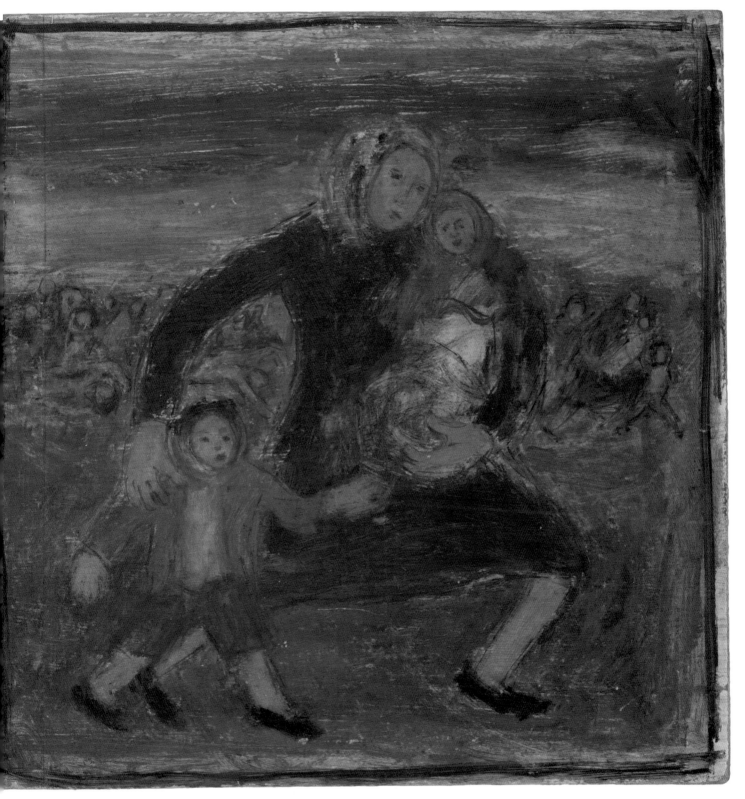

Fig. 12. *The Exodus of Mother with Two Children,* 1945, oil on cardboard, 37 × 37 cm. Family Collection

sympathize with, the object of the image at all. Far from offering historians and other writers a glimpse of the event, it confounds writing and forces them to grapple with what resides at both the images', and writing's, margins.[24]

Although originally developed to answer a phenomenon noted in literature, this theory can also account for those works by Kirszenbaum that feel dreamed up and removed from any actual lived reality despite simultaneously reflecting the artist's childhood in Staszów and subsequent displacement.

In addition to serving the role of a forgetful memory, Kirszenbaum's imagery of the return of the Messiah is resoundingly hopeful. Replete with numerous reminders of his personal belief that somehow, in the end, some form of salvation could be reached, some return to normalcy achieved, it remains ever positive. Overall, the images are bright in palette, overcoming the tendency to record the *shtetl* as a neutral-toned or colorless place, and they are peopled with the ever hopeful faces of those at hand to welcome the Messiah as he arrives on his donkey, their faith in salvation never flagging. Perhaps with the intent of ensuring our understanding that this dream was very much his own, Kirszenbaum included a depiction of himself in one of the images. In the left-hand, bottom corner of *Messiah and Angels Arriving in the Village* (fig. 8) the artist is shown at his easel, palette in hand, actively witnessing this momentous event. This Polish outcast counted his own self among those eagerly awaiting the arrival of the Messiah.

Kirszenbaum's nostalgic imagery of the individuals left behind in the *shtetl* never departs entirely from reality. In fact, although a "forgetful memory," significantly altered by his experience of great loss, it consistently remains anchored in the reality he knew first hand; consistently including depictions of the people of the *shtetl* – whether musicians, rabbis, or family members. Acutely aware of the loss and displacement of both his family and hordes of others, the artist developed his own very in-depth and personal study of this subject.[25] Much harsher and biting, reflecting almost no hope and very great loss, the body of work analyzed here, dating similarly to that of the return of the Messiah from the mid- to late 1930s, confirms Kirszenbaum's acknowledgement of the brutality of exile.

This oeuvre, sometimes known as the Exodus imagery, includes a variety of configurations, the common denominator is the presence of at least one, solitary, individual experiencing exile alone or with loved ones. There are individual wandering Jews, entire family units walking alongside wagons loaded with their belongings, mothers fleeing while clutching their children, and amorphous, unidentified groups, burdened by sacks on their back, aimlessly shuffling through nondescript landscapes of despair.[26]

Kirszenbaum's imagery of refugees captures the suffering and fortitude of those who were forced to leave everything they knew and search for a new beginning. *Wandering Jews* (fig. 9), now in the collection of the Israel Museum, presents the colorless reality of the homeless, unsettled Jews. The artist depicts them in a vague and unwelcoming environment, scattered throughout the image in various haphazard groups, obviously forced to settle wherever they were, when their feet could go no further. The lack of compositional organization in this image, and others on the theme, emphasizes the temporariness of their predicament; at any moment they will have to gather their belongings and move on.

Fleeing, from 1939 (fig. 10), depicts several French soldiers with extended bayonets escorting a group composed primarily of families. The artist arranges them in a lozenge format, extending back into the distance. This articulation stymies the viewer's ability to count those forced to leave their homes and purposefully gives the impression of the never-ending numbers of those in the same predicament. Nevertheless, within this seemingly endless parade of refugees, Kirszenbaum singles out one family unit. Leading the pack is a man holding

24 Michael Bernard-Donals, "Forgetful Memory and Images of the Holocaust," *College English* 66 (March 2004): 380–402.

25 The development of an actual iconography of exile by Kirszenbaum was no doubt influenced by contemporary artists' exploration. See Mirjam Rajner, "Chagall's Jew in Bright Red," *AJ* 4 (2008): 61–80; *Le Juif Errant* [catalogue, Musée d'art et d'histoire du Judaïsme] (Paris, 2001); Ziva Amishai-Maisels, "Menasseh Ben Israel and the 'Wandering Jew'," *AJ* 2 (2006): 59–82.

26 Goldberg Igra, "Kirszenbaum's Artistic Legacy," 89.

a satchel in one hand while grasping his young son by the shoulder with the other; beside him is his wife, noted wrapping her cloak around her infant child, attempting to protect her from their unknown future. Kirszenbaum incorporated family groups such as this one repeatedly in his works, emphasizing the effect of displacement and exile on the nuclear family. They were also featured among the crowds waiting on the side of the road for the arrival of the Messiah in the body of work explored above. The inclusion of this unit increases the immediacy and relevance of the images; it is a means of emphasizing the very personal effect of this exile on the individuals concerned as well as the artist himself. Although they are representative of millions of displaced individuals, an entire generation, these groups were not amorphous individuals but rather, a mother, a father, and a child, desperately clinging to what remained of their family.[27]

Kirszenbaum's imagery specifically depicted both the male and female experience of exile. Images such as *Man Carrying Bag on His Back* (fig. 11), indicating the back-breaking task of trying to carry one's life on one's back during an obviously arduous trek to safer ground, are included alongside those describing the desperate attempts by women to protect their children. In *The Exodus of Mother with Two Children* (fig. 12) from 1945, a frantic mother with a kerchief on her head is noted hurrying her children forward. The artist accentuates the mother's need to protect her precious cargo by extending the length of her arms. They curve and scoop, encompassing both the small boy struggling to keep up with the large strides of the mother and the blanket-swathed infant.

Although at first glance it seems as though the exodus theme was limited to less formal works in ink, perhaps intended for a more private audience, and indeed the majority of what exists of Kirszenbaum's oeuvre is in this

media, numerous examples in oil prove otherwise. In this last example Kirszenbaum uses bright accents of oil color to highlight areas of the figures' clothing, making them project from otherwise dull masses of material and accentuating the mother's individuality within the whole. Furthermore, the artist's placement of this figural group high above the horizon line, before a crowd of faceless individuals, effectively emphasizes one particularly tragic experience of displacement.

Kirszenbaum's study of the theme of exile encompassed not only the massive migration of eastern European Jews across the European continent but that over sea. His *Refugees* (fig. 13), in the collection of the Tel Aviv Museum of Art, describes a large group of people crowded together within a small boat. The steep, overhead angle, reminiscent of an earlier depiction of *Jonah in the Whale* (fig. 14),[28] allows the viewer a full view of the cramped conditions within the vessel. The huddled bodies of these exiled individuals, literally bent over under the weight of their oppression, are embraced by the curving arms of the boat. The sea overwhelms the boat from all sides, simultaneously threatening their search for salvation and offering the solace of its embracing swells.

The subject of ships crowded with refugees was a popular one amongst those artists forced to flee their homelands to escape the Nazi regime. An excellent example is that by Lasar Segall (1891–1957), another eastern European artist who had opted to leave the confining life in his home town (in this case Vilna, Lithuania) and seek a career in Germany – albeit studying at the Berlin Art Academy instead of the Bauhaus. Segall's *Exodus* (fig. 15) from 1947 was based on his own journey across the Atlantic to Brazil. Using a compositional solution similar to that noted in the work by Kirszenbaum, this artist depicts a cluster of people who almost seem to "float" within a compressed space indicative of a boat. Unlike Kirszenbaum's vessel,

27 Kirszenbaum's focus on both fleeing groups and single families aligns his oeuvre with a large group of refugee imagery from the twentieth century explored in Ziva Amishai-Maisels, *Depiction and Interpretation: The Influence of the Holocaust on the Visual Arts* (Oxford, 1993) and Mirjam Rajner, "The Continuity of 'Jewish Iconography'," *Legacy: Journal of the International School for Holocaust Studies* 4 (2011): 14–25. According to Rajner's categorization, Kirszenbaum's exploration of this theme, with

limited realistic delineation and an overall abstract nature, is more universal in effect.

28 This early image indicates the influence of Paul Klee, with whom the artist was in contact at the time. The denial of three-dimensional space and the dispersal and delineation of objects across the picture plane, confirming the very flatness of the canvas itself, owes much to the style espoused by this contemporary German master.

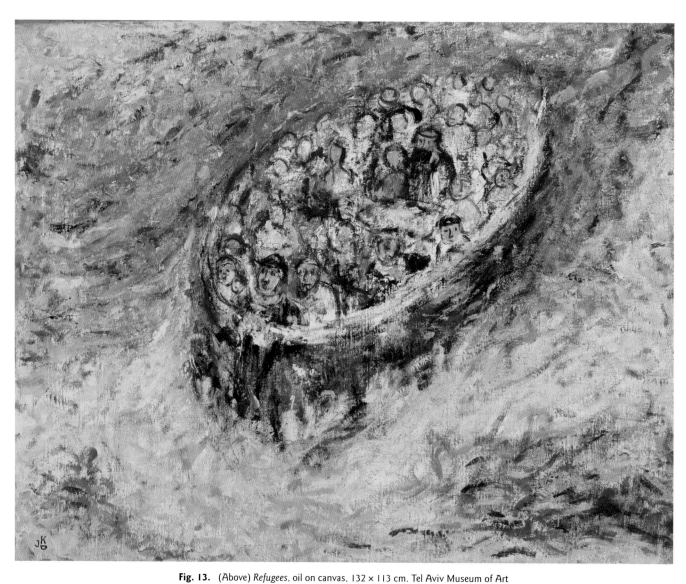

Fig. 13. (Above) *Refugees*, oil on canvas, 132 × 113 cm. Tel Aviv Museum of Art
Fig. 14. (Below) *Jonah in the Whale*, oil on canvas, Centre Pompidou-Mnam-Bibliothèque Kandinsky-Fonds Marc Vaux

the boat is not specifically delineated, but rather suggested. Nevertheless, the dreadful condition of the exiles here, as in Kirszenbaum's *Refugees*, is made clear. Segall uses a drab, gray palette and an exceptionally high angle of depiction to intensify the stressful effect of the image on the viewer and emphasize the desperation of these individuals' predicament – their low expectation of salvation. Relying upon the recollection of his own voyage, Segall generalizes the difficulties of the migration experience rather than painting one specific event.[29]

29 Goldberg Igra, "Kirszenbaum's Artistic Journey," 94–95.

Kirszenbaum's exploration of the experience of exile and displacement carefully extends from the general to the specific; encompassing the spectrum of experience. Although many of his images focus on one person – one soul, one individual – forced to leave everything he knows and, in the face of persecution, seek something better, somewhere safer, someplace he could call home, there is a feeling that the artist captures the experience of an entire generation. Although no one experience is exactly like any other, each one is just another and represents the whole. One of the ways the artist accomplishes this is by returning to the same cast of characters. The man carrying a heavy sack (fig. 11) resembles the one with his family being hurried along by

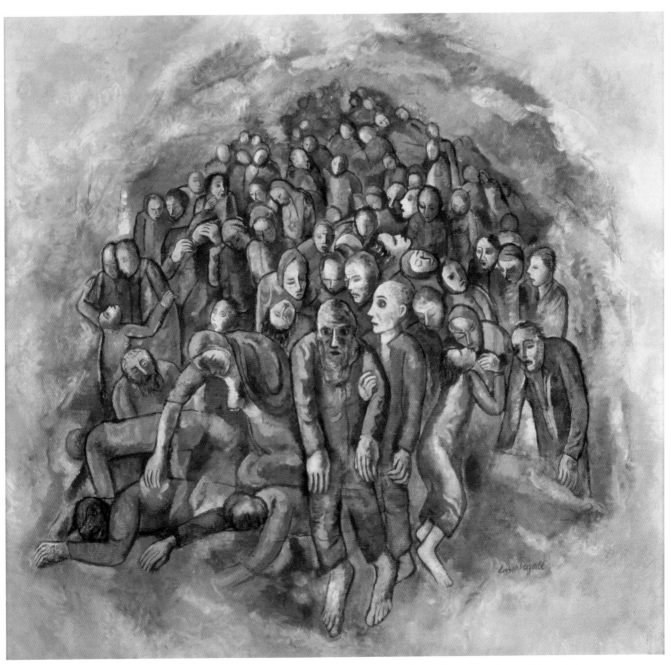

Fig. 15. Lasar Segall, *Exodus*, 1947, oil on canvas. The Jewish Museum New York, gift of James Rosenberg and George Baker in memory of Felix M. Warburg. Photo © The Jewish Museum, New York/ Art Resource, NY

a French soldier (fig. 10). The soldier in this latter image appears in various guises, both in oil and in ink – always with a mustache, and a hat and bayonet indicative of the French military – always curtailing and/or directing the free movement of the displaced. So, too, we find the mother with covered head, embracing her child, throughout his imagery.

The reappearance of a set cast of characters within Kirszenbaum's works cannot have been accidental, but instead signifies the existence of a program on the part of the artist. Interestingly enough, this same methodology is noted frequently in other creative work by Holocaust survivors. Apparently this population is known for using specific, identifiable, mediating figures in order to dramatize their act of recollection. In the case of Kirszenbaum, it is clear that his technique of repeatedly returning to a limited cast, in many cases the same unit of mother and child inserted into the background of an image, makes the ability of this "unit" to illustrate a chapter of history in a realistic manner greater. Most likely, it offered him another means with which to cope with his loss.[30] Returning to a faithful set of "knowns" offered him an anchor on which to base whatever expression of loss he chose to represent.

The impulse to return to this pain and re-experience it, as so clearly noted throughout Kirszenbaum's oeuvre, may have served as a means to increase the possibility of salvation. As noted in *My Tears Will Become a River*

(fig. 1), with its reflection of Psalm 137 – an exhortation against forgetting – the artist clearly attempted to heal through memory and recollection. Indeed, studies on exile indicate the importance to survivors of remembering their experience, of keeping that feeling of what exile was like at the forefront of their memory, that memory serving as a kind of ultimate testimony.[31] But beyond acting as testimony, this recollection encourages the ever-present hope for return on the part of the exiled. In his study on exile Michael Bernstein writes:

> Exile is less like the death of one's beloved than like a betrayal from which it is impossible ever to become fully healed because the prospect of a pathway home, of a return that is also a mutual pardoning, continues to exist. For the exiled, hope is itself part of his torment.[32]

The natural culmination of Kirszenbaum's earlier effort to deal with an all-too-painful past was the eventual creation of a series based on biblical figures. Having attempted to cope with his loss through both fantasy (the dreamlike image of the Messiah returning to save those left in the *shtetl*) and brutal reality (the images of displaced individuals), what remained was to appeal to the prophets of the past – those forefathers whose fortitude had seen them through both exile and persecution. Kirszenbaum's decision to turn back the clock, to explore its beginnings, illustrates not only another attempt to deal with his personal loss, and that of his entire generation, but furthermore, to achieve some kind of salvation through identification.

In 1946–47 Kirszenbaum painted iconic images of several well-known biblical prophets including Moses, Elijah, Jeremiah, and Job. The artist's exploration of biblical figures at this date probably doesn't indicate any actual religiosity. In fact, the references to religion made in his personal memoirs, especially regarding his early years in Staszów, indicate his ambivalence toward the faith embraced by his father.[33] Accordingly, the turn toward biblical subject matter, especially in consideration of his professed early interest in the stories of the Ḥumash, his fantasy of the saving power of the Messiah, and his

30 See Froma Zeitlin, "The Vicarious Witness: Belated Memory and Authorial Presence in Recent Holocaust Literature," *History and Memory* 10 (Fall 1998): 5–42. Although Zeitlin specifically refers to second generation survivors, her theory seems particularly relevant for Kirszenbaum.

31 Michael Andre Bernstein, "Exile, Cunning, and Loquaciousness," *Salmagundi* 111 (Summer 1996): 182–94.

32 Ibid.: 183. For more on the methods of survival adopted by survivors see Adina Grossman, "Victims, Villains, and Survivors: Gendered Perceptions and Self-Perceptions of Jewish Displaced Persons in Occupied Postwar Germany," *Journal of the History of Sexuality* 11, Special Issue: *Sexuality and German Fascism* (Jan.–Apr. 2002): 291–318.

33 Kirszenbaum, "Yaldut u-n'urim bi-Stashov," 1, reprinted in *J.D. Kirszenbaum (1900–1954)*, 129.

earlier exploration of exile and loss, seems more part of his programmatic effort to cope. Having already explored both fantasy and reality as conduits for loss, the turn to ancient times may have been a desperate last attempt to restore his hope for a more stable future.

Reincarnating his usual cast of characters, this time in the form of classic biblical forefathers, Kirszenbaum sought to move beyond memory – toward salvation. His imagery of the prophets in larger-than-life format is the culmination of two decades of loss and displacement. The obvious masterpiece in this genre is the triptych devoted to *The Prophet Moses*, *The Prophet Jeremiah* and *The Prophet Elijah* from 1947 (figs. 16, 17, 18), in the collection of the Tel Aviv Museum of Art. The triptych format was traditionally used within Christian ecclesiastical painting, dating back to eighth-century Byzantium, to elevate the status of adored saints. Kirszenbaum's adaptation of this classic Christian device in the creation of this expressionistic project indicates his interest in presenting these prophets as beacons of salvation.

Painted one per panel, each prophet receives our full attention. Their painted delineation is clearly meant to be ethereal and expressive: heavy, enclosing lines that elongate the figures and a particularly pasty skin tone recall the equally otherworldly, ecclesiastical oeuvre of El Greco from the sixteenth century. The effect of the fresco-like technique espoused by the artist was noted by contemporary critics:

His poetic gift made of him a Jewish Rouault, but his fresco-like temperament, his flexible manner, emotion, also released from his figures the beauty of medieval painting, assigning him a very personal place.[34]

Although the relevance of the triptych format demands acknowledgment of its roots, the search for the source of the particular style utilized by the artist to describe these patriarchs need not retreat so far into the past. In fact, it may have been strongly influenced by the work of Jakob Steinhardt and Die Pathetiker's group, with which Kirszenbaum is known to have been in contact.[35] This group of artists was actively focusing on prophet themes

well before the First World War and interestingly enough, Steinhardt himself created a work titled *The Prophet*, three meters in height, which featured at the Der Sturm gallery under the directorship of Walden. Although it is not clear that Kirszenbaum saw this specific work, as it was exhibited earlier in 1910, his own contact with Walden and Der Sturm later in the 1920s could certainly have been inspirational in his own development of the theme here.[36]

Whatever the source, one cannot discount the extremely personal nature of the artist's exploration of these patriarchs. In fact, their exaggerated high foreheads and elongated noses recall the artist's own description of his father, whom he admired greatly. In his written recollection of their reconciliation after his first departure from Staszów, following a disagreement between the two, Kirszenbaum clearly delineates aspects of his profile which he found impressive.

At that time I was drawing quite a lot, and I would often sketch the portrait of my father, while he was engrossed in his studies. I never saw such a magnificent profile. His nose was as marvelously sculptured as a Greek statue, his eyes were distinctive in their brilliance, and the curve of his forehead was fine and majestic.[37]

It is impressive to see these same features appear here on the patriarchs, his respect for both his father and his forefathers evident.

There is no question that Kirszenbaum's exploration of these particular biblical figures indicates their role in his personal catharsis. Each of these prophets was known for

34 "Son Don poétique sa foi font de lui un Rouault Israélite, mais son temperament de fresquiste, sa maniére plus souple, l'émotion, aussi se degageant de ses figures qui ont la beauté des peintures mediovales, lui assignment une place trés personnelle." Guy Dornant, "Exposicao de J.D. Kirszenbaum, 11–26 October 1948," Rio de Janeiro.

35 Goudz, "Herwarth Walden," 533.

36 See *The Woodcuts of Jakob Steinhardt*, ed. Leon Kolb (Philadelphia, 1962), 6.

37 Kirszenbaum, "Yaldut u-n'urim bi-Stashov," 14, reprinted in *J.D. Kirszenbaum (1900–1954)*, 167.

Fig. 16. *The Prophet Moses*, 1947, oil on canvas, 132 × 195 cm. Tel Aviv Museum of Art

Fig. 17. *The Prophet Jeremiah*, 1947, oil on canvas, 132 × 195 cm. Tel Aviv Museum of Art

Fig. 18. *The Prophet Elijah*, 1947, oil on canvas, 132 × 195 cm. Tel Aviv Museum of Art.

maintaining their faith in God despite being personally overwhelmed by common acts of evil and destruction. *The Prophet Moses* (fig. 16) is depicted raising the Ten Commandments high over his head. The upraised gesture of lifting the heavy tablets belies a clear reading, and at first it seems unclear whether he is presenting them to the people *before* discovering the Golden Calf or on the verge of smashing them to the ground in anger just *afterwards*. Nonetheless, the sadness and disappointment reflected within his facial expression make quite clear the latter situation. Kirszenbaum captures this prophetic leader on the brink of breakdown, coming to grips with the shortcomings of the people for whom he is responsible.

The deep disappointment and sadness experienced by Moses is also noted in the artist's depiction of *The Prophet Jeremiah* (fig. 17). Tightly squeezed between the ecclesiastical buildings depicted in the background of the image, he is shown trapped, with no hope of escape from his despair. He leans heavily on one arm, completely

devastated, every single contour line laid down by the artist pushing him deeper and deeper into an abyss of desperation. There is no doubt that this figure mourns the destruction of Jerusalem which he prophesied.[38]

The artist used both preparatory studies (see fig. 19) and earlier explorations of exasperation and lost hope to attain the precise amount of despair for this figure. And in fact, the emotional impact on the viewer is very close to that achieved in earlier images of devastated individuals described in a similar formal arrangement, such as *My Tears Will Become a River* (fig. 1). While Moses' eyes are open, confronting the disappointment with which he is faced; Jeremiah's are tightly closed, desperately trying to shut it out. Kirszenbaum's creation of a sculpted version of this prophet, with an almost identical expression of loss and resignation (fig. 20) – hand on head, eyes squeezed shut, body slumped forward – represents his repeated attempt to capture the tragedy of the Holocaust within the universal format provided by the Ḥumash.

Kirszenbaum's utilization of the traditional pose for "melancholy" in this sculpture in particular, and elsewhere

Ars Judaica 2014

38 Goldberg Igra, "Kirszenbaum's Artistic Journey," 105.

in his oeuvre, emphasizes his awareness of traditional depictions of despair. There are many examples that he could have been familiar with from his years in Berlin or Paris but it is also quite possible that he actually knew of Rembrandt's version of *Jeremiah Lamenting the Destruction of Jerusalem* in the Rijksmuseum. Kirszenbaum was in Amsterdam soon after the end of WWII and would probably have been interested in this fairly recent acquisition (1939) by the museum. Mirjam Rajner specifically discusses this Rembrandt in regard to the similar use of the traditional melancholy pose in Chagall's *Solitude* from 1933. There is no question that both artists drew on traditional formulas in the development of their own expressions of despair – both personal and collective.[39]

The emphasis on the rounded and enlarged forehead in this terracotta, as well as the painted imagery of these prophets, could relate to the artist's memory of his

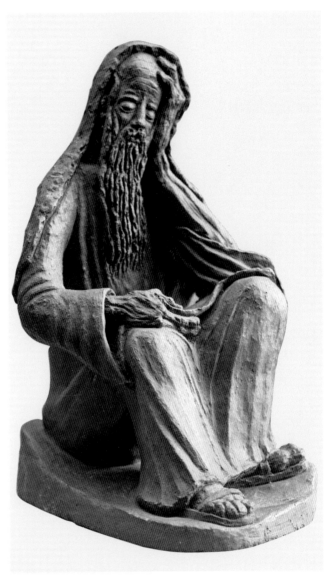

Fig. 20. *Jeremiah*, 1945, Sculpture terracotta, 30cm, location unknown, Centre Pompidou-Mnam-Bibliothèque Kandinsky-Fonds Marc Vaux

Fig. 19. *Jeremiah*, preparatory sketch for triptych, ink on paper, 48 × 32 cm. Family Collection

father. Yet as this detail is one which appears in much of Kirszenbaum's later, post-war imagery, it may also suggest the weight of the thoughts behind his figures' physical expressions: the immensity of the emotional burden they carried. The appearance of similar cranial delineation, in his depiction of a perplexed *Job or Man in Misery* from

39 Rajner, "The Continuity of 'Jewish Iconography'." Rajner cites Mira Friedman's earlier article on the subject as well: "On Chagall's *Solitude* in the Tel Aviv Museum," *Almanac* (Tel Aviv Museum), 1 (1982): 54–56 (Hebrew).

Fig. 21. *Job or Man in Misery*, ca. 1945, oil on canvas, 100 × 72 cm. Collection of Nadine Nieszawer

ca. 1945 (fig. 21), further supports this explanation. Apparently the artist felt it a fitting manner by which to represent the inner struggle of individuals forced to cope with the trials and tribulations to which they were exposed over the course of a lifetime.

The third panel of the triptych serves as an answer to the former two – almost a form of consolation.

Kirszenbaum's depiction of *The Prophet Elijah* (fig. 18), the individual who prophesied the return of the Jewish people to Jerusalem, appropriately offers a glimmer of hope after the disappointment and despair expressed by Moses and Jeremiah. There is no indication of exasperation, loss, or anger in the delineation of this biblical figure. His hand is raised high over his head, his erect posture

reflects physical strength and fortitude, and his eyes are wide open – all elements emitting a feeling of optimistic expectation.

Kirszenbaum's exploration of these three ancient prophets reflects his search for real leadership – for great men who would be able to counter the evil brought about by the power-hungry dictators of his own generation. While the despairing image of Jeremiah captures something of the loss of the Holocaust, that of Elijah looks forward to the post-war period. The successful encapsulation of the artist's experience of his time, in this triptych, was noted by Waldemar George at the time of Kirszenbaum's first retrospective exhibition in 1951:

> Kirszenbaum contributed immensely to the future of Jewish painting whose spirit is intimately connected to that of the contours of Yiddish poets. Like other illustrators of the Old Testament, he was powerfully attracted to the *Golden Legend*. Instead of opposing one another, the Synagogue and the Church blend together in the work of this visionary who regards the universe with dazzled eyes.[40]

Having earlier explored his personal loss through fantastic depictions of the return of the Messiah to his native Staszów as well as their polar opposite, realistic depictions of the gritty reality of a generation hurled into eternal movement, Kirszenbaum's recourse to the prophets of an Old Testament whose significance to him was more about symbol than faith, seems entirely understandable. The artist returns to the cultural basis of his Jewish roots, that part most easily embraced by one with his secular orientation, and thereby acknowledges his forefathers' contribution to his own historic, if not religious, past. Of course this appeal to the remote past is made all the more poignant by the fact that the more recent past had been so brutally erased by the onset of Fascism and the Nazi regime.

The artist's focus on these prominent biblical figures suffuses his viewer with a spirit of faith and hope intended to triumph over that loss resultant from displacement and exile. This last chapter in the iconographic study of loss that Kirszenbaum explored for over a decade represents the creation of a mythic history on his part – a means to restore order and coherence, to deny the disorder of actual history.[41] In this case, the artist's mythic history, ironically based on the biblical one he had studied in the ḥeder with his father, was part of his effort to cope with great loss through the cathartic exclamation of ancient faith. Although apparently unable to find solace in the faith provided by his Jewish education and the Jewish religion itself, Kirszenbaum appears to have found strength in the faith of others: in the case of this triptych, his ancient forefathers.

Kirszenbaum's programmatic attempt to restore loss reflects not only his artistic evolution, but his personal one as well. From the beginning, with those first images of the arrival of the Messiah, his optimistic nature shone through. The villagers noted waiting in the sidelines are never dirty, exhausted, or wayward. In fact, they are consistently depicted as well-dressed, eager, hopeful, and comfortable in their conviction that salvation will arrive. Kirszenbaum's affectionate and fond memories of Staszów are evident in its consistently groomed and tidy appearance – the bright, and never bleak, colors with which it is described. These nostalgic depictions, so important in healing his sense of loss, are consistently optimistic.

It must have been devastating for him to come to the conclusion that these images weren't enough; his disappointment was great enough to compel him to

40 "Kirszenbaum a contribué dans une très large mesure à l'avènement d'une peinture judaïque dont l'esprit est intimement lié à celui des contours et des poètes Yiddish. Comme d'autres illustrateurs de l'Ancien Testament, il a subi la puissante attraction de *La Légende dorée*. Au lieu de s'opposer, la Synagogue et l'Église se confondent dans l'oeuvre de ce voyant qui regarde l'univers avec des yeux éblouis." Waldemar George, "Introduction," in *J.D. Kirszenbaum: peintures, aquarelles, gouaches: du* *27 septembre au 11 octobre 1951* [catalogue, Galerie André Weil] (Paris, 1951), p. 3.

41 Erika Bourguigon, "Bringing the Past into the Present: Family Narratives of Holocaust, Exile, and Diaspora; Memory in an Amnesic World: Holocaust, Exile, and the Return of the Suppressed," *Anthropological Quarterly* 78 (Winter 2005): 63–88.

confront the far grimmer aspect of the life he had left behind. Hoping that it would assist his own personal recovery and help him deal with his loss, this next body of work focused entirely on the pain of the period. These explorations of loss are extremely realistic in nature, focusing on the exiled – those who wandered without destination, bent on escape. It may be exactly the desperation of this imagery, which allowed absolutely no glimmer of hope, which convinced him to seek yet another means of coping. After all, despite surviving the war years with great personal loss, Kirszenbaum still remained optimistic; the bare pain of his imagery of exile could not be part of his achievement of salvation.

The last chapter in the artist's exploration of loss, delving into territory far removed from his present life, indicates his intent on finding a place from which to draw strength. Suffocated by the desperation of not only his personal loss, but that of his generation, Kirszenbaum began a search through his own biblical roots. It was here that he hoped to find some sense of redemption and hope for the future. After all, if he were to acquire only an ounce of the strength, fortitude, and conviction for which his biblical forefathers were known, he might have some chance of surviving his loss and returning to life.

Beginning with images of the *shtetl* in the mid-1930s and culminating in ones of the prophets of the *Ḥumash* painted immediately following the end of the war, Kirszenbaum's oeuvre explores not only the experience of one, but that of many, extending beyond the realm of the personal to incorporate that of the universal. The artist's programmatic effort to find distinct ways in which to remember, memorialize, and cope with his tremendous loss, as revealed in three very different expressions, offers a salve for what could not, truly, be put back together again: the lost generation.

The Great Synagogue on Tłomackie Street: Warsaw Inspirations

Eleonora Bergman

The "Golden Book" – a record book of the Great Synagogue on Tłomackie Street in Warsaw – notes:

> In the year 5619 [1858/9], when the elders of the community gathered in the house of prayer on Daniłowiczowska Street, the wise scholar, our master and teacher Arye Leib Natanson, one of the elders, spoke to the hearts of his companions, who gathered by his side, and he said: Look brothers, we are sitting hidden in our houses, and this house, built in name of God, Lord of Hosts, has not enough beauty nor glory. Why should we sit with our idle hands, and be ashamed that the enlightened [Jews] of Warsaw do not have a house of prayer appropriate to their honor and wealth?[1]

In that year, the synagogue on Daniłowiczowska Street had already existed for more than half a century and its congregation practiced the strictly Orthodox liturgy until 1843, when Rabbi Abraham Meyer Goldschmidt

(1812–89) was installed as rabbi and preacher of this synagogue and introduced changes in the spirit of German Reform Judaism. Rabbi Goldschmidt, who came to Warsaw six years earlier as a twenty-four-year-old "candidate of theology" and private teacher,[2] found here many grateful assistants and followers. In 1849 he initiated the establishment of the new synagogue building, where he introduced a choir, sermons, and several additional modifications:

> After a long debate concerning all the suggestions and after putting aside strong objections on the part of the congregation members, the ritual of the Viennese synagogue was adopted, and its basis was the Maḥzor published by Mannheimer, preacher of that synagogue.[3]

The rite that differed from both Polish Jewish Orthodox Judaism and German Jewish Reform has been called "Progressive." The Daniłowiczowska Synagogue con-

1 "Złota Księga" (Golden Book), Archiwum Żydowskiego Instytutu Historycznego (Archive of the Jewish Historical Institute), Collection No. 199: Jewish Religious Community in Warsaw, manuscript, file 1, p. 9 (Polish, German, Hebrew, Russian); translation into Polish from Hebrew by Yale Reisner; see also Eleonora Bergman, "'Złota Księga' Wielkiej Synagogi w Warszawie" (Golden Book of the Great Synagogue in Warsaw), in Izaak Cylkow (1841–1908): Życie i dzieło (Isaac Cylkow: Life and Work), ed. Michał Galas (Cracow and Budapest, 2010), 57–67 (Polish).
2 Goldschmidt was called "a Germanized Posen Jew" by Jacob Shatzky, Di geshikhte fun yidn in varshe (History of the Jews in Warsaw), 3 vols. (New York, 1947–53), 2:117 (Yiddish). Goldschmidt himself recorded a "Bericht über Entstehung, Entwickelung Tendenz der Synagoge Daniłowiczewskastrasse 615 (die deutsche Synagoge genannt) verfasst und seiner theurn Gemeinde gewidmet von dem Prediger derselben Dr Abraham Meyer Goldschmidt, Warschau am 24 Februar 1858," "Złota Księga," 8.
3 Sara Zilbersztejn, "Postępowa synagoga na Daniłowiczowskiej w Warszawie: przyczynek do historii kultury Żydow polskich XIX stulecia" (Progressive Synagogue on Daniłowiczowska Street in Warsaw: A Contribution to the History of the Culture of Polish Jews of the 19th Century), MA thesis, Department of Humanities of the University of Warsaw, typescript, copy in the Archive of the Jewish Historical Institute, Warsaw, File No. 117/57, 25 (Polish). Isaac Noah Mannheimer, 1793–1865, was a preacher in synagogues in Copenhagen, Vienna, Berlin, and Leipzig. The prayer book which he translated into German was adopted by many communities.

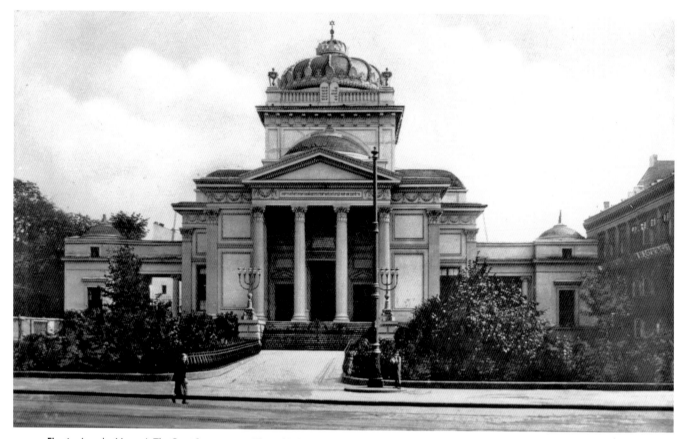

Fig. I. Leandro Marconi, The Great Synagogue on Tłomackie Street, Warsaw, 1875–78. Photo 1913. Courtesy of Gross Family Collection, Tel Aviv

gregation continued to maintain the new ritual after Rabbi Goldschmidt left for Leipzig in 1858, preferring, however, to hear sermons and some prayers in Polish rather than German, except for the period from 1871 to 1878, when Rabbi Isaac Cylkow preferred German as a language better understood by the majority of his congregation.

Even before the reforms in the Daniłowiczowska Synagogue, a group of Warsaw *maskilim* – mainly Jews of Prussian origin and other more assimilated Warsaw Jewish families – supported the establishment of the Warsaw Rabbinic School in 1826. Some of its graduates founded

another Progressive synagogue, on 52 Nalewki Street. While the former one was called "German," the latter acquired the name "Polish." The Great Synagogue on Tłomackie Street (fig. 1) was a successor to both of them.[4]

The initiators of the new Jewish house of prayer in Warsaw formed a committee that represented the wealthiest and the most assimilated, probably not more than 2–3 percent of the Warsaw Jewish population.[5] The most prominent among the founders were Samuel Orgelbrand, the brothers Henryk and Ludwik Natanson, Jakub Centnerszwer, Adam Epstein, Mathias Rosen, Henryk Toeplitz, and Salomon Lewental.[6] Their proposals

4 For the general social and cultural background of changes among the Warsaw Jews and their relationship with the Polish non-Jewish environment, see, for example, "Warsaw," *The YIVO Encyclopedia of Jews in Eastern Europe*, vol. 2 (New Haven and London, 2008); Antony Polonsky, *The Jews in Poland and Russia*, The Littman Library of Jewish Civilization, 3 vols. (Oxford and Portland, OR, 2010–12); Marcin Wodziński, *Haskalah and Hasidism in the Kingdom of Poland: A History of*

Conflict (Oxford and Portland, OR, 2005).

5 Approximately 41,000 in 1856, and 72,000 in 1864 – 26.3 and 32.3 percent of Warsaw's population, respectively. See Piotr Wróbel, "Jewish Warsaw before First World War," *Polin* 3 (1988): 165.

6 Ewa Małkowska, *Synagoga na Tłomackiem* (Warsaw, 1991), 14–20 (Polish). Orgelbrand was editor of the twenty-eight-volume first Polish General Encyclopedia; Henryk Natanson was an editor and banker; his

for a site for the new synagogue were not accepted by the authorities as there were still limitations on residence for Jews in Warsaw; the restrictions were abolished after the Jews in the Polish Kingdom[7] were granted equal rights in 1862. The lot on Tłomackie Street was purchased for the synagogue on 5 May 1872; seventeen days later, the committee decided to initiate an architectural competition and published its announcement on 11 July.[8] The building was supposed to be constructed "in a solemn style" and to seat approximately 2,300 people (women in the galleries). It was to include separate rooms for board meetings, an archive, a library, and classrooms for religious education. Central heating was required, as well as windows allowing enough daylight to illuminate the interior. The officials' apartments were to be in a separate building on the same plot.

On 9 March 1873 six designs were submitted and then exhibited in the Society of Fine Arts, where they remained for four weeks. The entries were reviewed on 23 May. First prize was awarded to Bronisław Żochowski and Teofil Lembke, and the second to Jan Heurich.[9] From the descriptions we can assume that both designs were adaptations of a Byzantine structure (this is my assumption based on the fact that the main prayer hall was described as octagonal); however, the decoration of the second was described as "mildly Moorish."[10]

It is probable that one of the anonymous participants in this competition was Stanisław Adamczewski. Although his name is not mentioned in the "Golden Book," Adamczewski published his project in a journal of which

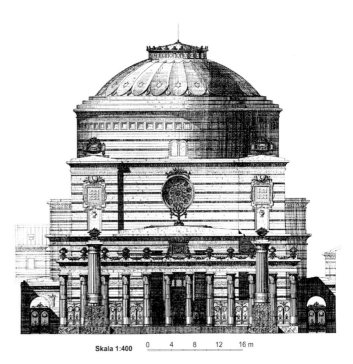

Fig. 2. Stanisław Adamczewski, design for The Great Synagogue on Tłomackie Street, façade. *Inżenieria i budownictwo* no. 39 (1880): 158, pls. 38–39

he was editor-in-chief, and therefore it is not surprising that the design was highly praised.[11] He planned the synagogue as a rotunda covered with a huge cupola, with two free-standing colossal columns in front of it (fig. 2). The layout of the circular main hall was not typical of synagogue architecture[12] and assumingly was modeled after the 1783 Lutheran church in Warsaw. Adamczewski asserted that his project alluded to the time of slavery of the Children of Israel in Egypt and stood for the

brother Ludwik was a medical doctor; Centnerszwer was a mathematician and educator, Epstein was a merchant and philanthropist, Rosen was a banker and *klal-tuer* (community activist), Toeplitz was a merchant and industrialist, and Lewental a book merchant and publisher.

7 The Polish Kingdom was established at the Congress of Vienna in 1815. Formally it remained under Russian rule as part of the territory acquired in the process of partitions among three empires: Russia, Prussia, and Austria (1772–95). It had a significant degree of autonomy, but lost much of this after the uprisings against the Tzarist regime in 1830–31 and in 1863.

8 On the competition, see Małkowska, *Synagoga*, 27–34.

9 Bronisław Żochowski (1836–1911) studied in Munich; he built residential houses, but also an orphanage, churches, and cemetery monuments, mainly in Warsaw. Teofil Lembke (1844–1914) built residential buildings, hospitals, alms houses, and a Lutheran church

in Warsaw. Jan Heurich (1834–87) also designed residential buildings in Warsaw as well as villas, a railway station, a circus, and a bridge. See Stanisław Łoza, *Architekci i budowniczowie w Polsce* (Architects and Builders in Poland) (Warsaw, 1954), s.v. "Żochowski, Bronisław," "Lembke, Teofil," and "Heurich, Jan" (Polish).

10 Małkowska, *Synagoga*, 28.

11 "Projekt konkursowy synagogi w Warszawie" (Design of a Synagogue for a Contest in Warsaw), *Inżenieria i budownictwo* (Engineering and Construction), 39 1880), 158, plates 35, 38–39 (Polish).

12 Rare examples of such synagogues are discussed in Eleonora Bergman, "Okrągła synagoga na rogu Szerokiej i Jagiellońskiej" [Round Synagogue at the Corner of Szeroka and Jagiellońska Streets], *Mazowsze* 5 (1995): 23–28 (Polish); Holger Brüls, *Synagogen in Sachsen-Anhalt* (Berlin, 1998), 49–56 (on the round synagogue in Wörlitz).

Temple of Solomon.[13] The symbolism designating the Jews as strangers was definitely not acceptable to the committee and the congregants, who strove for closer integration into Polish society.

Despite the prizes awarded, the projects were not considered entirely satisfactory. Therefore, on 28 June the committee re-invited Żochowski, Lembke, and Heurich, and also invited Jerzy Völck, Kazimierz Loewe, Wojciech Bobiński and Julian Ankiewicz, and Franciszek Tournelle,[14] to participate in a new competition. The work by Ankiewicz was found to be the most appropriate; however, the contract was not signed, probably because the project was found to be too expensive.[15] Finally, Leandro Marconi was commissioned to prepare the design. His project was submitted to the committee on 18 November 1874[16] and accepted on 3 January 1875. The first foundations were laid on 11 October 1875, two days after the Day of Atonement, the cornerstone laying ceremony took place on 14 May 1876, a day after Lag ba-Omer, and the synagogue was dedicated on 26 September 1878, one day before the Day of Atonement.

Leandro Jan Ludwik Marconi (1834–1919) began his professional career working under his father Henryk (Enrico; 1792–1863), the most important and most prolific builder in the Polish kingdom (since Henryk's

arrival from Italy in 1822 until his death) and a teacher of at least two co-participants in the competition for the Tłomackie Street synagogue, Jan Heurich and Franciszek Tournelle. As a builder, Leandro Marconi received the necessary formal certifications in 1854 and 1865. Unlike most of his contemporaneous architects, he was well-off enough to build only for wealthy clients. Thus, he had at his disposal the resources for a high level of work and finishing. A contemporary historian of Polish modern architecture, Tadeusz S. Jaroszewski, accepted the work of Leandro Marconi as representing

> the mature phase of historicism in Polish architecture. Buildings which he designed consisted of carefully composed historical architectural forms, mainly pertaining to the late Italian and French Renaissance. He also referred to the architecture of Polish Classicism […]. Although it was typical for architectural compositions of the late 19th century, he rarely connected various stylistic forms in one building.[17]

The synagogue was thus a unique example of an eclectic style in Leandro's architectural oeuvre.

While Henryk Marconi designed a few synagogues, none of them were ever built, and we do not know whether

13 Stanisław Adamczewski, 1830–1916, studied in Rome and Paris. He worked as a free-lance architect, building churches and some residential buildings, and published theoretical works, among them "Plan of the Capital of United Slavs"; see Adam Czyżewski, *Odwrotna strona życiorysu Stanisława Adamczewskiego – szkic biograficzny* (The Other Side of Stanisław Adamczewski's Curriculum Vitae – a Biographical Essay), in *Architektura XIX i początku XX wieku* (Architecture of the 19th and Early 20th Centuries), (Wrocław, Warsaw, and Cracow, 1991), 71–84 (Polish); the central part of "the Capital," designed in 1876, is almost identical to the synagogue's layout.

14 Jerzy Völck (1811–82), was an official builder of military installations; he also built residential houses, chapels, churches, and monuments at Warsaw cemeteries, including Jewish ones. Kazimierz Loewe (1845–1924) studied in Munich and St Petersburg; he worked on railroad construction in the Russian Empire, and built banks, plants, roads, and residential houses in Warsaw; in addition he built some houses for the Warsaw Jewish Community and also a Calvinist church. Wojciech Bobiński (1814–79) was a lecturer at the School of Fine Arts; he built Catholic and Lutheran churches, residential and commercial buildings throughout the country, including Warsaw. Julian Ankiewicz, (1820–

1903), who studied in London and Neapol, was the official builder for the municipality of Warsaw and the Bank of Poland; he built office and residential buildings as well as churches, mainly in Warsaw. Franciszek Tournelle (1818–80) was an official state builder who built a synagogue in Włocławek in 1854 and built and restored many churches, a hospital, a prison, and an asylum for the mentally ill. For all these, see Łoza, *Architekci i budowniczowie w Polsce*, s. v. "Völck, Jerzy," "Loewe, Kazimierz," "Bobiński, Wojciech," "Ankiewicz, Julian," and "Tournelle, Franciszek."

15 Małkowska, *Synagoga*, 25–26. The author misattributed the winning of the competition to Stanisław Adamczewski (confusing him with Julian Ankiewicz) and overlooked the name of Tournelle, the only participant who had any experience in building synagogues before competing for the new one on Tłomackie Street.

16 "Złota Księga," 59–60.

17 Tadeusz S. Jaroszewski and Andrzej Rottermund, *Katalog rysunków architektonicznych Henryka i Leandra Marconich w Archiwum Głównym Akt Dawnych w Warszawie* (Catalogue of Architectural Drawings of Henryk and Leandro Marconi in the Archive of Old Documents in Warsaw), (Warsaw, 1977), 9–14 (Polish).

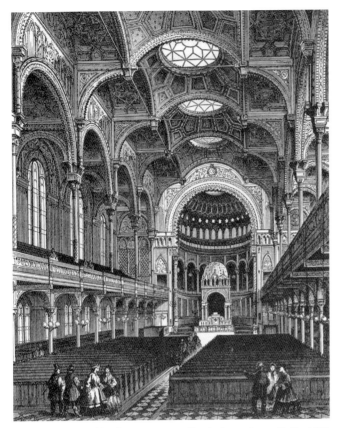

Fig. 3. Eduard Knoblauch, synagogue on Oranienburgerstrasse, Berlin, 1866. Lithograph after 1866. *Die neue Synagoge in Berlin*, eds. G. Knoblauch and F. Hollin (Berlin, 1992; reprint)

to that publication, the most popular model became the Leopoldstadt synagogue in Vienna, designed by Ludwig von Förster and built in 1853–58. Those who traveled across Europe could have seen new synagogues in Hanover, Breslau (now Wrocław), Stockholm, on Tabakgasse (Dohany utca) in Budapest, on Rue de la Victoire in Paris, and certainly on Oranienburgerstrasse in Berlin (inaugurated 1866; fig. 3), which most probably became Leandro Marconi's inspiration for his project of the synagogue on Tłomackie Street in Warsaw. Even if Leandro had not visited the Oranienburgerstrasse synagogue, he might have been acquainted with its design, published in great detail in a book of 1867[20] that was promoted by *Izraelita* (The Israelite), a Polish-Jewish weekly expressing the assimilative ideology of the Tłomackie Street synagogue's founders.[21]

The location of the synagogue on Tłomackie Street in the area in which Jews were formerly forbidden to reside, near important municipal offices, clearly symbolized the idea of Jewish emancipation. The religious requirement that the building be oriented eastwards was stipulated during the competition for the synagogue project in 1872,[22] but could hardly be implemented because of the shape of the lot, which was surrounded by neighboring buildings.[23] The congregation turned for halakhic advice to Dr Zacharias Frankel, director of the Breslau Jewish Theological Seminary. The assimilated Jewish congregation's choice of this traditional way of halakhic consultation caused ironic remarks in the progressive *Izraelita*:

The local Jewish community's halakhic knowledge was obviously not sufficient [...]; [since] the Talmud

Leandro had ever seen an actual synagogue. Since the late 1830s, architects and Jewish communities alike were in search of a proper concept for the new Jewish house of prayer. Leandro Marconi had scarcely seen new synagogues or even publications of synagogue projects in Poland until the boom in synagogue building from the late 1870s on.[18] The first manual with some general instructions for planning synagogues appeared only in 1884.[19] Thanks

18 Except for the designs of the Dresden and Vienna synagogues in *Allgemeine Bauzeitung* 12 (1847): 127, plates 105–7 and 24 (1859): 14–16, plates 230–35, respectively. Engraved images of some old Polish synagogues had been published in *Tygodnik Illustrowany* (Jurborg, Szarogród) and *Kłosy* (Łuck). The only new synagogue whose images could be found in the Polish press was that of Włocławek, in *Tygodnik Illustrowany* 9, no. 228 (1864): 48 (exterior) and 13, no. 254 (1872): 225 (interior).

19 [Edwin Oppler and Albrecht Haupt], "Synagogen und jüdische Begräbnisplätze" in *Baukunde des Architekten*, 2 (Berlin, 1884), 270–85.

20 *Die Neue Synagoge in Berlin entworfen und ausgeführt von Eduard Knoblauch, vollendet von August Stüler, herausgegeben von G. Knoblauch und F. Hollin* (Berlin, 1867; reprinted Berlin, 1992).

21 *Izraelita* was published weekly in Polish in Warsaw from 1866 through 1915, in approximately 500 copies. Since 1896, when Nachum Sokołów [Nahum Sokolow] replaced its former editor-in-chief, Samuel Peltyn, it embraced Zionism.

22 Małkowska, *Synagoga*, 25.

23 Archive of the City of Warsaw, Collection of Lindley Maps, Section 169, 1:200, 1885; additions: 1896, 1902.

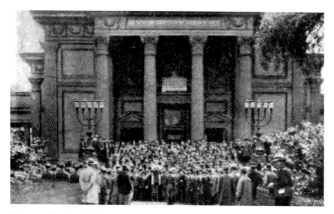

Fig. 4. Portico of The Great Synagogue on Tłomackie Street. Photo taken in the summer of 1933 on the occasion of the reunion of the members of the Association of the Jews – Fighters for the Independence of Poland. *Nasz Przegląd Ilustrowany*, July 2, 1933

forbids living where there is no *talmid hakham* [Hebrew: Jewish scholar, rabbinical authority], those who respect tradition should leave our city; we hope for the positive response of Dr Frankel [...].[24]

Frankel's response is not known to us, but it is likely that he insisted on the traditional orientation of the building and the congregation followed his prescription, as in practice the synagogue was turned quite precisely towards Jerusalem.

What in mid-nineteenth century Warsaw was accepted as a "solemn style," such as was required from the architect by the synagogue founders? The pedimented Corinthian tetrastyle imparted to the Great Synagogue's facade a distinctly Neoclassical character (fig. 4). In the discussion of the semantics of the classicized architecture in Poland, a renowned Polish philosopher and art historian, Władysław Tatarkiewicz's intimation of the ever changing nature and often eclectic implementation of Classicism that "appeared not only as a pure style, but in connection with other trends,"[25] was highly instrumental. Both in

theory and practice this trend connected Classical forms with non-classical ones. The Greco-Roman architectural forms were detached from their pagan connotations and adopted for synagogue architecture already in the ancient period; in Poland, this style was introduced in synagogue design in the late sixteenth century.[26] To the best of our knowledge, the early-nineteenth-century Neo-classicist synagogues – to mention but two, the synagogue built in Kępno in 1814 and that in Obuda (now Budapest) in 1820–1821 – were never associated with pagan sanctuaries. Discussing the classicizing style of American synagogues, Samuel Gruber argued that these too were not related to paganism:

> Because a large number of contemporary structures, including churches and custom houses, also utilized the Greek temple form, it could be that Jews were being fashionable, not symbolic, in their choice of style. Jewish communities felt secure and accepted. The architectural designs, often commissioned from the leading architects of the day, reflected this Jewish integration into the affairs of the new nation.[27]

The choice of the classicizing style for a synagogue in nineteenth-century Warsaw should be analyzed in its local historical, social, and artistic contexts.

In Warsaw, a version of Neoclassicism was introduced and promoted by Stanislaus Augustus, the last king of Poland (who reigned 1764–95), as the style for a wide range of structures including palaces, churches, governmental, and military buildings. This architecture still dominated the cityscape in the mid-nineteenth century, but the very few religious edifices built then in Warsaw were designed in different styles. Three of them were Catholic churches designed or redesigned by the

24 *Izraelita* no. 3 (January 4 [16], 1874): 20 (Polish); the author of the text was probably Samuel Peltyn, the editor-in-chief.

25 Władysław Tatarkiewicz, "O znaczeniu terminu klasycyzm" (On the Meaning of the Term Classicism), in *Muzeum i twórca: Studia z historii sztuki i kultury ku czci prof. dr Stanisława Lorentza* (Museum and Artist: Studies in the History of Art and Civilization in Honor of Prof. Dr Stanisław Lorentz), ed. Kazimierz Michałowski (Warsaw, 1969), 181,

184 (Polish).

26 See Ilia M. Rodov, *The Torah Ark in Renaissance Poland: A Jewish Revival of Classical Antiquity* (Leiden, 2013).

27 Samuel D. Gruber, *American Synagogues: A Century of Architecture and Jewish Community* (New York, 2003), 27, 34; idem, "Arnold W. Brunner and the New Classical Synagogue in America," *Jewish History* 25 (2011): 69–102.

Fig. 5. St. Anne's Church, Wilanów, façade remodeled by Henryk and Leandro Marconi, 1857. Photo: E. Bergman, 2013

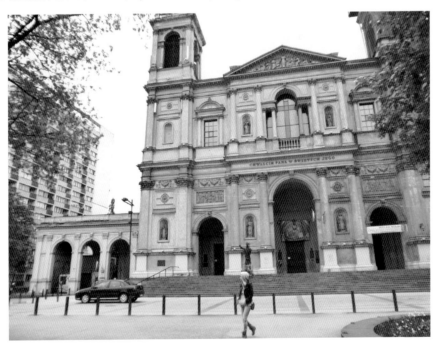

Fig. 6. Henryk Marconi, All Saints Church on Grzybowski Square, Warsaw, façade. Photo: E. Bergman, 2013

Marconis: St Carlo Borromeo was built by Henryk as an "old-Christian," two-tower and three-nave basilica in 1841–49; St Anne's Church in Wilanów was remodeled in the Renaissance Revival style by Henryk and Leandro in 1857 (fig. 5); and All Saints Church in Grzybow (a district of Warsaw) – a huge two-tower, three-nave church seating about seven thousand people – was designed by Henryk in 1860 (fig. 6). The only other Christian house

Fig. 7. Palace-on-the-Water, Łazienki Park, Warsaw, 18th century, south façade. Photo courtesy of Elżbieta Masek

of prayer was the Calvinist church built by Adolf Loewe in a Gothic Revival style in 1866–80.

Architectural historians have proposed diverse interpretations of the adoption of Neoclassicism in the Tłomackie Street synagogue. Marek Kwiatkowski traced the origins of the synagogue's style to the German Renaissance Revival, thus disconnecting its design from the Polish architectural tradition. In this vein, he also interpreted the planning of the synagogue as a strange and aggressive intrusion into the urban space. Kwiatkowski argued that the high synagogue building was erected

facing Tłomackie Square in spite of the late-Baroque tradition of surrounding the square with single- or two-storied modest houses, and that the synagogue blocked the axis on which a round water tower was constructed.[28]

In Carol Herselle Krinsky's opinion, since the synagogue's classicizing style "was associated with the imperial government in Moscow" and neither imitated churches nor looked exotic, it duly expressed the congregation's ideology of cultural – but not religious – assimilation with the Christian majority.[29] Indeed, the synagogue patrons paid tribute to the political sovereign of Poland by placing a monumental dedicatory inscription in Polish above the main entrance, in the shadow of the four-column portico: "To the glory of the one and only God, during the reign of Alexander the Second, Emperor of All Russia, King of Poland." The attitude towards the Jews in Warsaw (then under Russian protectorate) was nevertheless more tolerant than in the heart of the

28 Marek Kwiatkowski, "Tłumackie," *Rocznik Warszawski* 5 (1964): 67 (Polish). The water tower was built at the crossing of the east–west axis of Leszno Street and the south–north axis of the planned palace (never built) of Karol Schultz, owner of the square in the 1770–80s. The square was reconstructed by Warsaw architect Szymon Bogumił Zug in 1783.

29 Carol Herselle Krinsky, *Synagogues of Europe: Architecture, History, Meaning* (New York and Cambridge, MA, 1985), 90, 231.

Fig. 8. Leandro Marconi, Palace of the Tyszkiewicz family, Waka (now Trakų Vokė), 1876–80. Photo courtesy of Jakub Czarnowski

Russian Empire. It is noteworthy that when the Jews of Moscow had to invest great efforts to get permission for their "house of prayer" (they even could not use the term "synagogue" in official correspondence) from the Russian government, they referred to the Tłomackie Street synagogue in Warsaw as a precedent and after receiving permission they built their Choral Synagogue in the Neoclassical style.[30]

Others have stressed that the roots of the Tłomackie Street synagogue's classical appearance lie in the local architectural tradition and stylistic conventions. Alfred Lauterbach considered it a historicist reconstruction

of the Renaissance and the latest Renaissance-Revival project in Warsaw,[31] while Ewa Małkowska stated that the classical portico – such as that on the synagogue façade – seems to be native to the Polish architectural tradition.[32]

Several more distinctive components of the synagogue's spatial layout and design cited earlier are representative of contemporaneous Warsaw architecture. The general composition of the synagogue's exterior echoes that of the eighteenth-century Palace-on-the-Water in Warsaw's Łazienki Park (fig. 7). Leandro Marconi had already used it as a model for another design, a palace in Waka (fig. 8) (now Trakų Vokė) near Vilna (now Vilnius, Lituania)

30 Yvonne Kleinman, "Zdaniye kak religioznyy i politicheskiy simvol. Predystoriya Moskovskoy khoral'noy sinagogi (1869–1906)" (A Building as a Religious and Political Symbol: Pre-History of the Moscow Choral Synagogue [1869–1906]), in *100 let. Moskovskaya khoral'naya sinagoga* (A Century of the Moscow Choral Synagogue), ed. [Alexandr Lokshin] (Moscow, 2006), 10–25 (Russian).

31 Alfred Lauterbach, *Warszawa* (Warsaw, 1925), 203. Lauterbach (1884–1943), an art historian and expert on eighteenth-century Warsaw architecture, museologist, and conservator of historical monuments in inter-war period Poland, was murdered for his liberal opinions by the Gestapo.

32 Małkowska, *Synagoga*, 60.

Fig. 9. Antonio Corazzi, Colonnades on Bankowy Square, Warsaw, 1820s. *Warszawa Stolica Polski* (Warsaw, 1949), 35

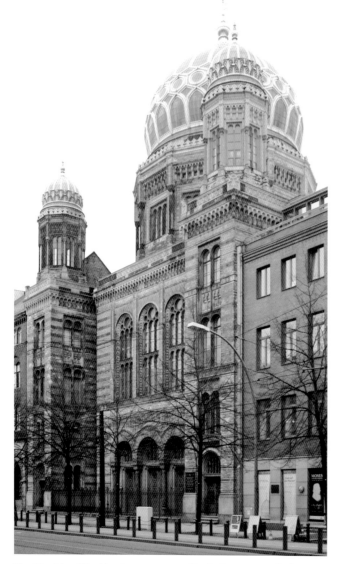

Fig. 10. Eduard Knoblauch, synagogue on Oranienburgerstrasse, Berlin, 1866, façade. Photo: Wikimedia Commons

for the Polish aristocratic Tyszkiewicz family.[33] Marconi's classical arcades and symmetrical side pavilions on the synagogue's west side connecting the building to the surrounding urban space are reminiscent of Antonio Corazzi's colonnades of the 1820s on the nearby Bankowy Square (fig. 9)[34] and the above-mentioned Renaissance-Revival All Saints Church in Grzybow, designed by Henryk Marconi in 1860. Thus the Neoclassical style of the Tłomackie Street synagogue, though exceptional for the time it was erected, meshed well into both the urban environment and local architectural tradition.

Contrasting with the classical elements on the Tłomackie Street synagogue's façade and the Pantheon-like cupola above the entrance lobby is the sumptuous two-story shaped dome above the prayer hall. Described elsewhere as Moorish or Byzantine,[35] its form closely resembles the cupola of the Paris Opera built by Charles Garnier in 1861–74,[36] and its decorative effect is akin to that of the dome of the synagogue on Oranienburgerstrasse in Berlin (fig. 10). The prominent cupola topped with a Shield of David made the whole building on Tłomackie Street a remarkable highlight in the urban skyline and clearly distinguished it from churches, as well as from much smaller and humbler traditional synagogues in Warsaw. A learned Jewish beholder could associate the cap-shaped dome encompassed by a diadem-like ornament with the Crown of the Torah – a traditional Jewish epithet for religious scholarship and piety, and a common symbol in the decoration of the Torah arks and Torah scrolls in Ashkenazi synagogues. Especially noteworthy is the fact that only a few decades before the Shield of David hexagram had become a pivotal and widespread Zionist symbol, the assimilated reporters of *Izraelita* criticized the hexagram atop the synagogue's dome as a weird and obsolete kabbalistic sign that is alien to the spirit of this new Jewish temple.[37]

33 Jaroszewski and Rottermund, *Katalog*, 14, 212; ills. 54, 55.

34 Małkowska, *Synagoga*, 6.

35 *Izraelita* 11(March 5[17], 1876); 20 (May 7[19], 1876): 158; 28 (July 2[14]): 219–20; Małkowska, *Synagoga*, 40–42.

36 See Krinsky, *Synagogues*, 231.

37 "Whoever recently passed by the new synagogue now being built on Tłomackie Street, could easily see two triangles put together on top of it.

Fig. 11. Leandro Marconi, The Great Synagogue on Tłomackie Street, layout for the ground floor and women's galleries level. *Architekt* (1902): 13–14, 21–22

The traditionalist aspect of the synagogue was expressed on its façade by the Tablets of the Law seen on the front side of the belvedere as well as two five-branched candelabra. It may be assumed that by giving the candlestick five rather than seven branches, its designer followed the Talmudic objection to reproducing the Temple's seven-branched menorah in its precise shape.[38] The Talmudic quotation in Hebrew, the language illegible not only to the Christian passerby but also to many assimilated Polish Jews, was inscribed above the portico: מי ששיכן שמו בבית הזה הוא ישכין ביניכם אהבה ואחוה ושלום ורעות ("He Who established His name in this building, He will cause love and harmony and peace and companionship to dwell among you")[39]. It is most probable that the texts

inscribed on the façade and inside the synagogue were selected by Isaac Cylkow, the preacher, an adherent of Polish-Jewish dialogue, proponent of deep religious Jewish education, and translator of the Hebrew Bible into Polish.[40] The *Izraelita* published a Polish transcription of the Hebrew text (in Ashkenazi pronunciation), and one of the newspaper's correspondents proclaimed that the phrase expresses the ideal cherished by Jews for thousands of years.[41] Nevertheless, the Orthodox majority of Warsaw Jews still considered the Tłomackie Street synagogue alien-looking, almost like a church.[42]

Since no technical documentation of the Tłomackie Street synagogue has been preserved,[43] one may gain some idea of its design only from a few photographs,

It is the so-called Shield of David, and this is supposed to be the visible sign of a cult to be later performed in this temple. Without entering the debate, a product of the later Kabbalistic lore, as to whether this Shield of David can represent the pure Mosaic faith, we should say here that introducing symbols like this is not appropriate for the spirit of our religion." *Izraelita* no. 15 (April 1 [13], 1877): 249 (Polish).
38 BT Menahot 28b, Avodah Zarah 43a, Rosh ha-Shanah 24a.

39 BT Berakhot 12a.
40 On this person, see *Izaak Cylkow.*
41 *Izraelita* no. 5 (January 18 [31]) 1902: 54.
42 Bernard Singer (Regnis), *Moje Nalewki* (My Nalewki Street), (Warsaw, 1993), 14 (Polish).
43 Tadeusz S. Jaroszewski, and Andrzej Rottermund believe that the drawings of the synagogue have been lost "somewhere," see idem, *Katalog*, 8.

Fig. 12. Karl Friedrich Schinkel, design for a small church with one tower, ground floor. *Sammlung architektonischer Entwürfe* (Leipzig, 1980; reprint of the 1841–43 edition)

Fig. 13. The Great Synagogue on Tłomackie Street, opening ceremony, 1878, wood engraving. *Kłosy* 695 (1878): 267

inscriptions, and the altar, chandeliers, and eternal lamp, make a truly religious impression – you feel strongly that you are in a temple.[46]

The anonymous witness presents the synagogue as a respectable sanctuary, which can be well described in terms of European architecture, neither "Moorish" nor "Oriental," "Byzantine" or in any other way exotic. Assumingly, he borrowed the term "altar" for the synagogue *bimah* from ecclesiastic rather than biblical nomenclature. The only detail that seemed strange to him was the superimposed capitals of the upper columns made of wrought iron, still a novelty in Polish architecture. A purist could also be disturbed by a dissonance between the Baroque effect of the capitals set under broken cornices (as far as we can judge from old illustrations; see fig. 13) and the classicizing style of Marconi's architecture. Referring to the synagogue as "temple," the author obviously had in mind the German Jewish Reform definition of the synagogue as *Tempel*, which the Progressive congregants of the Tłomackie Street synagogue never adopted. They, just like Orthodox Jews, considered this definition as contradicting the concept of the synagogue as a temporary

etchings, and descriptions. Two schematic drawings in the journal *Architekt* of 1902[44] show a rough representation of the ground plans of the ground-floor level and of the women's gallery (fig. 11) that resemble Karl F. Schinkel's exemplary church layouts (fig. 12).[45]

One of the only two descriptions of the synagogue interior known to us appears in the Polish bi-weekly *Biesiada Literacka* in the late 1870s:

> In general it is noble and harmonious, although some details, like capitals of the upper columns, seem foreign; however, the whole [space] decorated as it is with bronze chandeliers and railings at galleries around the temple must impress us. Walking further [from the entrance], the solemnity of red and white curtains, threaded through with gold and silver, the cedar ark, marble plaques with

44 *Architekt* 3 (1902): 13–14, 21–22 (Polish).
45 Karl Friedrich Schinkel, *Sammlung architektonischer Entwürfe* (Leipzig, 1980; reprint 1841–43), table 78.
46 Quoted in Małkowska, *Synagoga*, 44.

substitute for the destroyed Temple in Jerusalem that will be reconstructed in the messianic future.

Another description was published in an issue of *Architekt* in 1902:

> Columns of wrought iron; the structure of the aisles covered in iron, caned and planked, produced a look of three barrel vaults with lunettes. Behind the colossal arch supported with two somewhat different columns, Jachin and Boaz, is a round little Temple supported by four columns with a tiny cupola covered with mother of pearl scalework. Inside is a place to store scrolls, in the form of an ornate cabinet made of cedar wood imported from Lebanon. A gallery for women. Behind the apse, at the level of the gallery, separated with small arcades on small columns, is a choir loft.[47]

The person who wrote this description for the periodical on architecture and was well versed in professional terminology could not have been aware of Leandro Marconi's ideas regarding the synagogue's symbolism twenty-four years after its inauguration, but he would have been aware of the common symbols and conventions in both Christian and Jewish ritual architecture. This author more explicitly refers to the Temple in Jerusalem, applying the biblical definitions to the synagogue apse framed by two columns bearing a colossal arch, rather than to the entire building. He readily associated "somewhat different" columns flanking the apse with Jachin and Boaz, described in the Bible as similar but differently named bronze pillars that stood in front of the Solomonic Temple.[48] A pair of columns believed to be "Solomonic" had been a customary symbol or pars-pro-toto representation of the Temple on the façade or interior of churches and synagogues since the medieval period, and – as Bracha Yaniv has shown – in modern Ashkenazi synagogues they were often depicted on the *parokhet*, the Torah ark curtain.[49]

47 *Architekt* 3 (1902): 16 (Polish).
48 1 Kings 7:13–22, 41–42; 2 Kings 25:13, 17; Jer. 52:17, 20–23; 2 Chron. 3:15–17; 4:12–13.
49 Bracha Yaniv, "The Origins of the 'Two-Column Motif' in European Parokhot," *JA* 15 (1989): 26 , although, as Yaniv has proved, these columns originated in a complete representation of a gate.

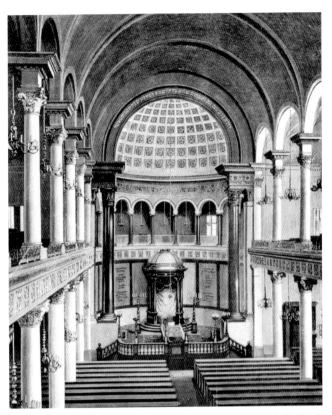

Fig. 14. S. Antoszewicz, *Tłomackie Synagogue*, interior towards the Torah ark, 1888, wood engraving. The Jewish Historical Institute, Warsaw

Supported by the reputedly Solomonic columns, the arch separating the sacral area from the prayer hall was obviously inspired by the so called "rainbow arch," an elaborate arch enclosing the altar in Polish Catholic churches. As we can learn from a surviving image (fig. 14), the "rainbow arch" in the synagogue bore a quotation from Proverbs 3:17–18: דרכיה דרכי־נעם וכל־נתיבתיה שלום: עץ־חיים היא למחזיקים בה ותמכיה מאושר (Her ways are ways of pleasantness, and all her paths are peace. She is a tree of life to those who take hold of her, and happy are all who retain her). These verses referring to divine wisdom, traditionally understood in Jewish tradition as the Torah, are recited during the ritual of returning the Torah scroll to the synagogue ark. Appreciation of the area behind the arch as the holiest space was borne out by the abovementioned correspondent of the *Architekt*, who described the round-plan domed Torah ark standing in the midst of the apse as a "little temple" (translation of the biblical *mikdash me'at*, Ezekiel 11:15), the common Jewish synonym for "synagogue" as a temporal substitute

for the destroyed Temple in Jerusalem.[50] The mention of the Lebanese cedar wood of which the synagogue ark was constructed reinforced its symbolic association with the Solomonic Temple, which "was furnished with cedar-trees" (1 Kings 9:11, see also 2 Chronicles 2:5).

In the course of time, the Tłomackie Street synagogue became the core of a cultural center for the emancipated Jewish community. In 1928 the roofing was repaired, façades were replastered, and the entrance steps were reconstructed by the architect Maurycy Grodzieński. The inscription in Polish affixed next to the entrance to commemorate the work expressed the pride of the congregation who sensed themselves equal citizens of the new Poland: "To the glory of the one and only God. This building was renovated in the 50th year since its erection and the 10th year since the resurrection of the Polish Republic."[51]

The idea of constructing a separate space for the synagogue library arose at a very early stage of planning the synagogue on Tłomackie Street. The synagogue's book collection was growing so fast that the room allotted to it was overflowing with books shortly after the library was opened to the public in 1880. In 1911 the congregation purchased a plot of land adjacent to the synagogue for a new library. Due to the First World War and difficulties of the post-war period, work began only in 1928 and continued until 1936 (fig. 15). The creator of the project, architect Edward Zachariasz Eber (1880–1953), designed two dissimilar façades: the south-western side duplicated the paneling of the synagogue walls, while the north-western side corresponded to the offices of a telephone company erected on the opposite corner of Tłomackie Square in 1929 (this building no longer exists).

The new building housed two institutions: the Main Judaic Library (Główna Biblioteka Judaistyczna),

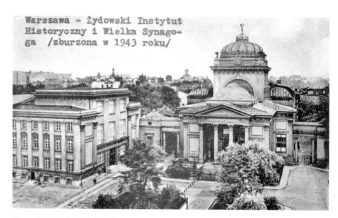

Fig. 15. Main Judaic Library and the Great Synagogue on Tłomackie Square, after 1936. The Jewish Historical Institute, Warsaw

containing a collection of approximately 30,000 volumes, in the side facing the synagogue, and the Institute for Judaic Studies (Instytut Nauk Judaistycznych) in the part facing the square. An institute for the education of modern rabbis, scholars, and social workers for Jewish charitable organizations was established in 1928 and functioned in rented rooms before moving to its new premises. At the inauguration of the Library on 22 April 1936, one of the founders of these institutions and the rabbi of the Great Synagogue, Moses Schorr (1874–1941),[52] proclaimed their goal to be harmony between faith and knowledge.[53] A rare remnant of pre-Holocaust Jewish architecture in Warsaw, the building of the Main Judaic Library has survived. In the absence of the synagogue nearby and the office building across the square, the library's two different façades certainly confuse the contemporary beholder. Since 1947, the former library is the home of the Jewish Historical Institute.

The Great Synagogue on Tłomackie Street, full of symbolic meanings, was destroyed by the Nazis on 16 May 1943, in order to mark the end of the total destruction of Jewish Warsaw.

50 The free-standing, round-plan ark reminds us of canopies over martyrs' relics such as those, for example, in St Peter's in Rome and St Stanislaus's in Cracow. See Adam Miłobędzki, *Architektura polska XVII wieku* (Polish Architecture of the 17th century) (Warsaw, 1980), 191, 193, fig. 147 (Polish).

51 Quoted in Małkowska, *Synagoga*, 63.

52 Rabbi Moses Schorr, historian, founder of the modern historiography of Polish Jews, and linguist, was the vice-president of B'nai Brith of Poland and a member of the Polish Senate. In 1939 he fled to the Soviet

Union, where he was imprisoned and died in a labor camp.

53 "Przemówienie Inauguracyjne wygłoszone przez Rabina Prof. D-ra Mojżesza Schorra Senatora Rzeczypospolitej na uroczystości otwarcia gmachu Głównej Biblioteki Judaistycznej przy Wielkiej Synagodze w Warszawie dnia 22 kwietnia 1936 roku" (Inaugural speech by Rabbi Prof. Dr Moses Schorr Senator of the Republic at the ceremony of the opening of the Main Judaic Library of the Great Synagogue in Warsaw, April 22, 1936) (pamphlet): 2 (Polish).

Leviathan Thanks the Lord:
Perek Shirah on a Wall of the Great Synagogue in Radyvyliv

Sergey R. Kravtsov and Vladimir Levin

Fig. 1. The Great Synagogue of Radyvyliv, view from east. Photo before 1914. After *M.A. Ginsburg: sa vie, son œuvre* (Paris, 1933), facing p. 13

Only three known photographs exist of the Great Synagogue in the town of Radyvyliv[1] in Volhynia (today western Ukraine), which was blown up in 1915. Two of them show the synagogue exterior (fig. 1)[2] and one more represents a portion of the inner wall of the upper-floor women's section on the western side of the synagogue (fig. 2).[3] The latter image was discovered in St Petersburg in 2003 among those taken by Solomon Yudovin (1892–1944) through the course of Solomon An-sky's expedition during 1912–13.[4] The inscription on the photograph's back suggests that Yudovin focused on the chandelier,[5] but our attention has been attracted

1　Radziwiłłów in Polish, Радзивилов (*Radzivilov*) in Russian, and ראדוויל (*Radvil*) in Yiddish.

2　On the surviving images of the Radyvyliv synagogue, see Sergey R. Kravtsov and Vladimir Levin, *Synagogues of Volhynia* (forthcoming).

3　We are grateful to Alla Sokolova of the Center "Petersburg Judaica" for providing us with this photograph.

4　On the photographs of An-sky's ethnographic expeditions see Alina Orlov, "From Zero to Ten: Discovering Yudovin's Photographs in Post-Soviet Russia," *East European Jewish Affairs* 35 (2005): 3–6; Alla Sokolova, *Photographs for the "Album of Jewish Artistic Antiquities"* vol. 2 (St. Petersburg, 2007); *Photographing the Jewish Nation: Pictures from S. An-sky's Ethnographic Expeditions*, eds. Eugene M. Avrutin, et al. (Hanover, 2009).

5　The inscription in pre-Reform Russian reads, "Канделябръ / Радзивиловъ" (Chandelier / Radyvyliv).

Fig. 2. Interior view of the Great Synagogue of Radyvyliv, view towards west. Photo by Solomon Yudovin. 1912–13. Courtesy of the Center "Petersburg Judaica"

by what he captured on the synagogue's western wall in the background: portrayals of an ox and fish, with inscribed verses from *Perek Shirah* – the only quotation from this text known to us that is explicitly inscribed on synagogue walls.[6] The evidence from Radyvyliv may significantly broaden our knowledge of the iconography of

synagogue paintings in eastern Europe and support Bracha Yaniv's theory connecting *Perek Shirah* to the decorative program of carved wooden Torah arks in east-European synagogues.[7]

An-sky and his team found the Radyvyliv synagogue after it had undergone several renovations during the nineteenth century and a refurbishing of the building and its interior in 1906;[8] expedition participant Avrom Rekhtman (1890–1972) could only record memories and legends about this synagogue in past times.[9] He was told that the old high wooden synagogue crowned with a turret and a dome was richly decorated inside: the signs of the Zodiac were painted in the dome, while

> the walls were covered by rare subjects, based on Bible verses, as, for example, "The mountains skipped like rams, the hills like young sheep" [Ps. 114:4], "Our hands were spread wide like the eagles in the sky, and our feet were light like gazelles," "The horse and his rider hath He thrown into the sea" [Exod. 15:1], and others.[10]

It is unclear whether, after some six years since the old inscriptions had disappeared, Rekhtman's informants quoted them from memory. It is possible that the congregants mentally restored these texts from the new inscriptions that could be either precise copies or close versions of the old ones. Rekhtman accurately defines the subjects as "based on Bible verses" rather than merely "biblical." Indeed, the phrase beginning with "Our hands were spread wide…" cites the prayer *Nishmat kol hai* (The soul of every living being),[11] and – as we shall see below –

6 *Perek Shirah* (Chapter of Song) is an anonymous compilation of short hymns in praise of the Creator placed in the mouths of His creatures; see Malachi Beit-Arie, "Perek Shirah," in *EJ*[2], 8:760.

7 Bracha Yaniv, "Praising the Lord: Discovering a Song of Ascents on Carved Torah Arks in Eastern Europe," *AJ2* (2006): 83–102.

8 Menahem Goldgart, "Zikhronot al beit-ha-kneset ha-gadol" (Memoirs on the Great Synagogue), in *Radzivilov: Sefer zikkaron* (Radyvyliv: Memorial Book), ed. Yaakov Adini (Tel Aviv, 1966), 133 (Hebrew).

9 Avrom Rekhtman, *Di yidishe etnografie un folklor* (Jewish Ethnography and Folklore) (Buenos Aires, 1958), 39–42 (Yiddish). Rekhtman recorded a tale of the miraculous salvation of the old wooden synagogue during the fire of 1882 by flocks of white pigeons, which sat on the roof and by flapping their wings repelled the flames. People

said that once upon a time Rabbi Velvele (Benyamin Zeev Volf) of Zbarazh (d. 1822) spent a Sabbath there and blessed the synagogue (ibid., 39–40).

10 Rekhtman, *Di yidishe etnografie*, 39; see also David Shein, "Ir moladeti Radzivilov" (My Native Town Radyvyliv) in *Radzivilov: Sefer zikkaron* (Radyvyliv: Memorial Book), ed. Yaakov Adini (Tel Aviv, 1966), 27–28 (Hebrew); Goldgart, "Zikhronot," 133.

11 Israel Davidson, *Ozar ha-shirah ve-ha-piyyut: mi-zman hatimat kitvei ha-kodesh ad reshit tkufat ha-haskalah* (Thesaurus of Hebrew Poetry: From the Times of Holy Scriptures to the Early Period of Haskalah), vol. 3 (New York, 1930), 231–32 (Hebrew). The prayer, also called *Birkat ha-Shir* (Benediction of the Song), is recited at Sabbath and festival morning services and became part of the Passover *Haggadah*; see Elie Munk, *The*

the verse beginning with "The horse and his rider…" might have been quoted from *Perek Shirah*, 5[12] rather than directly from the Book of Exodus. It is noteworthy that all the excerpts from the synagogue inscriptions have in common the expression of the praise and gratitude that nature and all creatures owe their Creator.

Menaḥem Goldgart, born in Radyvyliv, reported in 1966 that the old synagogue was renovated upon the initiative of the *gabbaim* (synagogue beadles) and at the expense of a local-born wealthy Jew, Moses Ginsburg (1851–1936).[13] The works done in 1906 included repair of the roof, replacement of the old brass hanging chandeliers with modern ones, and cleaning of the walls that caused the removal of the images. The community vigorously protested the alterations and compelled the synagogue *gabbaim* to consult with the town's rabbi Ḥaim Roitenberg (b. 1864) about what should be done with the murals which the congregants referred to as "holy." In turn, Roitenberg readdressed the question to a rabbi in Vilna, and the latter advised that the remnants of wall paintings be buried in the Jewish cemetery; the brass chandeliers should be sold and the money used to buy new ones.[14]

An old-looking chandelier seen in front of the new paintings in Yudovin's photograph (fig. 2) testifies that at least one of these lamps continued to be used in the synagogue after its reconstruction, but it remains unknown whether any part of the old paintings had been preserved. The decoration of 1906 is attributed to

a certain "painter from Lvov," who inscribed a dedication within a round cartouche flanked by lions' heads, most probably above the exit from the prayer hall, and did one more dedicatory text in a rectangular panel under an illusory curtain on the wall of the women's gallery. The texts praise the work of *gabbaim* Elḥanan (Ḥone) Shlomo Goldgart, Moses (Moshe) Azriel Goldgart, and Ze'ev (Velvl) son of Moses Zaks, as well as the donation of 5,000 rubles by Moses Ginsburg for the synagogue's renovation.[15] Apparently, the dedication outraged the opponents of the novelties who considered that mention of the *gabbaim* is inappropriate on the walls of this holy place.[16]

Unfortunately for the subject of the present article, Yudovin only partially caught the zoomorphic images within rectangular trompe l'oeil frames. On the left side of the photograph are the head and forelegs of an ox, with an inscription underneath reading שור אומר / אשירה לד' כי גאה גאה (Ox says: "I will sing unto the Lord, for He is highly exalted" [Exod. 15:1]). The inscription quotes the ox's praise of the Creator in *Perek Shirah*: "Ox says: Then sang Moses and the children of Israel this song unto the Lord, and spoke, saying: 'I will sing unto the Lord, for He is highly exalted; the horse and his rider hath He thrown into the sea' [Exod. 15:1]."[17] A smaller fragment of the painting on the right side seems to be the head of a fish facing left, and only the end of the caption is visible: לעולם חסדו ("for His mercy endureth for ever" [Ps. 136:1]). In *Perek Shirah*, this verse is recited by the legendary fish Leviathan: "Leviathan says: 'O give thanks unto the

World of Prayer: Commentary and Translations of the … Prayers, vol. 2 (New York, 1963), 29–32.

12 Translated into English after *Sefer Perek Shirah ha-meyuḥas le-David ha-melekh alav ha-shalom* (The Book of Perek Shirah attributed to King David, May He Rest in Peace), ed. Berl Klein (New York, 1997) (Hebrew).

13 Goldgart, "Zikhronot," 133. Ginsburg gained his fortune by supplying the Russian navy's Pacific fleet; see *Moses Ginsburg: His Life and Work* (Paris, 1936); *M.A. Ginsburg: sa vie, son œuvre* (Paris, 1933); Aleksandr Pilipenko, "Moisei Ginsburg – 'blagodetel' nashego Tikhookeanskogo flota: k istorii evreiskogo predprinimatel'stva v Rossii" (Moisei Ginsburg, a "Benefactor" of Our Pacific Navy: On the History of Jewish Entrepreneurship in Russia), *Vestnik evreiskogo universiteta* 2(20) (1999): 274–94 (Russian).

14 Goldgart, "Zikhronot," 133.

15 The inscription under a painted curtain reads:

[…] על ידי הגבאים המחסדים בבית / הכנסת / אלחנן שלמה [ג]אלדהארט / זאב בר מ[ש]ה ז'ק / משה עזר[יא]ל [גא]לדהארט / התקון […] [בשנ]ת [ת']ר'ס'ו'

([repaired] by the benevolent *gabbaim* in the synagogue Elḥanan Shlomo Goldhart, Zeev son of Moshe Zak, Moshe Azriel Goldhart. The repair [took place] in [5]666 [=1906]). The inscription in a round cartouche flanked by lions' heads reads:

על תקון [בית הכנסת] / פזר הנגיד קאמערץ ס[אווע]ט[ניק / ה' משה מנחם ב"ר עקב[א] [גינז]בערג / סך חמשת אלפים / רו"כ [– רובלי כסף]

(The notable Commerce Counselor Mr Moshe Menaḥem son of Akiva Ginzburg expended on the repair [of the synagogue] a sum of five thousand silver rubles). See also Menahem Goldgart, "Zikhronot min ha-ayarah" (Reminiscences from the Town), in *Radzivilov: Sefer zikkaron*, ed. Yaakov Adini (Tel Aviv, 1966), 69 (Hebrew).

16 Ibid.

17 *Perek Shirah* 5.

Lord, for He is good, for His mercy endureth for ever' [Ps. 136:1]."[18] The inscriptions seen in Yudovin's photograph, as well as those reported by Rekhtman, are in accord with our hypothesis that the paintings of 1906 in the Radyvyliv synagogue, and probably also their earlier versions, were illustrations of *Perek Shirah*.

The explicit textual reference to *Perek Shirah* in the Radyvyliv synagogue's paintings suggests an interpretation of the numerous zoomorphic images in other synagogues, which have no captions. The animals listed in this poem might have influenced the depiction of elephants, camels, foxes, bears, deer, gazelles, cats, and more types of creatures on the ceiling and walls of many late-nineteenth and early-twentieth-century synagogues from Lithuania to Romania.[19] However, these series seldom include paired images of an ox and a fish. This pair – often designed as a giant fish coiling around an ox – symbolized the Wild Ox (or Behemoth) and Leviathan. Their meaning is derived from the Midrashic eschatology that portrays the Ox and the Leviathan as antagonist monsters that will engage in mortal combat at the End of Days; after both of them perish, their bodies are to serve as food for the righteous in the hereafter.[20] The iconography of the Ox and the Leviathan is traced back to medieval Hebrew illuminated manuscripts[21] and it continued, in its diverse versions, in east-European synagogue art.[22]

Placed in an easily observable location near the dedicatory inscriptions in the center of the western wall of the prayer hall, the separate portrayals of the Ox and the Leviathan seem to have been a purposefully constructed composite emblem. It is likely that the painter of the Radyvyliv synagogue chose these two creatures from among the dozens of those featured in *Perek Shirah* and juxtaposed the Ox and the Leviathan facing each another in order to retain their traditional eschatological meaning. The easily seen images of the Wild Ox and the Leviathan are praising the Lord and His creation, while awaiting their eschatological combat that will harbinger the messianic Redemption.

Encouraged by many discoveries in the field of east-European synagogue paintings during the recent decades, we may only hope that some more images of the Radyvyliv synagogue or quotations from *Perek Shirah* on synagogues' walls will be found one day to enable us to substantiate or revise our hypothesis.

18 *Perek Shirah* 4.

19 A prominent surviving example of the kind is the Great Synagogue in Botoşani in Romania (built in 1834); see Aristide Streja and Lucian Schwarz, *Synagogues of Romania* (Bucharest, 1997), 98; and field documentation by Boris Khaimovich in the archives of the Center for Jewish Art, Hebrew University of Jerusalem. Note also Khaimovich's general assumption of a possible reference to the images of "animals, plants, and natural forces" in synagogue paintings and the creatures "praising the Lord through His creation" mentioned in *Perek Shirah*; see idem, *"The Work of Our Hands to Glorify": Murals of Beit Tfilah Benyamin Synagogue in Chernovits: Visual Language of Jewish Artist* (Kyiv, 2008), 50–51 (English and Russian).

20 Joseph Gutmann, "Leviathan, Behemoth and Ziz: Jewish Messianic Symbols in Art," *HUCA* 39 (1968): 219–30; idem, "When the Kingdom Comes, Messianic Themes in Medieval Jewish Art," *Art Journal* 27 (1967–68): 168–75. See also Jehuda Feliks, "Leviathan," in *EJ*², 12:696–97.

21 See Gutmann, "Leviathan, Behemoth and Ziz" and idem, "When the Kingdom Comes."

22 The Ox and the Leviathan appear in synagogue paintings in Hvizdets (Gwóździec), Min'kivtsi (Mińkowce), and Smotrych (Smotrycz) in the neighboring regions of Ruthenia and Podolia from the eighteenth century; see Thomas C. Hubka, *Resplendent Synagogue: Architecture and Worship in an Eighteenth-Century Polish Community* (Hanover, 2003), 173; Stefan Taranushenko, *Synahohy Ukrainy* (Synagogues of Ukraine) (Kharkiv, 2012), 57, 104 (Ukrainian). Symmetrically placed images of the Ox and the Leviathan were painted on the façade of the synagogue in Pishchanka (Pieszczanka), Podolia, in the late-nineteenth or early-twentieth century; see Boris Khaimovich, "Podol'skoe mestechko: prostranstvo i formy" (Podolian Town: Space and Shapes) in Veniamin Lukin and Boris Khaimovich, *100 evreiskikh mestechek Ukrainy: Podolia* (A Hundred Jewish Towns of Ukraine: Podolia), issue 1 (Jerusalem, 1998), 91–95 (Russian); for a reproduction of Pishchanka see *Tracing An-sky: Jewish Collections From the State Ethnographic Museum in St Petersburg*, eds. Mariëlla Beukers and Renée Waale (Zwolle, 1992), 62. Paired depictions of the Ox and the Leviathan are also known from the carvings on wooden Torah arks in the synagogues of Kėdainiai and Šaukėnai, both in Lithuania, dated to 1807 and 1886 respectively; see Sergey R. Kravtsov, "Synagogue Architecture in Lithuania," in Aliza Cohen-Mushlin et al., *Synagogues of Lithuania: A Catalogue*, vol. 1 (Vilna, 2010), 55; "Kėdainiai," in ibid., 247; Mariaja Rupeikienė, *A Disappearing Heritage: The Synagogue Architecture of Lithuania* (Vilnius, 2008), 63, fig. 36.

Obsessions of a Diasporist

Cilly Kugelmann, Eckhart Gillen, and Hubertus Gaßner, *Obsessions: R.B. Kitaj 1932–2007*
[catalogue, Jüdisches Museum, Berlin] (Bielefeld: Kerber Verlag, 2012),
263 pp., illustrations (chiefly colored), ISBN 978-3-86678-731-5

Ziva Amishai-Maisels

R.B. Kitaj was a complex intellectual artist with out-standing visual and technical skills. He was full of contradictions: an American Jewish expatriate who stressed his interest in types of sexuality along with his search for Jewish roots and a modern Jewish art. He broke

barriers and categories of art, employing realism and distortion in the same works, returning to figuration during the ascendance of Modernist abstraction and producing a highly personal Symbolism with texts incorporated among the images. He wanted the meanings of his works to be deciphered through an iconographical search for visual and literary sources mixed with biographical and historical references.

Retrospectives of his works sought to clarify all this by interweaving chronology with themes, inserting later works into their earlier periods of gestation. The Jewish Museum of Berlin makes this method comprehensible through a breakdown into ten relevant topics. "A Fragmented World" illustrates early works that are divided by grids or recombine fragments of painted images, texts, and photographs. Knowing that Kitaj's identification with Catalonia in the early 1960s led him to affirm his Judaism, "Catalonia as Trigger to Diaspora" includes *Kennst Du das Land?*, an anti-Fascist work that foreshadows his later obsession with the Holocaust. This is equally true of "Kitaj – Analyst of His Time" where works from the mid-1960s that deal with the London scene, violence, and the Vietnam war begin to use details from Nazi photographs. Whereas "A Circle of Friends" portrays actual friends from the 1970s, the central picture depicts Walter Benjamin whom Kitaj never met but whose writings influenced him. Benjamin strolls through *The Autumn of Central Paris* en route to his death while trying to escape the Nazis. In the same period, "Gallery of Character Types" presents those who adopt different identities, sometimes hidden,

at a time when Kitaj sought his own identity. This leads to "The Secret and the Public Jew" in which he reveals his hidden and overt Jewish identity in works such as *Marrano (The Secret Jew)* and *Cecil Court, London WC2 (The Refugees)*. The chapter "Distorted Bodies" seemingly deals with his mixture of Realism with Expressionism from the late 1970s to the mid-1980s, but several paintings, such as *The Rise of Fascism*, have clear Holocaust references, while *Self-Portrait in Saragossa* really shows Kitaj in Gestapo headquarters in Warsaw, seen here in a comparative photograph. Two other *Self-Portraits* stress his interest in contemporary German Neo-Expressionism and his identification with a woman in Vienna whom the Nazis forced to wear a sign admitting that she slept with a Jew. "Obsessions" relates to three of his obsessions in the 1980s: prostitutes and morality, his Jewish identity, and the Holocaust, while the next chapter, "The Library as a Diasporic Home," reveals his lifetime passion for books. The final chapter, "Self-Retreat," delves first into his traumatized reaction to the vicious criticism of his retrospective at the Tate Gallery in 1994, which he saw as anti-Semitic. He blamed the critics for the death of his wife Sandra and took revenge in *The Killer-Critic Assassinated by his Widower, Even* (1997). The fears of anti-Semitism that he began to express in 1985 re-asserted themselves in a paraphrase of Uccello's painting of Christians breaking into a Jewish home. This chapter also includes his feeling that Sandra continued to accompany him, his approach to the Arab-Jewish conflict, and ends with a series of late self-portraits in which he reveals his aging and suffering. In the last one (2007), he winks at us with a crooked smile, inviting us to share in his conflicts and conundrums. The choice and arrangement of the high-quality illustrations tell the complex story of Kitaj's career with clarity, while stressing as leitmotifs his Jewish identity and his obsession with anti-Semitism and the Holocaust, themes especially suited to the venue – Berlin's Jewish Museum.

This emphasis is reinforced in the enlightening articles. Only one, Edward Chaney's "Warburgian Artist: R.B. Kitaj, Edgar Wind, Ernst Gombrich, and the Warburg Institute," presents a general approach to the artist. It analyzes the ways he adapted to Modern Art the ideas of Warburg and Wind on motifs that are repeated with different meanings throughout history.

Kitaj's relationship with Germany is discussed by Martin Deppner in "Letters to a Young German Painter." Deppner contacted Kitaj at the time the latter was expressing the Holocaust in his *Passion* series. Feeling that Kitaj was influenced by German art, in 1988 Deppner organized a joint exhibition of London Jewish artists and Hamburg artists. He tells of Kitaj's wish to write a letter with questions of mutual interest to German and Jewish art. However, he downplays Kitaj's ambiguous attitude: stating that Kitaj felt his *Germania* series initiated a dialogue, Deppner ignores the fact that several of its works deal with the Holocaust. Deppner mentions, but does not explain, Kitaj's original publication of his *First Diasporist Manifesto* in German just before the 1988 joint exhibition. Deppner's positive approach makes sense in the context of an exhibition at the Jewish Museum in Berlin, but oversimplifies a complex problem.

Other articles deal with facets of Kitaj's Jewish identity. Eckhart Gillen's "R.B. Kitaj – Secret Jew and Avowed Diasporist," traces it from the early 1950s in Vienna, and stresses that the Eichmann trial made Kitaj understand that assimilating does not stop one from being Jewish. Gillen discusses Kitaj's use of Joe Singer as a Jewish alter-ego, and his marriage to Sandra Fisher at Bevis Marks Synagogue after having visited Drancy. After Sandra's death, Kitaj believed that she was the *Shekhinah* (Divine Presence) hovering over him.

David Myers' "Reflecting on the Jewish Condition in the Kaffeehaus" underlines Kitaj's obsession with the Jewish Question. Myers connects the writing of Kitaj's *Second Diasporist Manifesto* in a Los Angeles café with a wish to participate in the discussions on Zionism versus Jewish autonomy in the Diaspora that took place in cafés in Berlin and Vienna at the turn of the twentieth century. Kitaj admired Simon Dubnow's desire for autonomy, but realized that the Nazis had murdered him. Myers stresses Kitaj's emulation of Ahad Ha'am's demand for an unapologetic Jewish culture, his use of Kafka's blending of alienation and yearning, and Gershom Scholem's influence that led Kitaj to interpret Sandra's spirit as the *Shekhinah*.

Inka Bertz continues this line in "'Will I Be the Herzl (or Ahad Ha'am) of a nu [!] Jewish Art???': R.B. Kitaj's Manifestos on Diasporism." She traces the development of his thoughts on Jewish art from his article in 1984 that asked why there had never been a great Jewish artist. She stresses that his interest in this subject did not involve religion but the Jewishness that condemned Jews to death, a quality he felt could be expressed in art, wanting to "do Cézanne and Degas and Kafka over again: after Auschwitz." She also does not explain why his *First Diasporist Manifesto* was published in Germany a few months before his exhibition with German artists, but adds that the book was made to resemble those on the Holocaust. Comparing his concept of Diasporism with Gilles Deleuze's ideas on Minority Culture, she points out that the *Manifesto*'s English edition was criticized for broadly defining the Diaspora to include homosexuals and various misfits. She discerns the origins of the *Second Diasporist Manifesto*, published after his death, in articles he wrote on his relation to Jewish art, and finds preparations for a third manifesto in a sketch he wrote on his own Jewish art that asks the question in her title.

Michal Friedlander's "The Skeptical God-Seeker" investigates Kitaj's portraits of rabbis. Her father, Rabbi Albert Friedlander, met Kitaj in the 1980s; they discussed religion and Kitaj, as a free-thinking Jew, wanted to know where God was during the Holocaust. Kitaj painted Friedlander as *The Reform Rabbi*, a Diaspora Jew continuing German Liberal Judaism. *The Orthodox Rabbi* portrays Rabbi Adin Steinsaltz, whom Kitaj sketched during the latter's lectures in England. Kitaj studied Steinsaltz's Talmud in English, and found a kinship between the commentaries around the text and his own commentaries on his works. He did a series based on Steinsaltz's *Biblical Figures*, identifying with Abraham (Kitaj's Hebrew name) as "a stranger and a sojourner" (Gen. 23: 4). Kitaj felt that Steinsaltz had changed his life, and was happy when they finally met. Rabbi Abraham Levy, who presided over Kitaj's wedding to Sandra, irritated Kitaj by demanding proof that he was Jewish and not married, leading the artist to scribble over Levy's face in *Wedding*. However, Kitaj let him put a mezuzah on his doorpost, liking the sign that he belonged to the "tribe."

In "'I Accuse!' Kitaj's 'Tate War' and an Interview with Richard Morphet" Cilly Kugelmann investigates Kitaj's reaction to the violent criticisms of his show at the Tate Gallery curated by Morphet. Feeling that they were motivated by anti-Semitism, Kitaj published "I accuse!" – echoing Zola's defense of Dreyfus. Kugelmann clarifies that the shock of Sandra's death after the exhibition, for which he blamed the critics, was intensified by his mother's recent death. She briefly discusses his portraits of Sandra after her death and *The Killer-Critic Assassinated by his Widower, Even*, but her interview with Morphet adds very little.

Finally, Tracy Bartley's "My Years with Kitaj" gives a loving outline of his life in Los Angeles, where she was his assistant. She describes his house, his daily schedule, their discussions, and how he wrote his autobiographical *Confessions*, quoted in several of the articles. She explains his technique and the way he worked with source material. She also mentions that he developed Parkinson's and was depressed, but not his suicide.

A special aspect of this catalogue is the way it hints at the way Kitaj's mind worked. The beautiful illustrations of the exhibited works are often accompanied by short quotes from his numerous explanations and/or by very small photographs of relevant source material that were gleaned from his archives. My only criticism is that one needs a magnifying glass to see them. These comparisons are not labeled (they are listed on pp. 256–57), but their relevance is explained in the articles.

There are also five fascinating fold-out four-paged spreads that focus on inspirations for a single artwork: books, letters, sketches, photographs, and artistic sources. They provide insights into how Kitaj brought visual, personal, and written material together to produce something new, but as there is no explanation we must draw our own conclusions as to how he integrated them into his painting. Three fold-outs seem randomly scattered through the catalogue, but their location is purposeful. For example, amidst works from the early 1960s whose fragments have not yet coalesced appears *His New Freedom* (1978), a distorted figure made up of fragments from numerous sources convincingly molded together. In like manner, *If Not, Not* (1975–78), which suggests the

Holocaust, comes right after the section dealing with his reactions to world events. On the front of the fold-outs is an enlarged section of the painting, which is particularly valuable in *The Killer-Critic Assassinated by His Widower, Even*, where it allows us to read the angry inscriptions written among the violent images. We now perceive, for instance, that one of the avengers has the letter ק, Kitaj's Hebrew initial, as a head and an image of Sandra as an angel, labeled *Ma Jolie*, within his body literally fulfilling the inscription on her, "I stand in you."

These quotations, sources or documents do not give us the full story for, as Kitaj told me in 1988, he never tells all his secrets. He wanted the spectators to investigate on their own, only hinting at directions they might pursue to delve into the multiple meanings of his works. I believe he would have been delighted with these fold-out pages as well as with the hints given beside the other illustrations. This is an important contribution to the literature on Kitaj and I recommend it to anyone interested in him or in modern Jewish art.

Israel's Art Viewed and Reviewed

Yigal Zalmona, *A Century of Israeli Art* (Farnham, Surrey: Lund Humphries; Jerusalem: Israel Museum, 2013), 498 pp., 350 color and 50 black-and white illustrations, ISBN 978-1-84822-127-7

Larry Silver

Upon reaching a certain age, one realizes that a lifetime experienced in person has now become the record of history. Yigal Zalmona, senior curator at the Israel Museum, Jerusalem, has helped build a collection that participated in the century of Israeli art that forms the subject of this book. In the process he has also curated exhibitions about the formative early years of art-making in Palestine, from its origins at the Bezalel of Boris Schatz and Abel Pann to contemporary exhibitions at his own museum during his long tenure. Thus, even more than any artist, Zalmona has actively and variously crafted the very contours of Israeli art across the tidy epoch that he charts here. One could not hope for a better guide.

But of course, as a participant in Israeli art's evolving history, Zalmona has had to be a critic as much as a historian, and this book, too, makes choices among artists, to focus on certain individuals whom he regards as significant – for either their historical influence or their aesthetic merit. While widely comprehensive, this volume features areas of concentration and thus inevitably gives less attention to some individuals and even to some important media, such as early photography (though in recent decades, some photographers, notably Adi Nes, receive close scrutiny, and the staged theatricality of current photography is underscored, p. 401). Though some modern media, particularly installation, performance, and video (e.g., the arresting works of Michal Rovner, p. 408), are notoriously intractable to show in photos, Zalmona still manages to give proper attention to such performance artists as Motti Mizrahi (pp. 302–4), and he seems particularly sensitive to environmental, site-specific activities by artists, such as Micha Ullman's 1972 *Messer-Metzer Project: Exchange of Earth* (pp. 295–97). Indeed,

his facility with sculpture (even in an "expanded field," especially Ullman) is admirable throughout, particularly for Itzhak Danziger (*Nimrod*, 1939, is even a case study chapter, pp. 111–25) and Igael Tumarkin. Also notable is Zalmona's attention across the full century to influential teachers and their family tree of successful pupils.

Inevitably, one can feel that some favorites are slighted. (My personal favorite, Mordecai Ardon, seems barely visible [pp. 198–200], but his relative obscurity is justified as well as contextualized as the result of a lost battle for local significance –"too sublime?" is the segment

heading – to the pure abstractions of Yosef Zaritsky and New Horizons.)

The Ardon sample clearly reveals how Zalmona considers himself more art historian and culture historian than art critic, though he obviously is both (and art history of the best kind demands both – his analysis of Ardon's 1967 Israel Museum work, *At the Gates of Jerusalem*, remains richly insightful). One can point to many passages, especially in the more recent decades, where his critical insights and close scrutiny of individual works pay dividends. To take a nearly random example, his interpretive and thoughtful discussion (pp. 364–66) of a single painting (again in the Israel Museum), Dganit Berest's *The Observer, the Swimmer, and the Diver No 2* (1989), made me engage in a multiple dialogue with both the artwork and Zalmona's reading.

But Zalmona especially wants readers to understand the emerging historical contexts, both worldwide and Israeli, political and social as well as artistic, within which these works were fashioned. His book is organized by decades, lengthening as one approaches the present. And if sometimes the suggested connections are not fully obvious between context and content, Zalmona considers artworks as interactions with history as well as other artworks, both Israeli and Euro-American. Sometimes he notes or investigates foreign stimuli, but other times he lets the art of Israel alone tell its own emerging story. I did feel that some links – to U.S. Pop Art and to Robert Rauschenberg in particular, not to mention the modernist impulse towards abstraction – could be more forcefully delineated in the middle of the volume. But one does not want to see the history of art only as a series of responses, derivations, or influences. For the most part, this study retains its fixed vision on the art of Israel, as it should. Zalmona also does not attempt to resolve apparent period conflicts or contradictions, such as divergence around 1990 between simpler, stark assemblages and painted art detached from reality (Raffi Lavie's Madrasha art school circle; the Tel Aviv exhibition "Want of Matter") versus polish and beauty, and irony exhibited shortly thereafter ("Antipathos: Black Humor, Irony, and Cynicism" at the Israel Museum). Of course, some aesthetic contrasts are imbedded in history, especially the crucial 1920s contrast

between Jerusalem and Tel Aviv, between Bezalel and rising new younger artists such as Rubin, Paldi, and Gutman.

Some disadvantages do crop up in a separate-decades layout of history, though in a survey like this, one does see greater period coherence across different artists and movements, and one can also have the same feeling as Zalmona-the-curator, making sense of artistic and historical issues in real time, here aided by the benefit of hindsight. Splitting up the volume, however, undermines the extended careers of some artists, stressing their shifts of direction rather than consistency. For some artists, such as Joshua Neustein (chiefly discussed in the 1970s, pp. 274–79, but now the subject of a dazzling December 2012 retrospective at the Israel Museum, curated by Meira Perry-Lehmann), his contributions over time seem scattered and less fundamental. Of course, one can often go to some Zalmona single-artist exhibitions, such as his upcoming show on Ullman or his foundational study of Boris Schatz, to see that coherence restored. Yet some featured artists, notably painters Moshe Gershuni and Moshe Kupferman or sculptors Danziger and Tumarkin, remain scattered across chapters, even while remaining powerful and influential throughout their careers.

Neustein, moreover, possibly suffered here as well because he spent much of his career in New York – does that make him less of an "Israeli" artist in our current era of global movement and influence? For that matter, even Bulgarian Boris Schatz is father to the Boris Schatz of Bezalel, as duly noted (pp. 9–12). Indeed, most major early contributors to Israeli art in formation – and even some recent immigrants – were not born in the land. How important is their work in Europe or America, before or even after their time in Eretz Yisrael? How "Israeli" is E.M. Lilien (also scattered in this volume), Zionist artist *par excellence*, who contributed mightily with Schatz at Bezalel but then returned to Europe? As with any purported definition – whether "Jewish" art, "Israeli" art, or even "American" art – such boundaries are difficult to patrol, let alone define, and there is a danger (as I know from writing about modern Jewish artists) of having readers search for some ongoing essentialism.

Nonetheless, Zalmona never really explicitly confronts the issue of geography, even though a nation/region forms the basis of his chosen topic. The reader is impelled to read across the chapters to look for recurrent themes or issues of identity.

Here his book does offer an outstanding, if shifting analysis from beginning to end when Zalmona considers aspects of Israeli identity – at once within the historical "East" of ancient Mesopotamian or Egyptian glories as well as the Arab present. In recent decades the cultural assertion of Mizrahi (Oriental) Jewish ancestry plays an increasing role. Throughout, a complex awareness of Israel's in-between cultural location permeates these analyses. Not-U.S., not-Europe, not-Arab, but precariously poised at their overlapping cultural circles, Israel's own self-conscious self-fashioning still continues today. Zalmona quotes Ullman, who asserts (p. 381) a memorable truism that simply to dig in Israel opens up deep questions of archaeology and ancient – often biblical – history while pricking at the importance of holding onto land in the present. Here photography plays a significant role as do environmental projects, going back to Itzhak Danziger. Yet recent photographic imagery of Arab suppression, e.g., by Pavel Wolberg, is barely mentioned, though Miki Kratsman's *Nablus* (1989, p. 331) is illustrated. Nor is the intifada resistance addressed (such as Barry Frydlender's *Cafe Bialik, After*, 2002). Zalmona still shows the ongoing topicality of Israel's land as interpreted artistically, through two colorful recent artists – Gal Weinstein (pp. 434–39), including *Jezreel Valley* (2002), and Sigalit Landau, whose hypnotic video, *DeadSee* (2005, p. 489) is the final image.

Zalmona's ongoing historical scope allows him to underscore shifting attitudes to pioneer Zionist goals: pioneer possession by sabras, "muscular" Jews, and, soon, heroic soldiers. He shows clearly how increasingly critical attitudes towards those hoary positive stereotypes have emerged in recent decades, alongside artistic assertions of personal identity by gays and women (and of course Palestinian artists as well). In general, the role of Jewish traditions seems attenuated here – with Ardon being the case study of its absence (see also Michael Sgan-Cohen, *Moses*, pp. 443–44), but this curious absence remains largely unexamined – by Israeli artists and by Zalmona in this book. Beyond the moving Shoah memorials at Yad Vashem, only in recent decades has serious – and controversial – work about the Nazis been created by a generation born to survivors.

Even the prickly pear cactus, or sabra, has been represented ironically by some artists (Asim Abu Shakra, 1988, pp. 424–25; David Wackstein, *I am a Sabra*, 1985, pp. 345–46). Striking imagery about Arab neighbors becomes visible in the 1980s: Tsibi Geva's *Keffiyeh* (*Homage to Asim Abu Shakra*, 1992, pp. 347–51), Tumarkin's *Bedouin Crucifixion* (1982, pp. 352–53), and the Ka'aba abstraction by Joshua Borkovsky, *Pilgrimage* (1982, pp. 353–54). But does the vexed, yet fundamental question about the proper identity of a "Jewish state" ever arise (despite a recent Israel Museum presentation on Ḥaredim [ultra-Orthodox] as "A World Apart Next Door")? Certainly Adi Nes and Nir Hod (*Women Soldiers*, 1993, pp. 397–401) follow Igael Tumarkin's *He Walked through the Fields* (1967, p. 232) to provide more ambivalent assessments of the military. Imagery of gun violence even emerges occasionally (David Tartakover, *Happy New Fear*, p. 388; Arnon Ben David, *Jewish Art*, 1988, p. 442).

When I had the good fortune to spend a semester at the Hebrew University and tried to investigate Israeli art at the source in 2008, it was hardly on view. Both Tel Aviv and Jerusalem were busy (re-)constructing new, expanded installations, but then their permanent exhibitions shunted Israeli art to the side. Now, however, both institutions prominently display the national artistic heritage. Tel Aviv has published a serious handbook of its Israeli art collection, just as the Israel Museum has co-published this massive Zalmona tome. Moreover, to supplement his own indispensible English-language survey of Israeli art (1998; chiefly painting), Gideon Ofrat just published a valuable, dual-language catalogue of his own collection.[1] In the meantime, six nation-wide exhibitions

1 *The Museum Presents Itself: Israeli Art from the Museum Collection*, eds. Mordechai Omer and Ellen Ginton, rev. ed. (Tel Aviv, 2011); Gideon Ofrat, *Broad Horizons: 120 Years of Israeli Art from the Ofrat Collection to the Levin Collection* ([Jerusalem], 2012); id., *One Hundred Years of Art in Israel* (Boulder, 1998).

in 2008 surveyed Israeli art up until that year. Through this wealth of display and increased analysis, often in English, Israeli art history is now available for serious world-wide study. Culminating these major achievements, now Zalmona's volume provides the essential introduction – in all media, not just painting – and a lasting reference work (albeit quite thin concerning further references, with no bibliography). Lucidly written (and translated into English) and sumptuously illustrated with large-scale, color images, this authoritative survey makes a century of Israeli art a vital, distinctive participant in modern art history.

Alfred Moldovan (1921–2013)

William L. Gross

Dr Alfred Moldovan is no more. He passed away on November 4, 2013, leaving a rent in the fabric of the world of Jewish art that will be impossible to repair. This doyen of Judaica collectors, in the most meaningful and creative sense of that term, has left a legacy to us to both emulate and appreciate. It is very hard to imagine that this energetic vitality, this analytic virtuosity, and this acute intelligence, always expressed with wit and passion, has been silenced.

To enter the home of Al, which was the name everyone called him, and to view its contents, was the beginning of understanding the measure of the man. The first inescapable impression was of the library with its massive presence in every room of the apartment. More than 5,000 books lined the walls, covering every subject that interested him, which was virtually everything. From the history of all peoples and cultures to art of all varieties to philosophy to Marxism through medicine and on to all aspects of Jewish life: there was no end to Al's interests. Amazingly, he read all these books and remembered them, recalling with ease the subjects, ideas, and facts in them. All of this he integrated into his thoughts, conversations, and lectures, both formal and informal. To speak with Al was to receive a broad education anew each and every time.

On the shelves of ceiling-high display cases were the objects of Jewish ritual and custom in the synagogue and the home that constituted the collection. On the other walls in the living room, dining room, halls, and bedrooms were either additional overflowing bookshelves or framed pages and textiles displaying multiple and varied aspects of Jewish art and culture.

His contribution to the subject of Jewish art and collecting was highly significant. He was the first collector of these objects, books, prints and manuscripts in all the varied aspects of Judaica, with perhaps the exception of Professor Cecil Roth, to not only accumulate them but to attempt to study, understand, and interpret them. But Al was no ivory tower academic; he was a man of action in every part of his life and a man who shared. His home was open to anyone interested in Jewish culture and there is almost no person who has been actively involved in the field who has not visited there.

He generously participated in exhibitions, lending objects with openness and enthusiasm. He lectured and taught courses on the history of Jewish art and founded the longest lasting and still extant society for collectors of and people interested in Jewish art. That group, the Harry G. Friedman Society, has been meeting once a month in New York City for some thirty-five years, inviting lecturers to engage the members of the society in discussion of every possible aspect of the subject.

He gave of his enormous talents in public service for Jewish institutions as well, serving on the board of the Yeshiva University Museum and as a member of the

acquisition committee of the Jewish Museum of New York. Making use of his bibliographical knowledge and his facility for foreign languages, he volunteered for many years at the Library of the Jewish Theological Seminary, identifying and cataloging thousands of volumes that for decades had remained boxed after the great fire in that library.

His love of Jewish culture was actively shared by his wife Jean, who passed away eighteen years ago. Together they built the collection in general, as well as in specific areas of special interest. Her particular concerns led to marvelous examples of Jewish ethnic jewelry, Jewish posters, and a pioneering exploration of illustrated Jewish children's literature. Al adored Holy Land and Jerusalem imagery, spawning one of the foremost collections of Holy Land maps and views of Jerusalem, including unique examples that he personally documented. His two sons, Joseph and Micha, were also active participants in the family collection enterprise. As children, they awaited with excitement the arrival of each new acquisition and the consequent explanation of its significance from their parents.

Al's involvement in Jewish art was no small part of his passion for the Jewish people and its values, but not the only one. As he did for each and every piece in his Judaica collection, Al sought the truth and meaning in everything he did. And as it was in his life in Jewish art, one of numerous accomplishments, so it was in his approach to all his activities that contributed to carrying out his absolute commitment to what he saw as both Jewish and universal values.

The day that the Japanese attacked Pearl Harbor in 1941, Al enlisted in the US Army Air Corp and remained in service five years. He served in a bomber group based in Italy.

After being demobilized, Al entered medical school. Upon graduation, although he could have opened an office to serve the wealthier people in New York, in 1954 he opened a clinic in the middle of Harlem, where he remained for the forty-seven years of his practice, helping the disenfranchised populations of that area.

In 1964, he was one of the founders of the Medical Committee for Human Rights to assist in the civil rights movement of the period. In 1965 he left his family and office in New York for the South. On the first of the Selma, Alabama, to Montgomery marches, on what is known as Bloody Sunday, Al was there. He served as physician to Martin Luther King, remaining at his side. When the police attacked the demonstrators who had crossed the Edmund Pettus Bridge with clubs and tear gas, there were multiple casualties. Al, with the ambulances on the other side of the bridge, faced down the sheriff and his men who were blocking the medical staff from crossing to help the injured. The sheriff wielded his gun and threatened to shoot anyone attempting to cross. As the New York Times reported "Dr. Moldovan . . . broke away from the blockade by force of will, and the only ambulance to make it out of Selma crossed to find a . . . civilian battlefield littered with . . . prostrate human forms." That was Al Moldovan. Until Dr King left Selma, after two more marches, Al stayed with him, sleeping outside his room to protect him.

He organized hundreds of doctors and health workers in picket lines to force the American Medical Association to prohibit segregated state medical societies. He attended the student protests against the Vietnam War to treat those injured from police beatings.

In the first Gulf War in 1991, when Scuds began falling on Tel Aviv, Al boarded the first available plane to come to that city. While many people were leaving, Al arrived, identifying with the threat to the Jewish people and sharing it.

In a newspaper interview, Al told the reporter: "The leitmotif of my adult life has always revolved around my self-imposed injunction: 'Justify your existence.' . . . I've spent 70 years of my adult life trying to live up to that demand. I hope I have. I still believe in the innate goodness of man and the ability of man to be selfless." Al was a man who cared and his core warmth and love blessed a great many people.

Dr Alfred Moldovan indeed justified his existence each and every day of his ninety-two year life.

ABBREVIATIONS

AJ	*Ars Judaica*
AO	*Ars Orientalis*
BL	British Library, London
BnF	Bibliothèque Nationale de France, Paris
BT	Babylonian Talmud (preceding the name of a tractate)
EJ²	*Encyclopaedia Judaica*, 2d ed. (Detroit, 2007), 22 vols.
HUCA	*Hebrew Union College Annual*
JA	*Jewish Art*
JSQ	*Jewish Studies Quarterly*
JTSL	Jewish Theological Seminary Library, New York
JWCI	*Journal of the Warburg and Courtald Institutes*
NLI	National Library of Israel, Jerusalem
PL	*Patrologia Latina*

Prof. Ziva Amishai-Maisels	History of Art Department, the Hebrew University of Jerusalem
Dr Eleonora Bergman	The Emanuel Ringelblum Jewish Historical Institute, Warsaw
Prof. Evelyn M. Cohen	The Jewish Theological Seminary (JTS), New York
Dr Caroline Goldberg Igra	Guest Curator, Beit Hatfutsot, Tel Aviv
William L. Gross	Collector, Tel Aviv
Prof. Katrin Kogman-Appel	Ben-Gurion University of the Negev, Beer Sheva
Dr Sergey R. Kravtsov	Center for Jewish Art, the Hebrew University of Jerusalem
Dr Vladimir Levin	Center for Jewish Art, the Hebrew University of Jerusalem
Dr Sarit Shalev-Eyni	History of Art Department, the Hebrew University of Jerusalem
Prof. Larry Silver	History of Art Department, University of Pennsylvania
Dr Ronit Steinberg	History and Theory Department, Bezalel Academy of Arts and Design, Jerusalem

This journal's objective is to publish scholarly research concerning Jewish contribution to the visual arts and architecture, from antiquity to the present. *Ars Judaica* encourages the publication of research regarding Jewish art and its interaction with surrounding visual traditions. The journal promotes various approaches to the analysis of the visual arts: historical, iconographic, semiotic, psychological, social, ethnographic, and more. *Ars Judaica* is intended to serve art historians, collectors, curators, and all those who are interested in Jewish art.

Submission Guidelines

Manuscripts

The editors will not consider for publication an article that has previously been published or has been submitted for publication elsewhere in any language. Manuscripts should be submitted in English in digital file in Microsoft Word format. In addition to the text, the manuscript should include endnotes and captions for illustrations. All parts of the typescript – text, quotations, endnotes, captions, and appendices – must be double-spaced. Manuscripts should not exceed 8,000 words (excluding endnotes, captions, and appendices). Manuscripts for the "Special Item" section should not exceed 2,000 words.

Manuscripts should be submitted with an abstract of approximately 100 words, typed double-spaced. The author's name and email address should appear on a separate cover page, together with a brief biographical statement of approximately 50 words, including academic status and institutional affiliation, all typed double-spaced.

Photocopies of all images with caption information must be submitted together with the manuscript. The author will supply the original photographs or high-resolution scans after the manuscript is accepted for publication. The author is responsible for obtaining written permission from the holder of the rights to publish or reproduce all images that will appear in the article. Photographs will be returned to the author after publication.

Manuscripts are sent anonymously to referees and may be returned for revisions. A photocopy or digital file of the edited version will be returned to authors for proofreading, clarification, and approval prior to typesetting.

The submission digital package should include four files:

- The manuscript (including notes and captions);
- Captioned illustrations in a Power Point Presentation, Microsoft Word Document, or PDF file (to be used for reviewing and editorial work, not for the final publication);
- A cover page, together with a brief biographical statement;
- An abstract of the article.

Book Reviews

The following information must be provided at the beginning of the review: title of the review, author's/editor's name, complete title of book (with a colon between the main title and the subtitle), place of publication; publisher; date of publication; total number of pages (including all front matter and illustrations that do not carry page numbers); number of illustrations (black-and-white and color).

The submission digital package should include two files:
- The review, typed double-spaced;
- A cover page, together with a brief biographical statement, typed double-spaced.

List of Submitted Publications

Ars Judaica will publish a list of recent publications – books, catalogues, and article offprints – that will be submitted to the editors.

Style Guidelines

Style and Punctuation

Ars Judaica follows the American style of spelling and punctuation. As a rule, authors must adhere to *The Chicago Manual of Style*, latest edition. Special attention should be paid to deviations from this manual, in particular the citation of foreign languages, and in the style for bibliographic references and captions.

Languages other than English

Text

Prefer the English form of Jewish terms and names of historical figures as used in the *Encyclopaedia Judaica*, 1st ed. (Jerusalem, 1971).

Individual words (particularly terms) and short phrases, whether written in the original language (languages in Roman scripts) or in transliteration (languages in non-Roman scripts), are *italicized*. Foreign proper names and words that appear in a standard dictionary of the English language in non-italicized form will NOT be printed in italics.

For transliteration of Hebrew, as a rule follow the transliteration rules of the *Encyclopaedia Judaica*, 1st ed. (vol. 1, p. 90; use "General" and NOT "Scientific" format) or consult that encyclopedia's Index (vol. 1) for the relevant term. For transliteration of Yiddish, use the rules of YIVO, available on-line at "http://www.yivoinstitute.org/yiddish/alefbeys_fr.htm." For transliteration of other languages in non-Roman scripts, as a rule follow the rules of the 1997 edition of the *ALA-LC Romanization Tables: Transliteration Schemes for Non-Roman Scripts*, also available on-line at "http://lcweb.loc.gov/catdir/cpso/roman.html."

Inscriptions

If deemed essential for the text of the article, inscriptions will be provided in the original language. Inscriptions in Hebrew or Yiddish will be given in Hebrew letters, followed by an English translation in parentheses; those in other non-Roman scripts will be given in transliteration (*ALA-LC Tables*), followed by an English translation in parentheses.

Inscriptions in a language written in Roman script but deemed by the author of the article to be highly inaccessible to most readers will be followed, at the author's discretion, by an English translation in parentheses.

Biblical Citations

The editors prefer that biblical citations follow the English translation of the Bible published by The Jewish Publication Society, but this is not mandatory. Other translations will also be accepted.

References

Titles of books and articles in Roman script will be recorded in the original language. If that language is deemed by the author of the article to be highly inaccessible to most readers, they will be followed, at the author's discretion, by an English translation in parentheses.

Titles of books and articles in non-Roman scripts will be recorded in transliteration (following the relevant rules as noted above, under "Text") and followed by an English translation in parentheses. When the publisher of the book or journal provides the title or contents in English, in addition to the original language, prefer that translation unless it contains glaring mistakes. Only in cases of Hebrew titles whose literal translation is meaningless (generally of rabbinic works) will the title not be translated.

The entire reference will be followed by the language, in parentheses, i.e. (Hebrew), (Russian), (Norwegian), etc.

Captions

Illustrations should be referred to in the text in the following manner: (fig. 1). Captions should include all the following relevant items in this format: Fig. 1. Igael Tumarkin, *Triptych*, 1961/62, mixed media on canvas. Triptych: central panel, 320 × 195 cm; each side panel, 320 × 60 cm. The Israel Museum, Jerusalem (Photo: David Harris). Titles of the art works in captions should be in italics.

Notes

A work is referred to in full at its first appearance. Subsequent references will be in the form of author's last name and short title. Titles of books will be italicized, and titles of articles will be in quotation marks. Use double quotation marks ("), not single marks ('). The language of a transliterated title must be given at the end of the reference in parentheses, e.g.: (Yiddish). Note that the dash between page numbers is an "en-dash" (–). Ibid. and idem are to be set in regular type, not italicized. DO NOT USE op. cit. and loc. cit.

In notes, the form of reference is as follows:

- Book

Full reference: Ziva Amishai-Maisels, *Depiction and Interpretation: The Influence of the Holocaust on the Visual Arts* (Oxford, New York, Seoul and Tokyo, 1993), 221.

Subsequent reference: Amishai-Maisels, *Depiction and Interpretation*, 25.

- Edited Volume (in its entirety, not as the repository of an article)

Full reference: *Ierusalim v russkoy kul'ture* (Jerusalem in Russian Culture), eds. Andrey Batalov and Aleksey Lidov (Jerusalem, 1985) (Russian).

Subsequent reference: *Ierusalim v russkoy kul'ture*.

Article in Edited Volume

Full reference: Richard I. Cohen, "Exhibiting Nineteenth-Century Artists of Jewish Origin in the Twentieth Century: Identity, Politics, and Culture," in *The Emergence of Jewish Artists in Nineteenth-Century Europe*, ed. Susan Tumarkin Goodman (New York, 2001), 154.

Subsequent reference: Cohen, "Exhibiting Nineteenth-Century Artists," 152–53.

Article in Periodical

Full reference: Mira Friedman, "Pagan Images in Jewish Art," *Jewish Art* 19/20 (1993/94): 125–32.

Subsequent reference: Friedman, "Pagan Images": 130.

Catalogue of Exhibition

Full reference: *Kadimah: ha-mizraḥ be-omanut Yisrael* (To the East: Orientalism in the Arts in Israel) [catalogue, Israel Museum], curators Yigal Zalmona and Tamar Manor-Friedman (Jerusalem, 1998), 63–65 (Hebrew, with English summary).

Subsequent reference: *Kadimah*, 141.

Note: [catalogue, name of institution] is added following the title of the catalogue in square parentheses, unless the words "catalogue" or "exhibition catalogue" appear as part of the title. When the place in which the exhibiting institution is located is not the same as the place of publication, add it after the name of the institution.

Example: Sander L. Gilman, "The Jew's Body: Thoughts on Jewish Physical Differences," in *Too Jewish? Challenging Traditional Identities* [catalogue, Jewish Museum, New York], ed. Norman Kleeblatt (New Brunswick, NJ, 1996), 60–73.

Ars Judaica

Some back issues available, please inquire.